How to Draw & Sell

COMIC STRIPS

3rd edition!

How to Draw & Sell
COMIC STRIPS
3rd edition!

CONTENT, LAYOUT, STYLE, COLOUR, PRESENTATION

Alan McKenzie

TITAN BOOKS

A QUARTO BOOK

HOW TO DRAW AND SELL COMIC STRIPS
3RD EDITION
1 84576 076 X

Published by
Titan Books
A division of
Titan Publishing Group Ltd
144 Southwark St
London
SE1 0UP

3rd Edition August 2005
1 3 5 7 9 10 8 6 4 2

Visit our website:
www.titanbooks.com

Did you enjoy this book? We love to hear from our
readers. Please e-mail us at: readerfeedback@titanemail.com
or write to Reader Feedback at the above address.

To subscribe to our regular newsletter for up-to-the-
minute news, great offers and competitions, email:
titan-news@titanemail.com

Titan books are available from all good bookshops or
direct from our mail order service. For a free catalogue
or to order, phone 01536 76 46 46 with your credit card
details or contact Titan Books Mail Order, Unit 6, Pipewell
Industrial Estate, Desborough, Kettering, Northants NN14
2SW, quoting reference HD/SC.

Conceived, designed and produced by
Quarto Publishing plc
The Old Brewery, 6 Blundell Street, London N7 9BH

QUAR: HCS3

Editor	Michelle Pickering
Art editor	Tim Pattinson
Designer	Karin Skånberg
Illustrators	Kang Chen
	Nubian Greene
	Kevin Hopgood
	Steve Parkhouse
	Nick Stone
	Dylan Teague
	Simon Valderrama
Picture researcher	Claudia Tate
Photographer	Phil Wilkins
Indexer	Dorothy Frame
Assistant art director	Penny Cobb
Art director	Moira Clinch
Publisher	Paul Carslake

Colour separation by PICA Digital, Singapore
Printed by Star Standard Industries Pte, Singapore

Contents

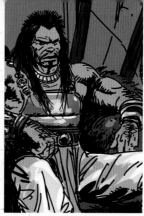

foreword

When I first broke into comics in the 1970s, most people in the field were trying to break out of it. Back then, comics were a mass entertainment medium, selling hundreds of thousands of copies a week, but at the very bottom of the cultural pile. They were produced exclusively for children, running the narrow spectrum from nursery comics to adolescent adventure.

Although the quality of the work produced back then was high, given the editorial restrictions, none of the artists or writers was ever credited. In fact, editorial 'bodgers' (art assistants) counted among their duties the whiting out of artists' signatures surreptitiously slipped onto the odd piece of work the artist did feel remotely proud of. The perceived wisdom was that the inclusion of credits or signatures would spoil the illusion for children, who thought they were looking at something that was really happening, rather than something that had been created by a human hand… I know, I know.

Of course, what the publishers really dreaded was that artists and writers, once they knew their work was more popular than that of their peers, might ask for more money to reflect the extra sales they generated.

Given the shameful and anonymous nature of their labours, it was hardly surprising that most artists longed for the rich pastures of magazines, advertising or fine art, where they might take credit for their work or at least be paid more money and not be embarrassed to admit their trade to friends and neighbours.

I belonged to arguably the first generation that saw the world of comics as a destination, rather than a temporary stop on the way to an honourable living. My generation had been weaned on the rich visuals of comic-strip artists. We knew that Dan Dare was drawn by Frank Hampson, that Batman was created by Bob Kane, and that Stan Lee and Jack Kirby wrote and drew the comic books of Mighty Marvel. Admittedly, Dick Sprang and Carl Barks were still only known as the 'good' Batman and 'good' Donald Duck artists, but at least we knew that the medium we loved was created by real people, people we could emulate.

At first, there seemed to be no great mystery as to how to produce the artwork for comics. Black ink and white paper seemed pretty much all you needed. That's how it seemed, but I used up a lot of my youth and my eyesight drawing tiny homemade comics at printed size before I discovered that real comics were drawn anything up to twice the size they appeared on the page. I suspected there were other tricks of the trade, hopefully less basic, but still very useful, if not essential, to the production of professional quality work.

I had a couple of Walter T. Foster cartooning books, but these were very general and dated in approach. Then there were books on figure drawing, but these were academic and musty in tone; books about pictorial composition that referred almost exclusively to sedate and tranquil effects; ink-drawing books featuring often laboriously hatched illustrative techniques; and hand-lettering manuals that were excessively traditional and formal in their examples. There were no books that I could find back then that dealt solely with the skills needed to produce comic art.

Even those who, unlike me, had been to art school fared little better. The whole commercial art field seemed to be regarded with disdain, with comics at its nethermost pole. Aside from formal drawing skills, there seemed little of relevance available there.

Things have improved for creators since then – paradoxically, since comics' role as a mass entertainment medium has declined in recent years, with video and gaming entertainment stealing their youthful audience. Comics have blossomed into a popular art form and specialist hobby that now boast their own retail outlets, worldwide conventions and celebrities, and that encompasses a wide variety of genres and niche audiences. Characters and properties that originated in the pages of cheap comics have gone on to become global entertainment sensations and some creators have enjoyed commercial and, sometimes, critical success that would have been way beyond the dreams of even the most ambitious comic artist of yore.

For those who wish to break into the field now, there are dozens of 'How To' books to offer the means. Unfortunately, some of these are superficial or overly focused on narrow areas, while others are written and drawn by people who, frankly, have precious little experience or expertise

themselves. Then there are the very few that combine expert, insider knowledge with clarity and breadth.

Alan McKenzie's book is among the latter. I'm betting that if you visited the studio of most professional comic artists, you'd find one of the earlier editions of it on a handy bookshelf. This latest edition contains everything you need to know from those previous incarnations and has been brought bang up to date with the latest technical and market information, not to mention fresh new examples and tutorials.

Alan has had long and varied professional experience in the comics field, having written and edited some of the UK's most popular titles. His frequent collaborator, Steve Parkhouse, is, as usual, on hand to demonstrate some of the artistic techniques and processes (I actually learned to letter comics back in the bad old days by, literally, looking over Steve's shoulder).

Not only is there the kind of creative and technical information here that I would have killed for when I was starting out, but there's also vital information on marketing and copyright that may save you from being scalped, if not actually killed, in today's commercial world. There's even advice on publishing your work yourself, in print or online, a development that was completely unsuspected back when I was breaking in.

Think of this book, then, as a shiny, newly cut set of keys to the comics business. Use them well and enjoy. Just spare a thought for those of us who had to climb over the back wall and jemmy open the kitchen window all those years ago!

Dave Gibbons, April 2005

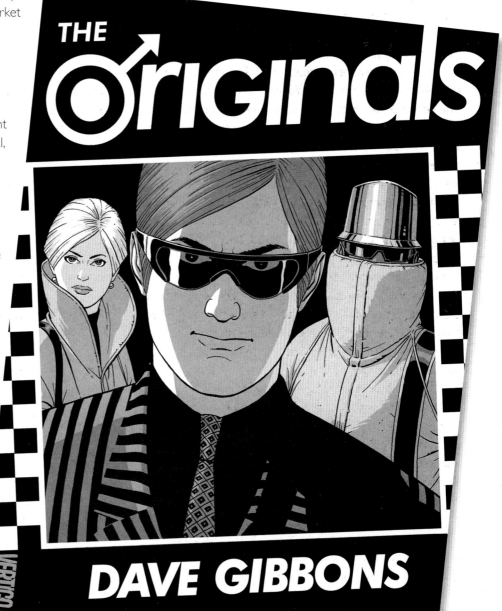

The Originals

Dave Gibbons, the artist responsible for *Watchmen* with writer Alan Moore – a series that revolutionized comics and helped them cross over into the bookshop marketplace – wrote, drew and designed the 160-page graphic novel *The Originals*, published 2004.

Chapter 1
A History of Comics

Comics have been around for over a
hundred years, so to do their history
justice would take up a whole book in
itself – and that book would need to
be two or three times as long as this
one. This chapter provides a
whistle-stop tour to give you
a better idea of how the
art of the comic has
changed over the years,
from the first stumbling steps as sales
premiums for the big city newspapers,
through the phenomenal sales figures
of the post-World War II years, right
up to the present day.

the newspaper strip (1900s–1930s)

The beginning of the comic strip was not a sudden 'Eureka' moment, but more of a slow evolution. Comics were not so much invented as discovered, so it is not really possible to point to any single inventor of the medium – the idea was built on by many.

Comics begin

The earliest appearance of the comic strip was in the pages of the big US newspapers at the turn of the 20th century. Gag panels (as they used to call one-picture cartoons) and political cartoons had been around for some time, so the idea of communicating ideas in a two-dimensional picture form was not a new one. However, in 1894, when the *continuity* strip first appeared, a whole new dimension was added to cartooning: *time*. By presenting a sequence of pictures, an artist could put across the illusion of a series of events in chronological order.

This introduced a vital quality, previously possible only in the live performance of an actor or comedian: *timing*. This advance was so influential that cartoonists spent the first 30 years exploring only the comic possibilities of strips. It is for this reason that the term 'comic strip' came to be applied to all continuity art, whether the strip in question was comic or dramatic.

As with all new art forms, the earliest comics were crude affairs, lacking any real artistic quality, and perhaps because of this, comics were not even regarded as a worthwhile endeavour for their own sake. They were nothing more than circulation boosters for the newspapers in which they appeared, the publishers relying on the novelty value of the comics rather than on any inherent artistic quality they might have.

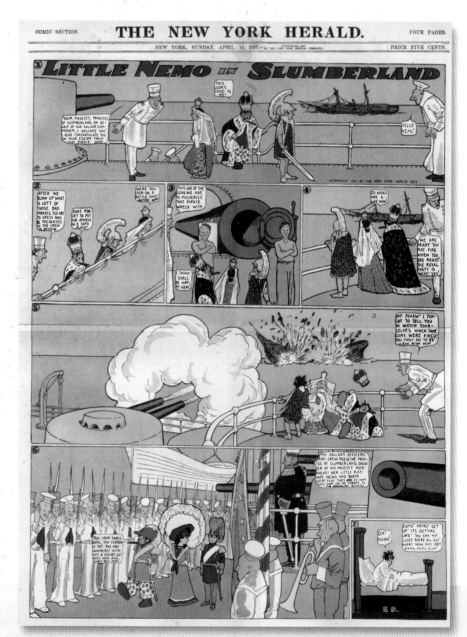

All join in

By 1905, every major newspaper in the US included a comic-strip section. As the amount of comic-strip material grew in the years leading up to World War I, provincial newspapers sought to climb on the comic-strip bandwagon. Unable to afford to commission their own comics, they instead bought second rights from their big city cousins. Spotting an opportunity, newspaper magnate William Hearst launched a concept in 1912 that would revolutionize the distribution of comic strips throughout the world: the syndication agency.

Hearst's International News Service sold reprint rights of his news and features – and, of course, comic strips – to independent newspapers throughout the world. Over the next few years, the service evolved into the King Features Syndicate, the biggest in the field, and spawned many imitators. Comic strips had become a part of everyone's daily life. It was only a matter of time before someone thought of the idea of publishing a paper that was *all* comic strip.

HOTEP

Tarzan

Hal Foster's *Tarzan* art (left) was a high-water mark in the history of the newspaper comic strip. Burne Hogarth took over the illustration of the *Tarzan* strip on Hal Foster's resignation in 1937 (below).

Many considered Burne Hogarth's art to be even better that of original *Tarzan* artist Hal Foster.

HOGARTH 1/30

OPPOSITE: Little Nemo

A superb page of *Little Nemo in Slumberland*, reproduced here as it would have appeared in a newspaper of the period: tabloid size and in full colour.

Note the absence of traditional speech balloons.

NEWSPAPER-STRIP MILESTONES

1905 *Little Nemo in Slumberland* by Winsor McCay was the first strip to break away from the humour tradition. McCay's artistic style on *Nemo* was a curious cross between art nouveau and surrealism, exploring the landscapes of a young boy's dreams.

1910 *Krazy Kat*, George Herriman's insane cat and mouse strip, began as a regular feature.

1929 Hal Foster's beautifully drawn *Tarzan* was published. Foster's work became so popular that, when he left the strip several years later, distributors King Features Syndicate were thrown into a panic. However, their hiring of a new young artist, Burne Hogarth, proved that no one

was indispensable and *Tarzan* continued, if anything more popular than before.

1929 Dick Calkins' science-fiction series *Buck Rogers in the 25th Century* paved the way for the more sophisticated *Flash Gordon* fives years later.

1932 Chester Gould's *Dick Tracy* appeared, featuring a menagerie of grotesque villains and setting the style for fictional tough lawmen.

1934 Alex Raymond wrote and drew the most famous space strip of all, *Flash Gordon*. This science-fiction strip was a masterpiece of comic art, creating a never-never land of mythic proportions on the fabulous planet of Mongo.

1934 Lee Falk's Mandrake the Magician had only to 'gesture hypnotically' to alter the very fabric of reality. The art by Phil Davis was in a kind of Alex Raymond style.

1934 Milton Caniff's *Terry and the Pirates* debuted. Terry, with his unofficial guardian Pat Ryan, became involved in a world of intrigue and drug smuggling. Head of the drug pushers was an exotic Eurasian woman called Dragon Lady. Caniff's drawing style was deceptively simple but produced a sophisticated result.

1934 Al Capp's satirical *Li'l Abner* strip used its simple-minded hillbilly hero as a yardstick against which to compare the foibles of society.

Relentlessly pursued by the marriage-mad Daisy Mae, Abner resisted for nearly 20 years until his favourite comic hero Fearless Fosdick, a wicked parody of Dick Tracy, became the husband of *his* long-time fiancée.

1936 Lee Falk's *The Phantom* featured the first masked costumed character in comics, The Ghost Who Walks, drawn by Ray Moore.

1937 Hal Foster resigned from the *Tarzan* strip and began his own medieval chivalric masterpiece, *Prince Valiant*.

the golden age (1930s–1950s)

The first recognizable comic books were unwieldy, tabloid-sized affairs, published in the late 1920s.
They were not a success, but when a new-format comic book was created in the early 1930s,
it heralded in the golden age of comics.

The first comic books

George Delacorte, later the founder of the Dell Comic Company, produced an all-original, tabloid-sized colour comic book called *The Funnies* in 1929. He distributed the oversized magazine through newsstands with a 10-cent cover price. However, the result looked just like a comics supplement a reader might find for free in a regular Sunday newspaper, so the experiment lasted only 13 issues.

In the early 1930s, the Eastern Color Publishing Company created a new-format comic book that was essentially a tabloid folded in half and stapled through the spine. This was the format that was to rule for the next 80 years.

At first these stand-alone comics were used simply as sales premiums, promoting the products of big companies like Procter & Gamble. Then, in 1933 under the direction of Max Charles Gaines, the company tried putting 10-cent stickers on the new-format comic book. They were an immediate success.

These first comics were all-reprint affairs, but at 64 pages per issue, they quickly ate into the supply of existing newspaper strips. Some of the early comic-book pioneers were therefore forced to commission writers and artists to produce new material especially for them.

GOLDEN AGE MILESTONES – COMIC BOOKS

1933 Eastern Color Publishing Company sales manager Harry Wildenberg figured out a way to produce a cheap all-reprint comic magazine to be used as a promotional giveaway: a tabloid folded in half and stapled through the spine, creating the format that is still in use by US comic books today.

1934 When Max Charles Gaines joined Eastern Color, he tried putting 10-cent stickers on a few dozen copies of *Famous Funnies* and placing the books on local newsstands. Within two days, every copy had sold out. Eastern Color immediately made a deal with American News for national distribution of their new baby, *Famous Funnies*.

1935 Major Malcolm Wheeler-Nicholson published the first issue of *New Fun Comics*, the first regular all-original comic book. Wheeler-Nicholson added *New Comics* at the end of the year.

1936 *New Fun Comics* became *More Fun Comics*; *New Comics* became *New Adventure* and then *Adventure Comics*. Wheeler-Nicholson's printer Harry Donenfeld took over the company.

1937 Donenfeld added *Detective Comics* to the line-up.

1938 A new title, *Action Comics*, featuring Superman, was launched by Donenfeld.

1939 *Detective Comics 27* was published, featuring the first appearance of The Batman.

1939 The 40th issue of *Adventure Comics* presented the first adventure of The Sandman.

1939 DC's rival Timely Comics published the first issue of *Marvel Mystery Comics*, starring two of the biggest names of the war years, The Sub-Mariner and The Human Torch.

1940 Back at DC, the first issue of *Flash Comics* starred The Flash and Hawkman, The Specter debuted in *More Fun 52*, Green Lantern made his first appearance in *All-American Comics 16*, and Wonder Woman launched in *All-Star Comics 8*.

1940 Superman's only real rival, Captain Marvel, was published by Fawcett in *Whiz Comics 2*.

1941 Timely's Captain America appeared full-blown in his own comic and entered the war on the United States' behalf, several months before Pearl Harbor.

Dawn of the superheroes

The fledgling DC Comics, founded in 1935 by Major Malcolm Wheeler-Nicholson, published a handful of comic books that were selling reasonably well, but not enough to keep the company going. Then, in 1936, Harry Donenfeld, the man who was printing Wheeler-Nicholson's books, bought out Wheeler-Nicholson's interest in the business. Donenfeld began to expand the line aggressively, adding first *Detective Comics* (1937) and then *Action Comics* (1938). These books became the homes of Batman and Superman, beginning a trend that has endured to this day: the cult of the superhero.

By 1940, superheroes were everywhere. Donenfeld, in partnership with Max Charles Gaines, added a dozen titles to the line, each starring its own costumed character. Other companies, such as pulp publishers Timely and Fawcett, weighed in with their own characters.

Timely, later to become Marvel Comics, offered The Human Torch and The Sub-Mariner in *Marvel Mystery Comics* and Captain America in his own title, while Fawcett published the adventures of Captain Marvel in *Whiz Comics*. Captain Marvel would go on to outsell Superman himself.

Twilight of the superheroes

Amazingly, the superheroes went as quickly as they came. In the post-World War II years, audiences seemed to tire of flying men in long underwear. By 1949, Flash, Green Lantern, Hawkman, Human Torch, Sub-Mariner and Captain America had all hung up their leotards, some of them for good. Captain Marvel would eventually be put out of business by Superman's lawyers. It was time for other kinds of stories to dominate the comics.

The first issue of *Action Comics* was published in 1938 complete with 10-cent price tag – the public was finally willing to pay for comics.

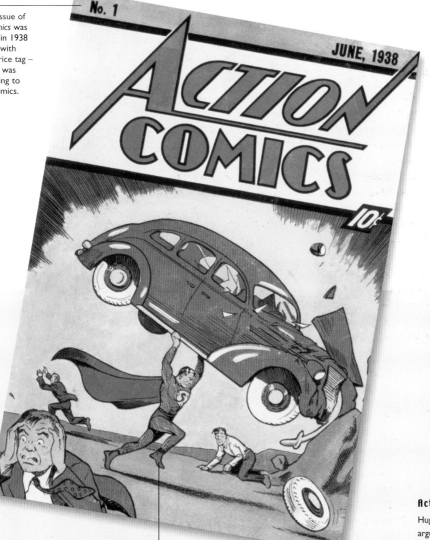

The first issue of *Action Comics* featured Superman. The cult of the superhero had arrived.

GOLDEN AGE MILESTONES – NEWSPAPER STRIPS

1941 Will Eisner's The Spirit made his first appearance as the star of a 16-page comic book given away with the Sunday editions of many US newspapers.

1946 Will Eisner returned from war service and began to turn the comic medium on its end. *The Spirit* became a showcase of just what could be done with comics as an art form.

1947 Milton Caniff followed up the success of *Terry and the Pirates* with *Steve Canyon*, about an ex-pilot who undertakes all manner of daredevil missions in an effort to raise sufficient funds to keep his ailing airline aloft.

1950 Charles Schultz began what would later become a multi-million dollar industry: *Peanuts*.

1950 Mort Walker's *Beetle Bailey* became hugely popular.

1951 The first appearance of *Dennis the Menace*.

Action Comics

Hugely influential, this is the comic that arguably started it all: *Action Comics 1*, featuring the first appearance of Superman.

the silver age (1950s–1960s)

The silver age of comics was born out of Cold War paranoia and the terrible specter of the atomic mushroom cloud. Although Superman, Batman and Wonder Woman survived the wilderness years of the early 1950s, the silver age of comics saw the birth of a new type of superhero.

The horror of it

With the demise of the traditional superhero, the comics industry began to cast around for something to replace them. It was Bill Gaines, the son of comic-book pioneer Max Charles Gaines, who provided the answer when he began publishing the notorious EC horror comics in the early 1950s.

As brilliantly written and drawn as they were, the EC comics spawned countless less savoury imitators. Within a couple of years, newspaper columnists were railing against the horror comics, blaming them for everything from juvenile delinquency to teenage drug addiction. So loud did the clamour become that the US government began to take notice, and in 1953 Bill Gaines and others were summoned to testify at a senate hearing on comics.

Realizing that they had to self-regulate or be outlawed, the comics publishers got together and formed the Comic Code Authority, a strict censorship body to which all comics must be submitted for approval. The horror books tried to adapt, but were out of business by 1955.

Sci-fi superheroes

In 1956, with the rise in popularity of science-fiction movies in Hollywood, comic-book editors once again turned their attentions to the creation of costumed characters.

DC Comics editor Julius Schwartz, who had been a prominent writers agent specializing in science fiction, was asked to think about reviving some of the old costumed characters of the 1940s. However, instead of simply resurrecting the old DC favourites, he began by giving The Flash a complete overhaul and a science-fiction origin. DC was cautious with the new character and

waited for three years before giving him his own book. By then, they were feeling brave enough to add a reversioned Green Lantern to the line-up. More characters followed and, by 1960, DC had enough new heroes to form The Justice League of America. Suddenly, superheroes were booming again.

Many of Marvel's heroes made their debuts in already existing mystery titles, eventually taking them over.

Journey into Mystery

The first appearance of Thor, Norse god of thunder, in issue 83 of Marvel's *Journey into Mystery* marked the beginning of artist Jack Kirby's two-decade obsession with mythological deities.

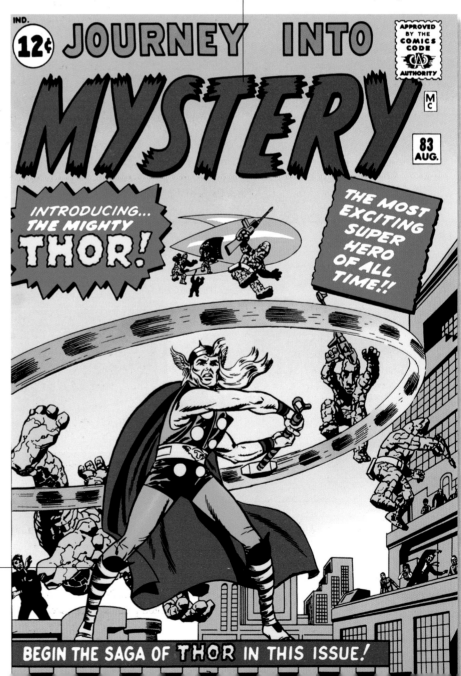

The figure of Thor is understated here, as Marvel's more in-your-face dynamism would not emerge until a couple of years after this 1962 debut.

SILVER AGE MILESTONES

1950 EC's *Crime Patrol* became *Crypt of Terror*, then changed to *Tales from the Crypt* three issues later. *War Against Crime*, which had featured EC's first horror story a year earlier, became *Vault of Horror*, while *Gunfighter* became *Haunt of Fear*.

1950 EC's *Saddle Romances* became *Weird Science*, while *A Moon, A Girl, A Romance* became *Weird Fantasy*. EC's sci-fi books were, if anything, even better than their horror books.

1952 EC began publication of *Mad* as a comic book.

1955 The same year the Comic Code Authority began regulating comics, DC launched Martian Manhunter in *Detective Comics 225*, their first new superhero in years.

1956 The silver age Flash, by Kanigher and Infantino, debuted in *Showcase 4*.

1959 The Flash was awarded his own title.

1959 A revised Green Lantern made his first appearance in *Showcase 22*.

1960 The Justice League of America appeared in *Brave and Bold 28*.

1961 A reversioned Hawkman appeared in *Brave and Bold 34*.

1961 A retooled version of The Atom made his debut in *Showcase*.

1961 Marvel Comics' The Fantastic Four took that fateful flight in the first issue of their own comic. In the fourth issue, wartime hero The Sub-Mariner returned as a villain.

1962 The origin of The Incredible Hulk was told in the first issue of his own comic.

1962 The last issue of Marvel Comics' *Amazing Fantasy* featured the first appearance of Lee and Ditko's Amazing Spider-Man.

1963 *The Incredible Hulk* was cancelled due to poor sales, but the character continued to crop up in other early Marvel comics, notably *The Fantastic Four 12* and *The Avengers 1–3*.

1963 The Avengers, Marvel's answer to DC's Justice League, and The X-Men appeared in the same month.

1966 The Silver Surfer appeared as a supporting character in *The Fantastic Four 48*.

1968 Marvel radically expanded its line, splitting *Strange Tales* into *Nick Fury, Agent of SHIELD* and *Dr Strange*; *Tales of Suspense* into *Captain America* and *Iron Man*; and *Tales to Astonish* into *Hulk* and *Sub-Mariner*.

1968 Marvel's Silver Surfer got his own prestige square-bound comic.

A comics marvel

Seeing what was going on at DC, Stan Lee, an editor at Marvel Comics who had been publishing mediocre monster tales in the wake of the Comic Code, figured the time was right to re-enter the costumed hero field. However, although Marvel publisher Marty Goodman wanted a clone of DC's Justice League, Stan Lee had the idea of creating a more realistic type of superhero, someone with whom kids could identify.

Lee's creative partner in the endeavour was cartoonist Jack Kirby, who had enjoyed brief success in the 1940s as the co-creator of Captain America, but whose career had been in a downward spiral ever since. His three-year stint at Marvel was like hitting skid-row for an artist of his talent, but all that was about to change.

With the first issue of *The Fantastic Four*, written by Lee and drawn by Kirby, the fledgling Marvel Comics was about to start beating DC Comics at their own game. Unlike the humourless personalities of Superman and Batman, who seemed to act more like the average reader's parents, Marvel's characters were anarchic, wisecracking misfits who spent much of their time bickering among themselves, deserting each other in moments of crisis and displaying other typically human traits.

The series was a huge hit and soon Lee had added other misfit heroes to his line-up of comics: The Amazing Spider-Man, a teenage nerd who was the butt of college jokes in his civilian identity of Peter Parker; The Incredible Hulk, a tormented green monster; and The X-Men, a group of teenage mutants who looked upon their powers as handicaps rather than blessings. A more neurotic bunch has never stalked a four-colour page.

Throughout the 1960s, Marvel Comics rose to become the market leader with its hip, irreverent style, and soon it was the big establishment companies like DC Comics and Archie that were trying to imitate the upstarts Marvel.

the bronze age (1970s–1980s)

By the end of the 1960s, the comics business was in pretty good shape. Marvel Comics ruled the roost and had massively expanded their line, but big changes were in the wind.

The house of ideas

By the beginning of the 1970s, Marvel's *The Fantastic Four* was nearing its 100th issue and a young artist called Neal Adams was making waves at DC with his grim and gritty revision of *Batman*. However, the first really big hit of the decade was Marvel's *Conan the Barbarian*, based on the pulp stories of Robert E. Howard. The project was the brainchild of Stan Lee's nominated successor Roy Thomas, who teamed with young British artist Barry Smith to produce a run of comics that broke the superhero mould and a few sales records into the bargain.

After that, Marvel struggled to find a big success. The company tried various horror-oriented titles, trialing first 'Werewolf by Night' and then 'Ghost Rider' in *Marvel Spotlight*, accompanied by *Monster of Frankenstein* and *Tomb of Dracula*. Other trial titles included *Marvel Premiere*, initially the home of alien superhero Warlock, later a vehicle for the revived Dr Strange, and *Marvel Feature*, which teamed up Dr Strange, The Sub-Mariner and The Hulk as The Defenders. *Marvel Super-Action* was the launch pad for

'Master of Kung Fu', which began as a cash-in on the martial arts craze of the early 1970s, but soon found its own path and went on to a hugely successful nine-year run, long outlasting the craze that spawned it. However, it was not until 1975's revamping of *The Uncanny X-Men*, by Len Wein and Dave Cockrum, which became a 30-year phenomenon, that Marvel hit the jackpot.

DC, too, was seeking that elusive big seller. They had given Jack Kirby his own line of comics after his acrimonious split with Marvel, starting with his cosmic revamp of the poor-selling *Jimmy Olsen* comic, paving the way for his 'Fourth World' series — *New Gods*, *Forever People* and *Mister Miracle* — but sales were lukewarm. DC also enjoyed much critical acclaim with Denny O'Neill and Neal Adams' important and impressive revamping of the *Green Lantern* title, and Len Wein and Bernie Wrightson scored an artistic hit with *Swamp Thing*, but no sales records were broken. The corporate players were floundering, at least sales-wise, and the time was ripe for a new way of doing things.

The fandom revolution

By the mid-1970s, critics and fans alike were predicting the imminent demise of 'the US comic book as we know it', until something happened that nobody had foreseen. Privately run stores were springing up around the United States and Europe, selling only comic books and related paraphernalia. Some diversified into distribution, albeit on a small scale, and began to supply retail outlets in other countries. By the end of the 1970s, every major city in the United States, Canada and Europe had at least one comics store.

A huge percentage of all comics being sold were going to older readers, particularly those

who had grown up with Stan Lee's Marvel comics during the 1960s and were reluctant to let their hobby go. Comics 'fandom' was a growing force. Comic conventions, in existence since the mid-1960s, became huge affairs, with whole hotels being taken over for weeks and literally thousands of comics fans and professionals in attendance. To be a successful comics creator was also to be a superstar a couple of weekends a year.

BRONZE AGE MILESTONES

1970 Marvel's *The Fantastic Four* reached its 100th issue. Two issues later, *FF* artist Jack Kirby left Marvel.

1970 Marvel published the first issue of *Conan the Barbarian*, adapted from Robert E. Howard's 1930s pulp adventures.

1970 *Silver Surfer* was cancelled, Marvel's first high-profile failure.

1970 DC Comics allowed Denny O'Neill and Neal Adams to revamp their *Green Lantern* comic in an attempt to take on Marvel at its own game.

1971 Beginning with *Marvel Feature* (which introduced The Defenders), Marvel began to experiment with a line of try-out titles, *Marvel Premiere* and *Marvel Spotlight*.

1973 One of those try-out titles introduced the Master of Kung Fu, which would long outlive the 1970s martial arts craze.

1975 *X-Men Giant Size 1* introduced Marvel's new line-up of mutant heroes and began a continuity that is breaking sales records to this day.

1976 Jack Kirby returned to Marvel and tried a variation of his DC 'Fourth World' saga with even less success.

1978 Don McGregor and Paul Gulacy's *Sabre* graphic novel was published by Eclipse.

1980 Eclipse's second graphic novel, *Detectives Inc* by McGregor and Marshall Rogers, was published.

1981 Jack Kirby's *Capt Victory and the Galactic Rangers* was published by First Comics.

1982 Marvel published its first graphic novel, *The Death of Captain Marvel*.

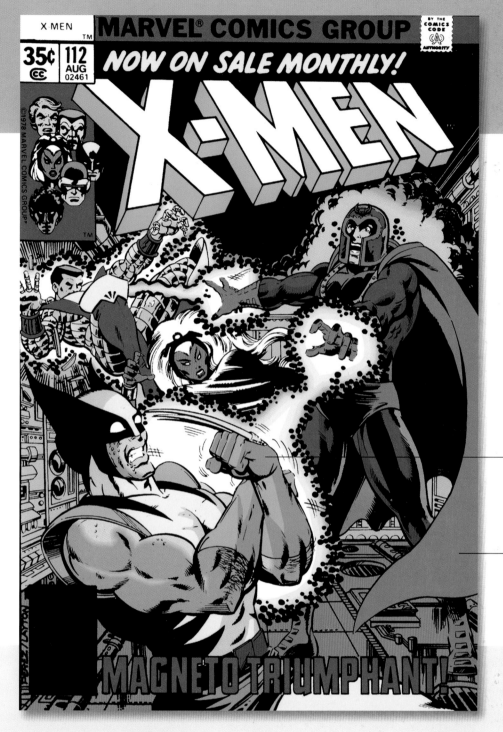

X-Men

The revamp of Marvel's 1960s teen team, The Uncanny X-Men, by veteran editor Len Wein and novice artist Dave Cockrum paved the way for Marvel's domination of the sales charts that has continued to the present day.

One of the reasons for the team's continued success was the inclusion of the tough-talking Wolverine.

And another reason has to be the on-going villainy of the Master of the Evil Mutants, Magneto.

Creators in control

The fact that comics were being distributed on a low-risk, non-returnable basis through specialist retail outlets meant that it suddenly became viable for small companies, and even individuals, to publish comics. In 1978, brothers Jan and Dean Mullaney of Eclipse Enterprises were approached by maverick Marvel scripter Don McGregor with a new character, Sabre. Originally conceived as a weekly newspaper strip, the project had fallen through, leaving Sabre without a home. With hot Master of Kung Fu artist Paul Gulacy on board, the project changed from a weekly comic to a single long story in one book. McGregor and Gulacy would retain ownership of the character and take a small advance against royalties rather than a flat page rate. The outcome was that, between them, they had invented two new facets of comic publishing that would have a profound effect on the industry: the contracting of comics professionals to work on what were essentially, at this stage, amateur publishing ventures, and the concept of 'graphic novels'. The big companies would soon be forced into offering similar opportunities to creators in order to compete.

the modern age (1980s onwards)

The modern age of comics is defined by sales and distribution switching from newsstands to comic stores; the rise of independent publishers like First Comics, Dark Horse and Image; and the increasing importance of graphic novels.

And in other business news

During the 1980s and early 1990s, some of the best comics on the market were being published by the small companies. Special mention should be made of Aardvark-Vanaheim, publishers of Dave Sim's still hilarious *Cerebus the Aardvark*; Dark Horse Comics, publishers of *The Mask, Barb Wire* and the very successful *Star Wars* and *Aliens* licensed comics; Topps, who published the highly successful *X-Files* comic; and, of course, Image Comics, formed in 1992 by a group of dissatisfied Marvel Comics artists who felt their contribution to the company's output was not properly appreciated.

The early Image titles – Jim Lee's *WildC.A.T.S*, Erik Larson's *Savage Dragon*, Rob Liefield's *Brigade*, Sam Keith's *The Maxx* and Todd McFarlane's *Spawn* – immediately shot to the top of the charts, outselling Marvel's *X-Men* books. However, a downward turn in the comics marketplace in 1993, coupled with some Image creators' inability to publish their books on time, meant that Image was no longer able to sell a million copies per issue. In fact, only *Spawn* has weathered that storm, due in part to McFarlane's ability to stick to a deadline.

MODERN AGE MILESTONES

1985 In a major house-cleaning exercise at DC Comics' *Crisis on Infinite Earths*, the character roster was streamlined and several major characters, such as The Flash and Supergirl, were killed off.

1986 DC Comics published Frank Miller's extraordinary tale of the twilight of Batman's career, *The Dark Knight Returns*.

1986 DC Comics released Alan Moore's seminal superhero revisionist *Watchmen*, originally intended as a revamp of the Charlton heroes.

1986 After making a reputation for himself on Marvel's *X-Men* series, artist John Byrne wrote and drew a revision of the Superman character for DC Comics.

1988 Todd McFarlane produced his first art on *The Amazing Spider-Man 298*.

1989 Jim Lee's first X-Men artwork was published in *Uncanny X-Men 248* and Rob Liefield's art appeared in *X-Factor 40*.

1989 The first issue of *Cry for Dawn* was published, kicking off the popular 'Bad Girl' genre.

1992 Image Comics launched with *Spawn, Youngblood, Brigade, Savage Dragon* and *Witchblade*.

1994 *Shi: Way of the Warrior* reinforced Dawn among the 'Bad Girls' of the martial arts genre.

1996 Marvel lured back the Image creators to revamp their core titles: *Fantastic Four, Avengers, Captain America* and *Iron Man*.

2000 Marvel's incredibly successful 'Ultimates' line of comics started with *Ultimate Spider-Man 1*.

2001 Marvel continued the 'Ultimates' franchise with *Ultimate X-Men 1*, scripted by British writer Mark Millar.

2003 Jim Lee's art on *Batman* revitalized sales on the book and rocketed DC Comics to the top of the sales charts.

2004 Jim Lee began a 12-issue run on *Superman* and similarly made the book the best-selling comic in the US.

Comics go digital

Another big change to comics during the early 1990s was the introduction of computer colouring. Computers had been around since the 1980s, and the first computer-generated comic, *Shatter*, was published in 1985 by First Comics. It was a crude affair, mostly due to the primitive nature of the available technology, but by the early 1990s technology had advanced to the point where it was possible for comics to sport airbrush-style colouring over hand-drawn linework at a cost that effectively rendered old-style mechanical colour separations redundant. Today, almost every comic published is coloured by computer.

The most shocking development in the comic-book business of the 1990s was Marvel's financial difficulties. Even though they published eight of the top ten comics in the US during the 1990s, Marvel's low year-end profits for 1996 resulted in the loss of 260 jobs and the company filing for Chapter 11 bankruptcy in May 1997.

The comic's unique selling point is Linsner's gorgeous draughtsmanship and mastery of the human figure.

Dawn

Joseph Linsner's *Cry for Dawn* debuted as a self-published black-and-white comic in 1988 and pretty much started a whole subgenre: 'Bad Girl' comics. Such was the success that, by the 1990s, *Dawn* was published in full painted colour and covers such as this one ensured *Dawn* of a place in comic history.

By the time of this cover, *Dawn* was so successful that Linsner felt able to break with tradition and place the logo at the bottom of the cover, risking the wrath of wholesalers and retailers.

The British are coming

It was also during this period that British creators, most of whom were alumni of the UK's *2000AD* comic, were making a name for themselves over at DC Comics. After Alan Moore's successful run on *Swamp Thing* from 1984 to 1987, the doors were opened for other UK comics creators to get work. Neil Gaiman's *Sandman*, Peter Milligan's *Shade the Changing Man* and Grant Morrison's extraordinary runs on *Animal Man* and *Doom Patrol* paved the way for big success stories like Garth Ennis and Steve Dillon's *Preacher* and Grant Morrison's *Invisibles* and revamped *JLA*, which put DC Comics at the top of the sales charts for the first time in memory.

More recently, the sales charts have been dominated by Grant Morrison's version of *The X-Men* for Marvel Comics, and another former *2000AD* scripter, Mark Millar, has been writing up a storm on Marvel's 'Ultimates' series as well as *Wolverine* and *Spider-Man*.

At the time of writing, the best-selling comic book in the United States is the Brian Azzarello/Jim Lee run on DC Comic's *Superman*, which is outselling its nearest rival by a margin of 100 per cent.

Chapter 2
Basic Elements

In the past two decades, technology has brought sweeping changes to the way in which comics are created, published and distributed. The biggest impact of all has been the introduction of digital tools into the workflow, mostly in the areas of colouring and lettering. In this chapter, we visit the tools of the trade and explore some of the basic elements of drawing comics.

traditional equipment

As in any branch of creative art, the choice of equipment is an intensely personal one. However, because of the peculiar requirements of comic-strip art and the limitations within which the artist must work, only certain drawing materials will be suitable.

KEEP IT SHARP

You will need something to sharpen your pencils with. The standard type of pencil sharpener you had at school will do the job, as will an electric pencil sharpener. The advantage of the latter is that they tend to produce a regular-shaped point. However, a scalpel with replaceable blades puts the best point on any pencil and are available from most art-supply stores. Always treat them with respect. They are very sharp and you will not realize you have cut yourself until it is too late.

Scalpels with replaceable blades are the best tools for sharpening pencils.

Wooden pencils are the cheapest drawing tool and come in a range of grades from soft to hard.

Technical pencils can be loaded with different grades of lead and often have a built-in sharpener.

RUB IT OUT

However good you are, you will need a pencil eraser. A soft eraser such as the Staedtler Mars Plastic eraser is ideal, although some artists prefer a kneadable putty eraser that can be moulded into various shapes. The problem with both these options is that there is movement – and hence smearing – between the eraser and the paper. If the eraser you use is too hard, it will drive the graphite particles deeper into the fibre of the paper. You could try using a removable adhesive such as Blu-Tack. This moulds into any shape and can lift graphite from paper or board without rubbing. Use it to remove some graphite from a pencilled area, or all the graphite. If any traces are left behind, finish up with a soft eraser like the Staedtler Mars Plastic.

Pencils

Pencils are absolutely essential. Nobody draws directly onto paper or board with ink. The finished art is always roughed out in pencil first. There are several different types of pencils an artist can choose.

Wooden lead pencils The cheapest is the standard wooden lead pencil, which comes in a variety of grades – 8B, the softest and blackest, through to 8H, the hardest and lightest, with HB marking the midway point. The grade of pencil you use is entirely up to you. However, the very softest pencils have a tendency to make lines that smear easily, while the very hardest make lines that you can hardly see unless you exert heavy pressure, which will indent the paper. Although the most common pencils for comic-strip work are HB and B, the best thing to do is to buy a selection and try them.

Technical pencils Another type of pencil favoured by comic-strip artists is the technical or 'clutch' pencil. There are many brands on the market. Pentel and Staedtler are two of the better known. These pencils can be loaded with leads of any grade and generally have special built-in sharpeners with which to touch up the point, although you should use a blade to keep the lead sharp. A second type of technical pencil uses a much thinner lead than the standard clutch pencil and does not require sharpening.

TIP DON'T BREAK IT

Treat wooden pencils with care. When dropped, the lead inside has a tendency to break. Leads in technical pencils are much less likely to break with rough handling.

There are many different types of eraser, but a soft eraser like the Staedtler Mars Plastic is ideal.

A wide variety of nibs is available for dip pens, allowing you to produce a range of effects.

Felt-tipped pens produce thick lines for a bold style of inking.

Dip pens come in different shapes and sizes, so test out a few until you find one that is comfortable to use.

Technical pens produce fine, consistent lines that are more suitable for lettering than for artwork.

TIP WIPE IT CLEAN
Keep a pad of folded paper towels handy (you could even tape it to your drawing board). Wiping ink from your pen periodically means the nib is less likely to clog.

Markers are available in a wide variety of widths and colours. They usually have a limited range of expression where line quality is concerned, but are much quicker and easier to use that dip pens.

Pens

The range of available pens is vast, but there are only a few types that are really suitable for the comic-strip artist.

Dip pens The comic-strip artist is pretty much obliged to use Indian ink, so the ordinary fountain pen is ruled out. Indian ink dries and clogs a regular fountain pen before very much can be accomplished. A simple dip pen is the simplest alternative. These come in a variety of shapes and sizes. Which you choose is very much up to you. Make sure you find a handle that is comfortable to hold.

Choosing the right nib for the job is also crucial. The Rolls-Royce of pen nibs is the Gillot steel nib. With this nib, an artist can adjust the thickness of the line by varying the pressure. Most art-supply stores carry Gillot nibs. The 'crowquill' or mapping nib is also widely used among comic-strip artists.

Speedball pens Constantly dipping a pen into an inkpot can get a little tedious, but there is a type of pen, called the Speedball, that has a small reservoir attached to hold more ink. The Speedball was favoured by old-school lettering artists, but has largely fallen from favour now.

Technical pens With their tubular nib and Indian ink cartridge, technical pens such as the Rotring are more widely used for hand lettering. Although the line produced by such pens is constant and therefore a little too boring for actual artwork, technical pens can be useful for ruling straight lines, especially panel borders.

Other pens In the last few years, pen technology has made some considerable advances. Many comic-strip artists are experimenting with felt-tipped pens, plastic-tipped pens, and felt markers. Neal Adams, best known for his extraordinary work on *Batman*, *Green Lantern/Green Arrow* and *Deadman* during the 1970s, uses a Pentel marker for inking his work. Alex Toth, veteran comic-strip artist, uses felt-tipped pens to achieve his bold, thick-lined inking style. For novices, however, it is probably best to master the basic dip pen before experimenting with new technology.

TIP HANDLE WITH CARE

A brush with too thin a handle will give you cramp in the hand inside an hour. A brush handle can be thickened by winding masking tape around it.

Roundhair sable brushes are relatively expensive, but are the most responsive for drawing. Use fine-tipped brushes for linework and larger brushes for washes and filling areas with colour.

CORRECTING YOUR MISTAKES

Erasing areas of dried ink can be difficult. Depending on the surface of the board or paper you are using, it may be possible to scratch out small errors with the point of a scalpel. Alternatively, you could try sticking a piece of patch paper over the error and redrawing the area, though ink will bleed along the edges of stuck-down patch paper, so this is not an ideal solution. Suitable self-adhesive patch paper – one brand is Tik-Tak – can be bought from most art-supply stores. Another method of correcting inking errors is to use spirit-based typewriter-correction fluid – brands such as Liquid Paper are readily available – or water-based process white. Do not use branded correction fluid, like Tippex, on Pentel or marker inks because the spirit solvent dissolves the ink and you will end up with a grey splodge.

TIP STOCK UP

If you find a particular material or tool that suits you perfectly, buy a good supply while you have the chance. Art-supply manufacturers regularly discontinue lines that do not show enough profit, so you could go back to your local supplier three months after finding the best type of Bristol board ever made only to find that it is not made any more.

Brushes

When it comes to linework for comic-strip art, there really is no better brush than the Winsor & Newton sable size 2 or 3. Just about all professionals pick one of these two brushes as their favourite, although larger brushes can be used for filling in areas of black. Will Eisner, veteran writer/artist of *The Spirit*, has Winsor & Newton brushes he has owned for 20 years.

To keep a brush operational for that amount of time requires special care. Most professionals agree that a Winsor & Newton will last forever if looked after properly. Try to get into the habit of washing out your brush with water as often as possible. This will stop the ferrule from becoming clogged with ink. If Indian ink dries inside the ferrule, the hairs of the brush will splay outwards, effectively destroying the point.

Keep in mind the old saying: 'You get what you pay for.' Cheap brushes do not have the resilience of the sable type and wear out more quickly. They therefore represent a false economy.

TIP KEEP THINGS TIDY

Always keep your brushes, pens and pencils together in some kind of container or desk tidy. Never store brushes or pens point down.

Inks

Indian ink is used because of the dense black lines it produces. Black ink designed for fountain pens tends to be a little thin and therefore too grey for comic-strip work. You will be drawing for reproduction by the litho photographic printing process, so it is less important that your artwork looks good to the naked eye than that the lines look black to the printer's camera or scanner. Some Indian inks, especially the cheaper kinds, can be a little thick. This is not a problem when it comes to photographic reproduction, but it will cause you headaches when the ink starts to clog your pens and brushes. The Indian ink designed for use with technical pens – Rotring is a well-known brand – is slightly thinner, but dark enough for comic-strip purposes.

TIP TESTING INK QUALITY

A simple test for quality when buying ink is to draw a line with a brush or pen, wait until the ink dries and then hold the paper up to the light. If the dried ink line shows up as being slightly raised from the paper, the ink contains plenty of shellac (an important ingredient in Indian ink). If the ink soaks into the paper, it contains too little shellac and therefore is of inferior quality.

TIP REMOVING FINGERPRINTS

Smooth boards have a tendency to retain oils from your fingertips, which can repel Indian ink. Remove fingerprints by rubbing over the area with a soft pencil eraser.

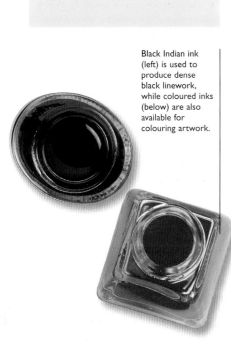

Black Indian ink (left) is used to produce dense black linework, while coloured inks (below) are also available for colouring artwork.

SIZE IS IMPORTANT

The usual size of comic-strip artwork is one-and-a-half times its printed size. Thus, the art on a standard comic-book page for a US comic is printed 152 x 241mm (6 x 9½in) from artwork 229 x 362mm (9 x 14¼in). The size of art for UK comic papers tends to be bigger, printing at 203 x 273mm (8 x 10¾in) from artwork drawn to 406 x 546mm (16 x 21½in). It is advisable to ask the editor for the correct dimensions. Sizes for newspaper comic strips and European comics vary a little more, so it is best to check for yourself. However, a good average for drawing a newspaper strip is 330 x 95mm (13 x 3¾in). These days, the larger comics companies supply their own preprinted board to artists for finished artwork. This has a grid of the appropriate dimensions printed on each sheet in pale blue ink (which will not reproduce under the printer's camera). In this way, the companies can be sure that the artwork produced is drawn to the correct proportions. The actual board supplied is invariably some kind of two-ply Bristol board measuring about 254 x 381mm (10 x 15in), allowing for borders, often with a slightly rougher than usual surface that is geared more towards penwork than brushwork.

Hot-pressed board (top) has a smooth surface, while not board (bottom) is rougher. Something between the two is ideal.

As Indian ink gets older, it tends to thicken because of evaporation. A drop of water fixes this. A word of advice, though: it is best to use distilled water for thinning old ink. Tap water, especially in hard-water areas, tends to contain impurities that can cause the particles suspended in Indian ink to clump together. Although not visible in regular use, these clumps become obvious when you thin the Indian ink for use in wash work, laying down areas of grey.

Paper and board

As with every other type of supply, an artist's paper is very much a case of personal choice. However, as a general principle, a layout pad will be useful for thumbnail sketches and character studies, and a box of lightweight typing paper is handy for working up your initial breakdowns of comic pages.

'Hot-pressed' board This has a slightly glossy surface, achieved during manufacture when the board is pressed between two hot rollers to dry it. This surface is fine for comic-strip work, although it will repel Indian ink in areas where the artist's fingers have rested. The shinier the board, the more of a problem this can become.

'Not' board This has a slightly rougher surface. It is *not* hot-pressed during manufacture, which accounts for its less smooth finish, or 'tooth'. Ideally, the comic-strip artist needs something between the two types: not too shiny, not too rough.

CS10 board There is a type of illustration board called CS10 that is very popular among some illustrators. This is a thick board – about 3mm (⅛in) thick – that can take pen-and-ink and coloured inks quite well. The main problems with it are that it picks up fingerprints easily, leading to repulsion of inks, and that it is heavy. Its weight is no problem when the board is used for short newspaper-type comic strips, but if you were to try to send a 20-page comic-book story drawn on CS10 through the mail, especially air mail, your postage could well come to more than the check you receive from the publisher.

the workspace

It is absolutely crucial that an artist establishes a space in which to work. Some people may be able to produce wonderful artwork lying on the living-room floor with family and pets crawling all over them – but it's doubtful.

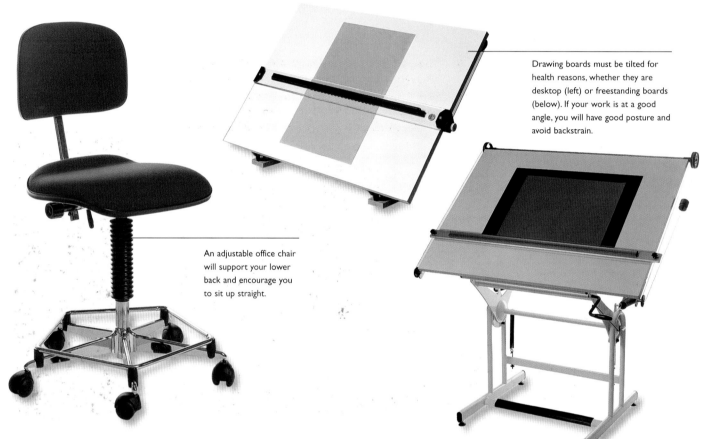

Drawing boards must be tilted for health reasons, whether they are desktop (left) or freestanding boards (below). If your work is at a good angle, you will have good posture and avoid backstrain.

An adjustable office chair will support your lower back and encourage you to sit up straight.

Office set-up

The ideal situation is to have a separate room set aside where you can spread yourself out and fit a desk, bookshelves for reference materials, filing cabinets for picture files and storage space for art supplies. Of course, if you have limited space this is not possible. In this case, a corner of a room that can be left undisturbed when inspiration temporarily runs out will have to do.

Desk and chair As obvious as it sounds, you really must have a desk (or table) to work at as well as a comfortable chair to sit on. Remember that you are going to be labouring over your artwork for hours at a stretch – if you are serious about it – and the first consideration is your physical comfort and health. Back trouble is the single biggest cause of work hours lost through sickness in the western world, so your desk set-up

should be arranged to minimize backstrain. A typist's swivel chair with a facility for adjusting the height is a good starting point, and can be obtained second-hand quite easily. If you have a little more money to spend,

there are 'chairs' available on which you sort of half-kneel and half-sit. These are designed to keep your back as straight as possible while you work, and are made under many brand names.

Ideally, you will have a separate room to use as a studio, but whatever kind of workspace you have, it is essential that the lighting and equipment are carefully arranged to avoid health problems such as back- and eyestrain.

An Anglepoise lamp is ideal
for the workspace because
it can be swivelled and
angled into any position.

COMPUTER EQUIPMENT

A computer is now a standard
piece of equipment for the comic-
book artist. However, even if you
are only interested in writing
comic strips rather than drawing
them, you will still need a
computer because scripts have to
be typed. No comics editor in the
business will put a handwritten
manuscript at the top of the 'must
read' pile. Computer hardware and
software specifications are dealt
with in detail on pages 28–33.

As far workspace requirements
are concerned, the computer
monitor should be higher than
desk height to avoid tilting your
head down or forward too much.
Your hands and forearms should be
supported; you could put padding
on your desk for this. The way you
set up your computer is dependent
on your chair, so you have to
organize the two together to get
the most comfortable combination.

The computer monitor should
be positioned so that you do not
have to tilt your head, and your
hands and forearms should also
be supported.

Drawing board You must ensure that the
artwork you will be working on is high
enough that you do not have to lean over it;
your back should be as straight as possible.
This means that you need some kind of
sloping drawing board. Freestanding drawing
boards designed especially for artists,
complete with parallel rule attachments,
are available, but they are an expensive
investment for the beginner. Alternatively,
and more cheaply, there are similar drawing
boards that rest on top of a desk or table.
Most big cities have stores that deal in used
office furniture. However, if you are of limited
means, a simple table with a homemade
drawing board will do the job just as well.

Lighting A useful additional piece of
equipment is a light to work by. The standard
adjustable desk lamp is cheap, readily available
and ideally suited to the purposes of most
artists. However, there are more sophisticated
models on the market, some of which attach
directly to the drawing board and some of
which contain a small striplight rather than a
standard lightbulb. If you are right-handed,
place the lamp to the left of your desk so that
your drawing hand does not cast a shadow
on your work, and vice versa. Angle the light
directly onto the work area.

TIP CHOOSING A STARTER KIT

There may be other pieces of office equipment that are best acquired as you find a need for them,
but recommended items for your starting kit are: a pot of water for cleaning brushes; a steel ruler
for cutting up board with a scalpel; a plastic cutting mat to protect the work surface; a triangle; ink
and pencil compasses; and drawing pins to tack drawing paper to the drawing board.

digital equipment

In recent years, the computer has become increasingly important in the creative areas of all types of publishing. In comics, it is most commonly used for scripting, colouring and lettering. The kind of computer you invest in depends on your budget and what kind of work you plan to use it for.

Which computer?

Most computers have far more processing power than the average home user will ever need. The manufacturers have us all in a gigahertz lather, feeling that we must have more power if we are not to be left behind.
For scripting If you are planning to pursue a career in scripting and never intend to attempt any artwork, you will never need to buy a state-of-the-art computer. Word processing requires only a small amount of processing power and you will find that a cheap computer will not be appreciably slower at handling text documents than a new machine.

In general, the Apple Mac is the computer that most editors in the publishing business use. However, if you already have a PC-format computer, your editor's Mac will be able to read your PC disks and files, so you will not have to switch over.
For digital art Producing artwork on computer takes your processing requirements to a whole new level. With artwork, you will be handling much larger files and therefore you will need increased memory and processing capacity to deal with the extra workload.

For drawing or colouring work, you would need an Apple PowerMac with a memory capacity of 256Mb at the *very* least, and a 80Gb hard disk. The faster the processor, the better the performance. The ideal choice would be a dual processor machine running OSX, because this new system software is designed to run faster on twin processor machines. With any Mac slower than 400MHz, you are going to be sitting watching your page redraw itself on screen for seemingly endless seconds every time you scroll.

If you have your heart set on a PC, you should get the fastest PC you can afford. The Pentium 4 processor goes up to about 4.2GHz at the time of writing. PCs require a little more memory than Macs, so the minimum RAM you should be looking for is around 512Mb, while the minimum hard drive size should be about 80Gb.

You will need a removable storage medium such as CDs or DVDs for sending your artworks to publishers.

MONITORING YOUR WORK

Most Macs are supplied as CPU (central processing unit), keyboard and mouse only, leaving you to choose the monitor you want to use. While a small screen – 43cm (17in) is pretty much the minimum these days – is fine for word-processing work, if you are planning on getting into digital artwork, you are going to need the best screen you can afford. A 48cm (19in) screen will do, but you should really be aiming towards a 53cm (21in) monitor, because most graphics software requires space for several control palettes on screen at the same time.

If you are going to be staring at a monitor for long stretches, you should also think about what is best for your eyes. The original style CRT (cathode ray tube) monitors give the best colour reproduction, but emit low-frequency magnetic fields. The newer LCD (liquid crystal display) screens use less energy, emit less radiation and are falling in price.

You also need a screen with a decent refresh rate to save your eyes from becoming fatigued after a long day's work. A decent refresh rate would be nothing less than 75Hz. A lower refresh rate would mean that the screen has a discernible flicker, leading to eyestrain and eventually headaches.

Peripherals and accessories

In addition to your computer, you will also need a range of peripheral devices and accessories.
Store it First, you will need some kind of removable storage medium so that you can get the images of your artwork off the computer to send to the publishing company. You might be able to manage with an Iomega 100Mb or 250Mb zip drive, but a CD burner would be better. CDs can hold about 20 or so pages of full-colour artwork and are so cheap as to be negligible. The costs of DVD burners and disks have also fallen dramatically in recent years, so now a DVD burner is a viable option for the home user. Nobody uses floppy disks any more.
Scan it You will also need a scanner to load your line artwork into the computer. Many artists still produce pencils and inks on paper and then do the colouring on screen.

Mac or PC?
The Apple Mac is the publishing industry standard, although you can use a PC just as successfully.

If you are creating artwork, buy the best and largest screen you can afford.

A keyboard and mouse are supplied with most computers. You may want to supplement these with a graphics tablet and stylus for manipulating artwork.

HARDWARE JARGON BUSTER

CPU This stands for central processing unit, which is the main body of the computer – the bit that does all the work.

Gigabyte (Gb) A measurement of data. 1Gb is the equivalent of 1 billion pieces of information, with a byte being roughly equal to a single character, such as a letter or a single digit number.

Gigahertz (GHz) A measurement of cycles per second. 1GHz is 1 billion cycles per second.

Hard drive The area of the computer where files are permanently stored. Hard drives have capacities measured in Gb.

Megabyte (Mb) A measurement of data. 1Mb is the equivalent of 1 thousand pieces of information.

Megahertz (MHz) A measurement of cycles per second. 1MHz is 1 thousand cycles per second.

Processor speed This refers to how fast your computer processes instructions and is usually measured in MHz or GHz. Apple G5 PowerMacs have a top speed of about 2.5GHz, while a Pentium PC has a speed of about 4.2GHz, though one is not really any faster than the other in practice.

RAM This stands for random access memory, and is the area where the computer holds data before passing it to the CPU. The more RAM your machine has, the faster it can pass information to be processed. Data held in the RAM is lost if the power is cut.

Refresh rate This is how many times per second the monitor renews the image you are looking at. The faster the refresh rate, the more 'natural' the image on the screen appears.

TIP SETTING UP FROM SCRATCH

If you already own a computer, all you need to do is get a scanner and a CD burner and you are set. However, if you are setting up from scratch, the minimum price for this kit new is £1,500. The best advice is to hold off investing in expensive new computer equipment until you have so much steady work that you can write a proportion of your investment off against your tax bill.

Scanners are so inexpensive now that a serviceable device could be a low as £30. If you are a Mac owner, check that the scanner includes drivers for your platform. If not, do not panic. You can buy a copy of Vuescan, which enables almost any scanner to be used with an OSX Mac, over the internet for about £20.
Draw it An optional bit of tackle would be a graphics tablet, a piece of equipment that lets you 'draw' directly onto your computer using a plastic stylus. It is much more like real drawing than trying to manipulate your digital artwork with a mouse. Many artists are now making use of these and find that, with practice, they can eliminate the need for a scanner. Graphics tablets become exponentially more expensive as the size increases, but you can pick up an entry-level Wacom graphics tablet for around £60.

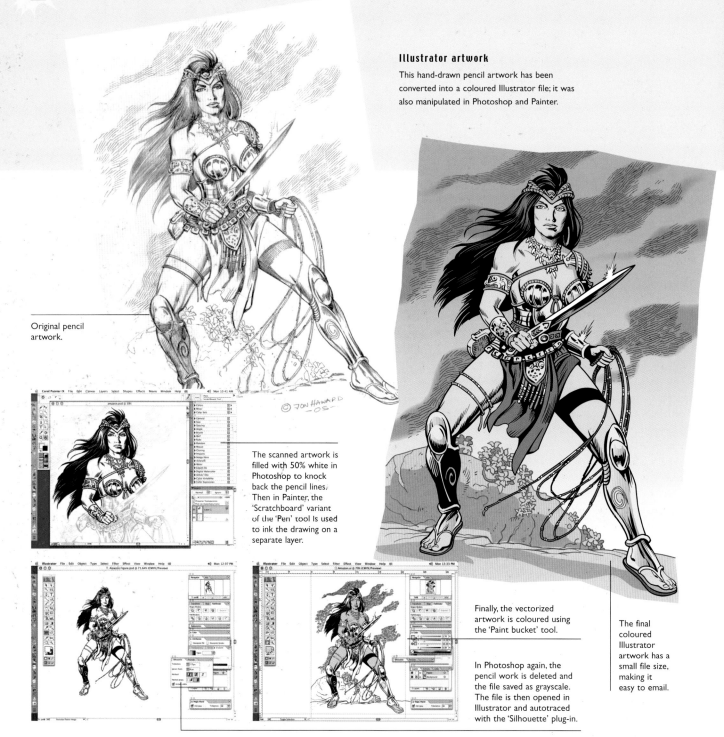

Illustrator artwork

This hand-drawn pencil artwork has been converted into a coloured Illustrator file; it was also manipulated in Photoshop and Painter.

Original pencil artwork.

The scanned artwork is filled with 50% white in Photoshop to knock back the pencil lines. Then in Painter, the 'Scratchboard' variant of the 'Pen' tool Is used to ink the drawing on a separate layer.

Finally, the vectorized artwork is coloured using the 'Paint bucket' tool.

In Photoshop again, the pencil work is deleted and the file saved as grayscale. The file is then opened in Illustrator and autotraced with the 'Silhouette' plug-in.

The final coloured Illustrator artwork has a small file size, making it easy to email.

Software

Software is expensive – probably more expensive than it needs to be – but there is no escaping that you need certain types of software if you are to write scripts or create, letter or colour your artwork on a computer.

Word processing Gone are the days of the typewriter. If you are determined to make a career out of writing, a computer with a suitable word-processing package will make

your life a good deal easier. It will not make you a better writer, but it will take the drudge out of the typing process and enable you to restructure your words with a minimum of wastage of time and trees. The other big advantage is that you will have ready access to additional copies of your manuscript. The industry standard for word processing – from scripting to writing simple letters – is Microsoft Word.

Vector programs For drawing and lettering work, some kind of vector package is essential. Vector art is made up of mathematically calculated lines. This keeps file sizes small. Probably the best-known vector application is Adobe Illustrator. You can draw with the mouse in Illustrator, but it is better to use a graphics tablet and stylus because this more closely resembles 'real' drawing with a pencil or pen on paper. Illustrator can also be

Vector versus bitmap

The images below demonstrate the way in which a vector image can be enlarged without loss of quality, whereas a bitmap image deteriorates. Bitmap images allow subtler gradations of tone, however.

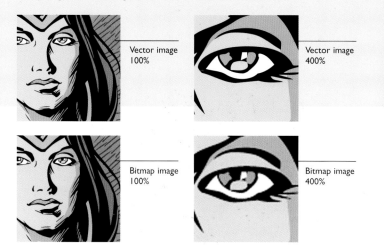

Vector image 100%

Vector image 400%

Bitmap image 100%

Bitmap image 400%

Photoshop artwork

Colouring artwork with Adobe Photoshop uses a different technology from Illustrator. Here, the artist is painting with pixels, small coloured dots, which allows for more subtle gradations in tone – a bit like a digital airbrush – but does result in much larger file sizes.

HOW A COMPUTER WORKS

In brief, a computer is simply a powerful calculator. When you scan in artwork, you are digitizing it – that is, reducing it to series of numbers that the computer understands. The program Photoshop, for example, is able to understand the long list of numbers that comprise a digital image and interpret them so that the computer can present the image on its monitor.

An image that is stored on the hard drive reaches the screen in the following way. The computer starts up an imaging program like Photoshop and holds the program in its memory (RAM). Then the image is copied from the hard drive to the RAM. Your instructions that change the image are relayed to the RAM from the keyboard and mouse. The instructions are interpreted by Photoshop in the RAM and the image data is passed

to the processor where the calculations are performed. The answers are then returned to the RAM, where Photoshop translates the digital data into an image that can be presented on the monitor. If you choose to save the changes, the new data is copied back to the hard drive where it replaces the previous file stored there.

With modern versions of image-editing software like Photoshop, the more RAM you have available, the faster the throughput of data from the hard drive to the processor and back again. This means that you do not have to wait as long for Photoshop to make the changes to the image and present the changed image to you on the monitor. Things that slow down this process include not enough RAM or a slow processor.

used to manipulate type, and is brilliant at distorting and customizing existing fonts.

Illustrator's closest rival is Macromedia's Freehand program, which is quite a bit cheaper and every bit as functional. Very often, computer magazines offer trial versions of these packages on their cover-mounted CDs, so you can try them for 30 days and decide which you prefer. If you have a good internet connection, you can

download the trial versions from the manufacturers' websites.

Bitmap programs Bitmap art is made up of pixels or dots. This makes for large file sizes. Adobe Photoshop is the best-known bitmap application and is extremely versatile, being able to handle drawing, airbrush painting and photo retouching. As with Illustrator, you can draw with the mouse or use a graphics tablet and stylus, which gives better control.

Photoshop is expensive at £500, but it is the top-of-the-range artworking tool. There are cheaper packages around – PaintShop Pro (Windows only) is wonderful value at £50 – but if you are serious, it has to be Photoshop.

Enhance your software

There is a wide range of useful plug-ins for Photoshop. Eye Candy is a remarkable application that allows you to create amazing special effects in Photoshop, like flames or smoke, with just a click of the mouse. PhotoFrame from Extensis is also very useful. It creates striking edges for your artwork, like torn paper or scratchboard effects.

If you are planning on doing lettering work on computer, you will need to get a lettering font. These can be bought easily over the internet, but the problem with commercial lettering fonts is that it is not *your* lettering. It is far better to create your own font from your hand lettering so that your work has a distinctive style. There are several font-building applications available, such as Fontographer from Macromedia.

Black linework

Artist Steve Parkhouse produced this inked drawing, which was then coloured by Chris Blythe. The pair collaborated at the layout stage to decide how much detail should be added at the inking stage and what could be left for the colourist. For example, the sky and water effects were left for the colour stage.

PhotoFrame effects

PhotoFrame, from Extensis, is a useful tool for Photoshop that enables the artist to add pre-rendered border effects onto any bitmap image, with styles ranging from a photo mount effect (left) to a dry brush look (below).

TIP BUY A BUNDLE

Both Illustrator and Photoshop retail at around £500 each. This represents a big investment. If you need to buy both at retail, it is more cost-effective to buy Adobe Creative Suite. This costs less than the above two applications and you get Adobe InDesign thrown in as well.

SOFTWARE JARGON BUSTER

Bitmap This refers to a computer image that is made up of dots or pixels. Bitmap images tend to have a large file size and cannot be enlarged a great deal without becoming blurry.

Font A particular style of alphabet that can be displayed on screen by the computer. Both Mac and PC operating systems come with a basic range of fonts, but you can add free, shareware or commercial fonts to your machine.

Pixel A single coloured dot that forms part of a digital image.

Plug-in This is an add-on enhancement for an existing software package. Some plug-ins are offered free or as shareware; some are sold as commercial packages.

Vector A vector image is a picture made up of mathematically calculated lines. Vector images have a smaller file size than bitmap images and can be enlarged without any loss of clarity.

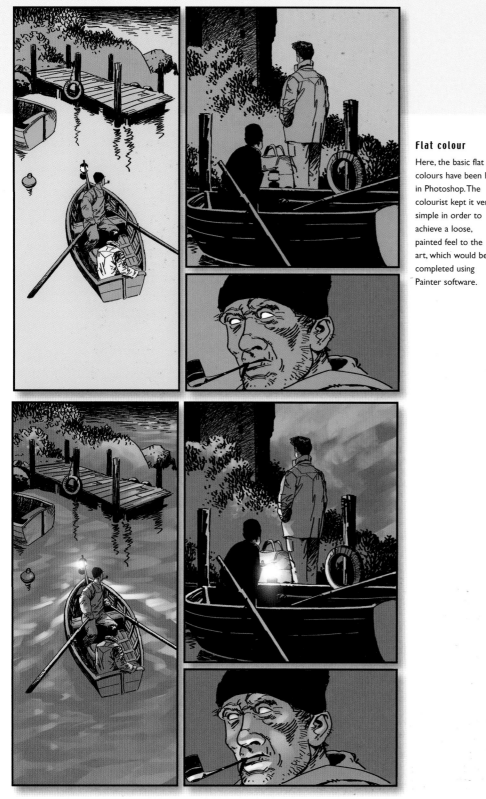

Flat colour

Here, the basic flat colours have been laid in Photoshop. The colourist kept it very simple in order to achieve a loose, painted feel to the art, which would be completed using Painter software.

Finished artwork

The finished artwork, with modelling and highlights complete. The colourist used the 'Oil pastel' tool in Painter, only rarely using the flat colours as masks to avoid going over the linework. The idea was to create a piece that stood out from the usual over-modelled digital artwork.

CHEAP BUT LEGAL

No one would argue that software is not hugely expensive. Sometimes it may seem too expensive, but do try to avoid buying pirated software. Aside from being illegal, there can be all kinds of hidden pitfalls. For example, you run the risk of your computer being infected with a virus. Viruses can cause havoc on a PC, eliminating essential files and sending themselves to all your email contacts. If your PC becomes infected with a virus that you cannot remove with a standard antivirus software package, you could be looking at having to rebuild your machine's operating system from the ground up, which can take days. Fortunately for Mac users, OSX viruses are still unheard of at the time of writing.

So, if you cannot afford the latest version of Photoshop, consider buying an older version second-hand. Photoshop 4 is still a pretty respectable package and can be found very cheaply second-hand, especially on internet auction sites like eBay. Always do your homework before buying, though. For example, Photoshop 4 works only with Mac operating systems up to OS9; if you have OSX, you will need Photoshop 7.

format: newspaper strips

For our purposes, the newspaper strip can be split into two distinct types: the gag strip, a single-tier humourous strip; and the story strip, a single-tier adventure strip.

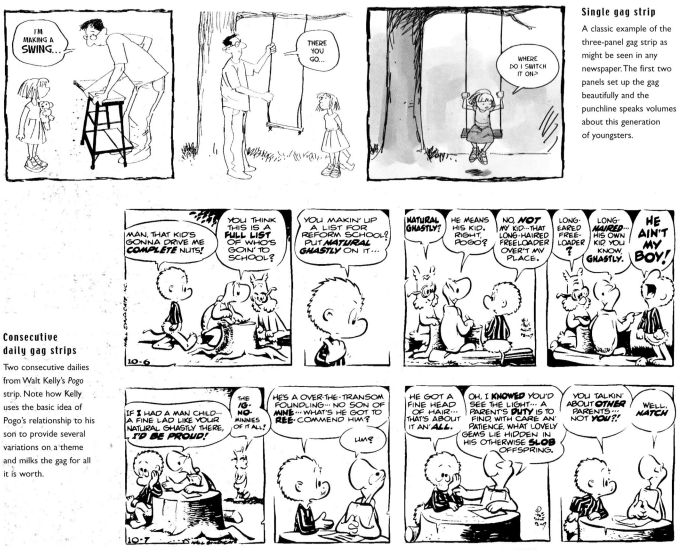

Single gag strip

A classic example of the three-panel gag strip as might be seen in any newspaper. The first two panels set up the gag beautifully and the punchline speaks volumes about this generation of youngsters.

Consecutive daily gag strips

Two consecutive dailies from Walt Kelly's *Pogo* strip. Note how Kelly uses the basic idea of Pogo's relationship to his son to provide several variations on a theme and milks the gag for all it is worth.

The gag strip

Examples of the gag strip include *Garfield*, *The Wizard of Id* and *Peanuts*. Originally drawn for reproduction as simple monochrome line art, the few gag strips appearing in newspapers nowadays are increasingly printed in colour. The gag strip is usually in the format of a joke told in a single row or tier of three to four panels or frames. Most often the writer and the artist are the same person, so most successful cartoonists have a finely tuned sense of comedic storytelling as well as the ability to draw.

With the gag strip, each day's episode should be a self-contained joke so that readers unfamiliar with the strip will still get a laugh out of it. At the same time, it is possible to build one joke on another so that, when followed in sequence, the reader gets the sense of a string of jokes leading towards a big pay-off. *Peanuts* creator Charles Schultz was the master of this kind of sequence.

From this you might think that the drawing component of gag strips is less important

than the gag itself. Indeed, with a strip like *Peanuts*, Schultz's attractive depiction of children and their pet beagle is a major factor in the appeal of the strip. The drawing style is simple and open and uses few lines. Thus the art is used to *enhance* the gag it is illustrating. In addition, by keeping the artwork simple, the artist does not distract the reader from the real business at hand: the telling of a joke. Ultimately, the appeal of the drawing style is more important than its technical virtuosity.

TIP KEEP IT BRIEF

Everything about newspaper strips, whether action/adventure or humour, is centred around economy. With a newspaper strip, there is no room for rumination. You have to get in, make your point and get out.

Even though she does not speak here, Dredd's partner on this case, Judge Hershey, is shown in the panel to remind readers that she is still around.

Daily story strip

These are the last two episodes of a seven-week *Judge Dredd* daily newspaper strip. Each episode is constructed to be a standalone portion of the bigger story. Here, Dredd sums up the loose ends of the story for the assembled judges. Note how the cadet judge's line 'All Gerald Ford Blockers' at the end of the first episode is repeated by Dredd at the beginning of the next strip to provide day-to-day continuity for the readers.

The final panel with the grotesque human foot in the bucket was added by artist Ron Smith. Smith knows the world of Judge Dredd better than just about any other artist, and that little visual gag is prime Dredd.

The story strip

The story strip takes a realistic approach to artwork, and with this comes all the attendant problems of figure drawing, perspective and lighting. Examples of the story strip include *Modesty Blaise, Steve Canyon, Dick Tracy* and *Judge Dredd*.

The story-strip format, similar to that of the gag strip at three or four panels per episode, demands that a tale is told in short, snappy chunks. This kind of storytelling is difficult and it is more usual for story strips to be created by a separate writer and artist.

Story strips can be approached in much the same way as the gag strip, planning each episode like a joke with a set-up and a pay-off, while at the same time ensuring that the story or plot is carried forward.

format: comic books

The comic book appears in many different formats, from one-offs and chapters/episodes for anthology comics through to the holy grail for many comics creators: the graphic novel.

Comic-book formats

There are four frequently seen comic-book formats.

The anthology chapter This is a component of a longer story that appears weekly (as with the UK comic *2000AD*) or monthly (as with the US *Dark Horse Presents*…), varying between 6 and 10 pages.

The comic book The standard US comic-book format is that of a 20-page story printed in four colours in a newsprint magazine of 32 pages plus covers. There are variations in book length and paper quality. In the UK and Europe, the general rule is to have several episodic strips in one comic 'paper' that is usually printed monochrome or two-colour; there are assorted paper qualities.

The comic annual or special Similar to the regular comic book but just longer at 30 to 40 pages.

The graphic novel Originally referring to a self-contained story of 60 or more pages, this term is now often used for collections of three or more issues of a regular comic in a softcover book format.

This is an editorial page featuring information about what is in this issue, the next issue and other *2000AD*-related comics. It is always placed here because it would look odd to begin the actual story on the glossy paper of the inside of the front cover and then continue it on the newsprint paper used for the interior pages of the comic.

Since Judge Dredd is the most popular character, it makes sense to begin the comic with his story.

The second story is a magic strip scripted by Alan McKenzie and drawn by Steve Parkhouse. It is placed here to provide a deliberate change of pace from Dredd.

Putting *2000AD*'s advertisements here allows the next feature to begin on a two-page unit, known as a spread.

Originally created by *2000AD* launch editor Pat Mills for an aborted *2000AD* sister comic called *Alternity*, 'Dynasty' was about a royal family of intelligent dinosaurs, with lots of in-your-face violence.

Judge Dredd appears on about a quarter of all *2000AD* covers. He is by far the most popular character, making it good commercial sense to put him on the cover.

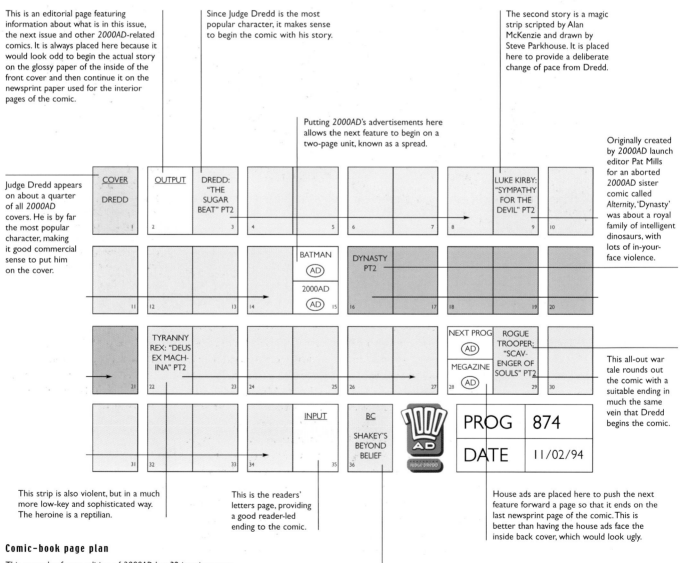

This all-out war tale rounds out the comic with a suitable ending in much the same vein that Dredd begins the comic.

This strip is also violent, but in a much more low-key and sophisticated way. The heroine is a reptilian.

This is the readers' letters page, providing a good reader-led ending to the comic.

House ads are placed here to push the next feature forward a page so that it ends on the last newsprint page of the comic. This is better than having the house ads face the inside back cover, which would look ugly.

Comic-book page plan

This page plan for an edition of *2000AD* has 32 interior pages, plus 4 pages for the cover. This particular comic book features several episodic strips rather than a single story.

This one-page feature pokes gentle fun at the long-running American newspaper feature 'Ripley's Believe it or Not'. It provides a useful filler that can be placed anywhere in the comic it might be needed.

This story begins on a left-hand page, although there is no imperative for it to do so. It could just as comfortably begin on a right-hand page.

2000AD
The self-styled 'Galaxy's Greatest Comic', *2000AD* is an example of the weekly anthology title. This spread shows the first two pages of an episode of 'Bradley's Bedtime Stories', in which traditional fairytales are subverted for a more knowing modern readership.

FORMAT AND STORYTELLING

Different formats require a different approach to storytelling. **Keeping it tight** In general, the comic book gives writers and artists the luxury of space to tell their story. Up until the 1960s, most comics were filled with two or more short, self-contained stories. Stories that filled the whole 20 or so editorial pages were a rarity, and when they did appear, it was because the story was important enough to merit filling the whole comic. During the early 1960s, DC's *Superman* comic began to feature full-length stories. By the

time Marvel Comics got underway, the shorter anthology stories had all but disappeared, and these days, anthologies are the exception rather than the rule.
Spreading it out Marvel Comics also introduced the idea of the annual, an additional, double-length edition of a title, often containing some kind of 'event' story. Marvel's first annual was *Fantastic Four Annual 1*, which contained a 37-page epic of The FF battling The Sub-Mariner. Today, most comics tell their stories in a leisurely way, with a single tale often spanning

several issues of a comic. Some comics are more like soap operas, with no clear ending to one story before another storyline starts (Marvel's *X-Men* springs to mind as an example of this kind of sprawling continuity).
Short, sharp shocks However, shorter anthology stories are a useful proving ground for artists and writers to hone their crafts. On the UK comic *2000AD*, new writers and artists were asked to produce three- or four-page 'future shock' short stories to demonstrate they had the

discipline to tell their tale in a limited space before being turned loose on a multipart epic. Sadly, such opportunities are now limited because the anthology title has largely fallen out of vogue.

comic covers

The cover of a comic is probably the most important artwork in the book. It is the advertisement, the selling image that will make the prospective reader pick up the book and buy it.

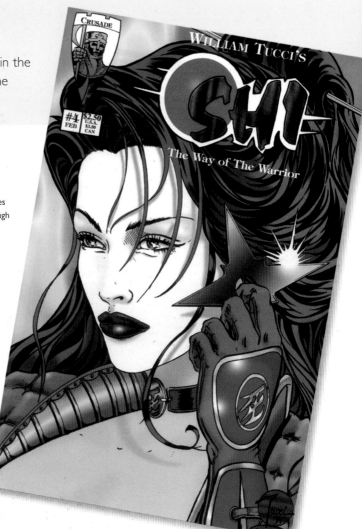

Shi

One of the big success stories in the 'Bad Girl' genre, although not really a bad girl, was *Shi* by William Tucci. Tucci's fine draughtsmanship enabled him to create distinctive covers such as this one, centring on the deadly beauty of Shi's face.

Cover types

Covers are generally designed by the publisher's art director, often in collaboration with the editor, and then a rough pencil sketch is passed over to an experienced artist for actual execution. Very seldom will an artist – let alone a novice artist – be called upon to draw a cover from the ground up.

Needless to say, an artist will only be called upon to produce covers if he or she is working in the comic-book side of the business. Covers require a different approach to the task of drawing. A cover, like a whole page of comic strip, should ideally tell a story, or part of a story. The problem is that the artist only has a single picture to tell that story. As with any other comic-strip story, the protagonist is the most important element, followed by the antagonist and then by the location in which they face each other. The hero must therefore have visibility.

Good versus evil The aim is to arrest the potential buyer's attention with a single, powerful image. The easiest, and therefore most often seen, cover formula is to have the hero battling the villain in an unusual location.

Heroic pose A less effective approach is to pose the leading character in an attitude that would make a good poster, often with the hero being heroic or rushing towards the viewer, frequently yelling like a demented banshee. This is probably the least effective cover formula, but nevertheless is in common use.

Unusual situation The third approach is not seen very much these days, but was popular during the 1950s and 1960s. Here, the hero is shown in some kind of unusual or unlikely situation, the aim being to stimulate the potential customers' curiosity, and thus make them buy the comic to find out what is going on. *Superman* comics of the mid-1960s used this approach very well, as did some EC comics of the 1950s.

THE CRITERIA FOR A GOOD COVER

The cover of a comic book exists for just one reason: to entice a reader to pick up and buy that particular issue of that comic. Remembering that every issue of a comic is a first issue for somebody, a cover cannot make any assumptions, and there are several requirements a cover has to satisfy in order to qualify as a great cover. Admittedly, it would be hard for any cover to meet all of these criteria, but aiming for three out of the seven would be an acceptable goal.

Involvement The readers have to feel like they are part of the action. The use of composition, lighting and colour can help to focus a reader's attention on the important part of the cover.

Design The cover image has to be immediately arresting, and for this the design must be outstanding.

Curiosity A cover should set up a situation or mystery that can only be resolved by looking inside the book.

Conflict The essence of drama is conflict. No one ever messed up a cover by showing the hero battling the villain.

Danger Danger is not always the same as conflict. Danger can be mortal or social. The hero can be hanging by his fingernails from a ledge or be just about to have his secret identity revealed.

Impact The reader should be able to understand the story of the cover instantly. The impact is lost if the reader has to wade through 75 words in order to discover what is going on.

Cover line While a great cover does not need a cover line, sometimes an appropriate phrase can enhance an already terrific cover image.

The cover line says it all. Judge Anderson battles a gang of mutants atop a statue of the Buddha.

Alien editor Tharg radiates a multitude of characters from the *2000AD* universe.

Art editor Steve Cook came up with the idea of mimicking the Apple Macintosh interface to create a striking Brigand Doom cover.

2000AD covers

These three covers of *2000AD* demonstrate three different approaches to creating a successful comic cover. From left to right: a threat cover, a pin-up cover and a novelty cover.

Dawn

After the raw sex appeal of the first issue of *Dawn* (see page 19), artist Joseph Linsner gave readers an altogether more demure Dawn for the cover of issue two.

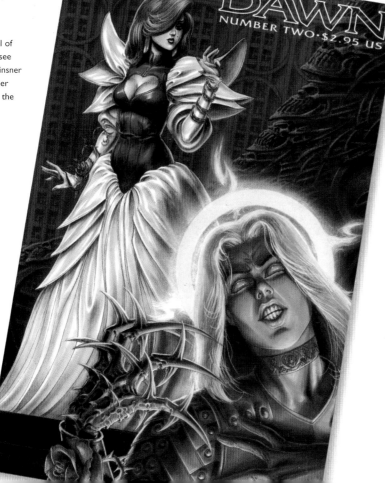

COVERS UNCOVERED

There is no simple, one-size-fits-all solution for how to draw an exciting, selling comic cover. During the late 1950s and early 1960s, top-of-the-heap comic publisher DC Comics used to commission the covers first and then write the interior stories around the dramatic scenes depicted on the cover. This was fine at first, but as the simple story ideas were used up, the more complicated stories that followed required more explanation on the cover. By far the greatest practitioner of this was Mort Weisinger, editor of the *Superman* titles.

When Marvel came along in the early 1960s, they emulated the cover style of their great rivals DC Comics, creating wordy explanatory cover ideas. *Fantastic Four 5* (July 1962) had as many speech balloons as any Mort Weisinger cover. By *FF 10*, speech balloons were falling out of favour, and by *FF 22*, they had disappeared entirely.

drawing the figure

The human figure is both the most demanding thing an artist is called upon to draw and the most frequent. As command of the human figure is crucial to the effective telling of a story, it is essential that it is fully mastered by the comic artist.

Drawing conventions

The comic strip and the cinema share many storytelling conventions. One such convention states that the good guys should be tall and handsome, the heroines should be slim and beautiful, and the baddies should be ugly. How you portray your characters is very important because characters are what every story is about.

Proportion The average well-proportioned man stands about six-and-a-half to seven heads tall. This rule simply means that the average drawn figure of a man is six-and-a-half to seven times the height of the head of the same figure. Such a proportion is fine for innocent bystanders, the villain's henchmen and the hero's best friend – but the hero himself is always taller. Depending on what sort of hero you are aiming to depict, the height of the figure should be somewhere between seven-and-a-half and eight-and-a-half heads tall.

A variety of physiques

Avoid the temptation to make all your characters the same height and build. Varying the physiques of your characters will help the reader to distinguish who is who.

Poses The next difficulty encountered by novice comic-strip artists is that of drawing the figures of their characters in convincing poses. For example, the wider apart you draw the feet, the more stable and firmly planted a figure will look. If you imagine the shape of a pyramid, a structure that is able to withstand thousands of years of exposure to the elements, then transfer that shape to the depiction of the human figure, you will begin to see how to make a human figure seem strong and solid.

Heroic poses

The superhero's exaggerated musculature allows him to contort his body into a range of highly stylized poses that emphasize his superhuman powers.

Although the body is arched backwards, the lowered head indicates that the hero is about to swing his sword with devastating force.

Upside-down suction: just what every superhero needs.

The wide stance and lowered hand anchor the hero firmly to the ground, but the pointed feet and hand emphasize that he is ready to spring into action.

This highly dynamic pose demonstrates the hero's superb agility.

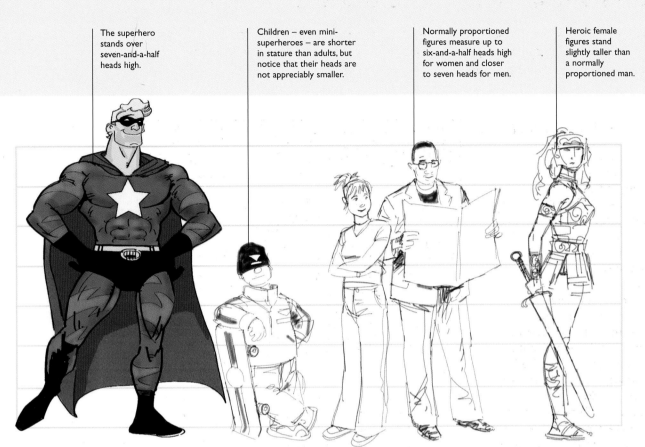

The superhero stands over seven-and-a-half heads high.

Children – even mini-superheroes – are shorter in stature than adults, but notice that their heads are not appreciably smaller.

Normally proportioned figures measure up to six-and-a-half heads high for women and closer to seven heads for men.

Heroic female figures stand slightly taller than a normally proportioned man.

Comparing proportions

This selection of differently proportioned human figures is drawn in front of a grid divided into head-height units so that you can easily see the relationships in height.

Villainous poses

A villain needs to be almost as strong as the superhero in order to be a convincing foe, but is generally drawn in less dynamic and graceful poses.

Pointing the finger of blame elsewhere: a typical villain pose.

The hand gestures could indicate that the villain is planning his next move or that he is studying his latest devilish deed.

This pose has an animalistic quality to it, like an unpleasant beast crawling through undergrowth.

The splayed fingers stretch towards the reader with evil intent.

the figure in motion

Cinema and comics have much in common, but there is one thing movies have that comics do not: *movement*. Since most comics are about action, comic-strip artists have had to find a variety of ways to get around this limitation.

The centre of gravity

In order to depict a human figure in motion convincingly, it is first necessary to understand the concept of the *centre of gravity*. The centre of gravity of an everyday object, like a cube, is easy to determine. Simply draw intersecting lines connecting the diagonally opposed corners: the point where all three lines meet is the cube's centre of gravity. It is no coincidence that this point is the cube's physical centre as well.

Now, if the cube is tilted in any direction, the centre of gravity can rise only while it stays vertically above some part of the cube's base; in such circumstances, when the cube is released, it falls back to its stable position.

However, a point is reached where the centre of gravity ceases to rise and begins to fall; this is when it passes over the boundaries of the cube's base. In this situation, a released cube will continue to move so as to allow its centre of gravity to move to its next lowest position. If we repeat the experiment with a sphere, however, we see that, since the centre of gravity neither rises nor falls when the sphere is displaced, there are no settling or toppling effects.

Dynamic figures

The human figure resembles the cube rather than the sphere insofar as its centre of gravity (located somewhere around the groin) is concerned. If the human figure is displaced to the side, it will invariably settle back to its original position, provided the centre of gravity has not passed beyond the limits of the base (the feet) and begun to fall.

Applying the same principle in reverse, it is possible to make the human figure seem unstable – and thus in motion – by placing the centre of gravity outside the limits of the base. By following this rule, artists can ensure that their action scenes have dynamism, which gives the illusion of movement.

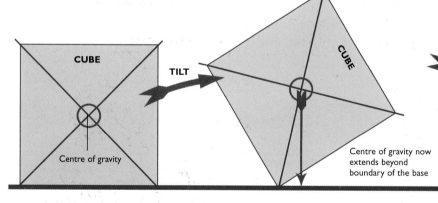

How the centre of gravity works

It is easy to see how the centre of gravity works by looking at a toppling cube (above). The centre of gravity of a human figure works in the same way. Artists can position the centre of gravity to make their drawn figures appear to be in motion (below).

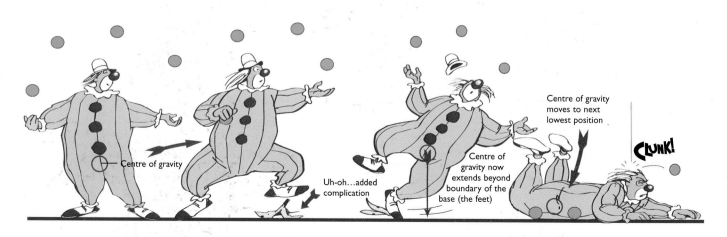

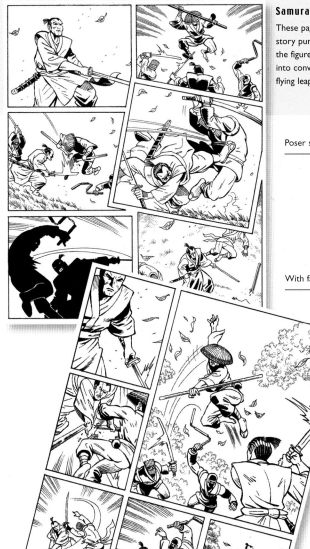

Samurai fight

These pages by Jon Haward tell the story purely through the action. Moving the figures' centres of gravity puts them into convincing motion, from taking flying leaps to delivering punishing kicks.

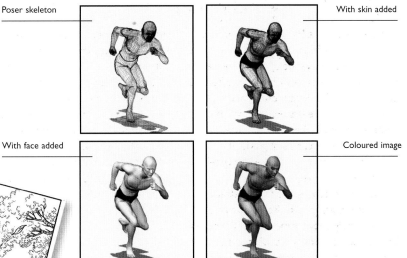

Poser skeleton

With skin added

With face added

Coloured image

Poser moving figure

The original pencil sketch was based on a maquette pose (below left), then rendered in colour using Poser animation software (above). This type of software can be extremely helpful in creating convincing moving figures.

Maquette pose

Pencil sketch

Final image, with blurred shadow

basic perspective

If you stand in the centre of a railroad track, looking along the line, it appears as if the rails meet at the horizon. Of course, in reality the rails never touch each other. What you are experiencing is an optical illusion: *perspective*.

Circular perspective

A coin viewed straight on from eye-level is circular (left), then gradually changes to a narrow oval as it is tilted away from the reader (middle and right).

Two-point perspective

Here, the vanishing points are either side of the horizon line, and the object appears to be at an angle to the reader. The object's relation to the horizon line fixes the viewpoint high (as here), low or at eye-level.

Three-point perspective

A third vanishing point produces a dramatic impression of height and depth. It can be placed above or below the horizon line, depending on the angle of view required. When placed above, as here, it creates a low-angle view.

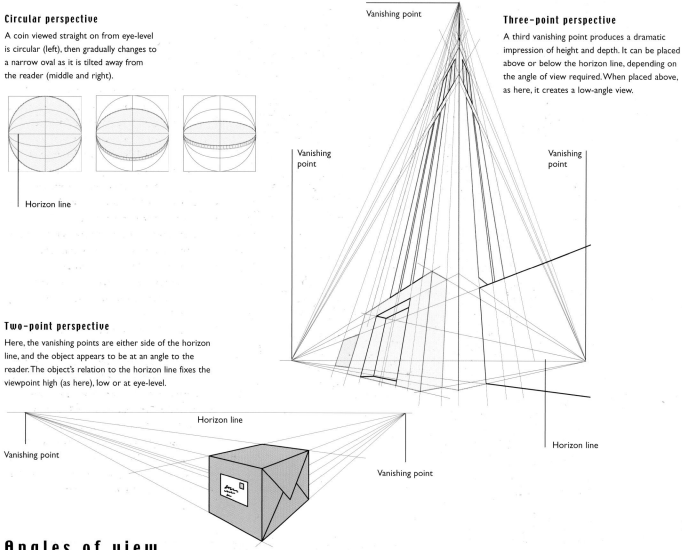

Angles of view

Perspective is one of the first elements discussed in any rudimentary art course. Here, we shall assume that you have at least a working knowledge of perspective and concentrate more on how to use it as a storytelling tool. Perspective and its distortion can both be used to invoke a variety of emotions in a reader. It cues the reader as to the angle from which he or she is viewing a scene. There are only three categories of angle that will affect the perspective.

Eye-level Here, the reader is on the same level as the objects or characters in a scene.

When you show a scene from eye-level – the commonest angle used in comic-strip panels – you are giving readers the illusion that they are physically involved in the incidents depicted, which is the usual aim of a storyteller. Of course, because eye-level is the commonest angle used by comic-strip artists, its effects are minimized by overexposure, and so the eye-level angle is also the most neutral of the three. However, the unobtrusiveness of the eye-level angle subtly increases the involvement of readers in the story that is being told. When readers are involved in the

story, they get to experience vicariously the emotions felt by the story's characters (it is possible to invoke in readers emotions other than those experienced by the characters, but this involves different techniques).

Low-angle A low-angle view, also called worm's-eye view, places the reader below the level of the objects or characters in a scene, and is designed to make the readers feel small in comparison. By using this angle, therefore, the artist can make his or her readers feel subconsciously threatened or intimidated. Conversely, the same technique can be used

ARE YOU NOT SPEAKING TODAY?

Extreme high-angle
The extreme high-angle viewpoint of this image emphasizes the precarious position of the professor at the top of the ladder.

THE FIGURE IN PERSPECTIVE

By depicting the figure in perspective – also called foreshortening – the comic-strip artist can achieve a similar effect to that created when showing the figure in motion, but with enhanced dynamism. If the sense of movement is conveyed by tilting the human figure off-balance, think of how effective the trick can be if the figure is tipped off-balance *towards* or *away from* the readers. This trick is used extensively in comic books published by Marvel, and was invented by their premier artist of the 1960s, Jack Kirby. In fact, Stan Lee's book *How to Draw Comics the Marvel Way* spends a good deal of its content dealing with this effect.

Another comic-strip trick that relies on showing the human figure in perspective is to have a character pointing either out of the panel towards the reader, or into it. This was a trademark of the late Frank Bellamy, who drew the *Garth* newspaper strip and strip versions of Gerry Anderson's puppet television shows for a UK comic called *TV2*. The effect is that the readers' sense of depth is enhanced, making what is happening in the strip seem all the more realistic.

not so much to make the reader feel smaller as to make the characters appear larger and more threatening. Marvel Comics' popular character The Incredible Hulk is frequently drawn from a low-angle view to enhance his physical bulk and menace. Finally, a low-angle view can be used to make an object – particularly a piece of architecture or a huge spaceship – seem even grander and larger. The effect is enhanced if the building or spaceship is loaded with surface detail.
High-angle Also called bird's-eye view, this places the reader above the level of the

objects or characters in a scene. The aim of a high-angle viewpoint is to make the readers feel separated from the scene at which they are looking. It is very useful for establishing shots (comic-strip panels, usually the first of a new scene, that establish in the readers' minds exactly where they are and what they are looking at – the same technique is used in just about every movie you will ever see). Thus, a panoramic view of the countryside in which, say, a squad of commandos is operating would be best shown from a high angle.

However, as well as putting space between the readers and the scene they are viewing, a high-angle shot can also be made to work the other way: it can make readers feel that the characters in a scene are cut off from the rest of the world. Thus, a sense of loneliness can be invoked in readers by showing a character from a high angle, surrounded by space, thereby conveying the feeling that he or she is without companions.

lighting

The earliest comic-strip artists drew as if they had never heard of lighting, but in fact lighting can be used to convey a mood or an atmosphere with great power.

Shadows and light

Most early comic strips, with a few exceptions such as Alex Raymond's *Flash Gordon* and Will Eisner's *The Spirit*, were drawn in a flat line style. To be fair, this was partly due to the limitations imposed by the primitive printing techniques in use at the time, but not entirely. However, with the arrival of the 1950s and the appearance of the outstanding horror comics published by Bill Gaines' EC company, lighting became a major factor in establishing mood. A trick favoured by the late Wally Wood, who contributed many memorable science-fiction tales to the EC line of comics, was to light the human face from two separate sources.

The idea was taken farther in the 1970s by such remarkable comic-strip artists as

Bernie Wrightson, the original artist on DC Comics' *Swamp Thing,* and Neal Adams, who returned *Batman* to the original 'Dark Creature of the Night' concept of the 1930s.

High contrast and deep shadows provide the most effective way of transmitting feelings of the supernatural or of menace to readers. The old cliché of lighting a menacing character from below combines a low-angle viewpoint with moody lighting to give a potent, if familiar, result.

Invoking a mood

The same figure of a man can be drawn as though lit from different angles, each invoking a different mood.

Straight on

Simple, flat lighting gives little dramatic effect.

From above

Obscuring the eyes in shadow tends to depersonalize.

From below

This clichéd devise is used extensively for horror effect.

From one side

This effect is seen in comics inspired by *film noir*.

Adding menace

A character enters a darkened room, with light flooding in from the passageway outside. This adds menace and mystery to the situation into which the character is entering.

Sinister atmosphere

This deep lighting conveys a sinister mood. With half the face obscured by shadow, it is difficult to read the character's intentions.

General lighting

Although well-drawn with striking deep shadows around the nose and jaw, this kind of lighting is not associated with any one particular mood.

LIGHT SOURCES

The use of one or more light sources will create a variety of different effects.

Single light source This is the most commonly used style of lighting and can create different moods, depending on where the light source is placed. A face lit from the front has little dramatic impact. Lighting from above throws the eyes into shadow and gives an air of mystery. Lighting from below is a bit of a horror-movie cliché, but it does give an easy, instantly sinister effect. Lighting from one side was used extensively in the *film noir* thrillers of the 1940s.

Twin light sources This effect was a favourite of top EC Comics artist Wally Wood and has also been used by great artists such as Al Williamson and Will Eisner, and later by Neal Adams and Bernie Wrightson.

Multiple light sources This very ambitious lighting trick, often used by photographers, can be pulled off to brilliant effect, provided the artist has taken time to analyze how shadows are thrown by several light sources.

Single light source

Twin light sources

Multiple light sources

Chapter 3
Storytelling

In this chapter we deal with the writing of the story and its breakdown into pages and panels. Unlike other kinds of storytelling, comics are governed by the finite number of pages or panels the creator has available, and it is this discipline that must be mastered first.

the script

If there has been one identifiable problem throughout the history of the comic strip, it has been that the script has always taken a back seat to the art. However, without exception, the script is the single most important component of a comic strip.

A good storyline

The script is the one 'invisible' component of any comic strip. While anyone can tell at a glance whether a comic strip is well drawn or not, to discern whether the script is any good takes more skill. The truth is that very few people know a good story when they see one – other than the audiences. Even many in the comics business cannot tell the difference between a good script and a bad one.

A good script is crucial to a comic's success. Readers will tolerate barely competent art and scruffy lettering, but nothing sends a comic strip to well-deserved oblivion faster than a poor storyline. During the 1970s, this simple fact of life seemed to escape most comics editors. Flashy art was in vogue, and while the work of such artists as Barry Windsor-Smith and Mike Kaluta was indisputably excellent, the standard of scripts these artists were being asked to illustrate was below average. Happily, the good scriptwriter has now come back into style, and once again emphasis is being placed on superior storytelling.

Creating a script

There are many ways in which a comic strip can be produced, depending on whether it is produced by one, two or more creative individuals, but all can be reduced to a combination of the following techniques.

The full script Within the comics business, there are several different ways that writers and artists can divide up the various tasks that go into producing a story in comic-strip form. The sharpest division of tasks occurs when the artist works from a script that is solely the product of a scriptwriter. This method is favoured by many major comics companies, including DC Comics in the US and Fleetway in the UK, but is by no means rigidly adhered to.

The Marvel method Another method, used only in the production of comic books, is referred to as the Marvel method because it is credited to Stan Lee, editor of the entire Marvel Comics line during the 1960s and early 1970s. When the company's output grew too large for one man to handle, Lee began a production system whereby he

would first discuss a plot with an artist, often Jack Kirby. Kirby would then draw the story in 20 pages or so – the number of pages depending on what the current page count of a Marvel magazine might be – then hand the pencil-drawn pages back to Lee to have the dialogue added. Lee would write the characters' dialogue directly onto the pages in pencil. The dialogue would then be lettered onto the artwork by a calligrapher, and then the pages would be inked by a separate artist. With the migration of writers and artists back and forth between all the major US comics companies, the method has spread considerably. A Marvel synopsis-style script and a full script of the same story are shown on pages 52–53.

Extreme close-up
This very close shot is used to emphasize a character's reaction to a situation.

Tracking shot
Although you cannot move in comic strips, you can hint at it by imitating camera movement over a series of panels. Here, the 'camera' moves from an establishing shot in panel 1 to close-ups of the hero's face and gun in panels 2 and 3.

Establishing shot

This type of panel is used to give the reader an overview of what is going on and who is involved.

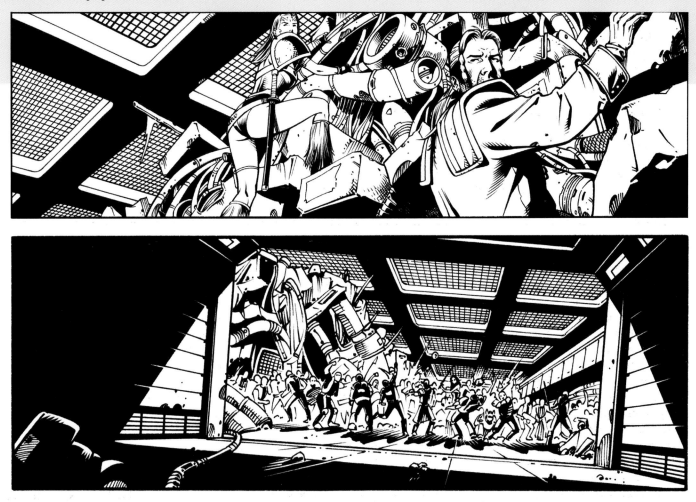

Long shot

This is a scenic shot that shows the location of the action – in this case a battle.

Close-up

This shows the face and head of the subject or a close view of an object. It displays a character's feelings and reactions in a more realistic way than an extreme close-up.

TECHNICAL TERMS

It is most important that the writer and the artist understand each other during their collaboration. For this reason, a system of specialized terminology has become pretty much standard, with only a little regional variation. Terms used in the descriptions of panels in comic-strip scripts are more or less self-explanatory: 'close-up', 'extreme close-up', 'long shot' and 'establishing shot'.

The technical terminology of comic strips crosses over frequently with the terms used in film making. However, despite the superficial similarities, there are major differences between the storytelling techniques in films and comics, the most obvious being the lack of sound in comics. The advantage with comics is that the writer can be a little more subtle than in film, as the reader can always turn back a few pages and reread something he or she is not clear about, which you cannot do in a cinema.

Marvel method script

This script outline could be used as the basis for a story by an artist using the Marvel method. Many writers also produce this type of outline as a preliminary stage to writing a full script.

Publication: 2000AD
Series: The Journal of Luke Kirby
Title: The Old Straight Track

Part 1

1. Sunday April 24th, 1964. Luke and his mum are visiting Luke's cousin Kim and her family. They live in a pleasant street of houses that are well-kept, tidy and clean. Luke is playing marbles with some kids; Kim is nearby, but she's reading a copy of Fabulous, a pop pin-up magazine with full-page colour pictures of pop stars of the era. Closer shot of Luke as he prepares to take his turn, aiming his marble carefully at the others in the chalk circle on the pavement. Before he takes his shot, Luke glances up at Kim for a brief second. Luke shoots his marble, which ricochets around, clearing the circle of all the other marbles.

2. The kids stare on open-mouthed shock at what's just happened, Luke less surprised than his pals. Luke looks along the pavement and sees a shabby figure approaching. It's Zeke, the tramp who's become Luke's mentor. Luke runs pell-mell to meet Zeke. He stops in front of Zeke and the two shake hands in an almost formal way. Luke turns slightly as him mum calls him and Kim in for their supper. As Luke and Kim enter the house, Luke's mum eyes the departing tramp suspiciously, asking who that was.

3. In the middle of the night, Luke is woken up by Zeke 'calling' to him telepathically. Luke goes down to talk to Zeke. Zeke greets Luke jovially; Luke tries to 'Shh' him. Zeke says that Luke has to accompany him to The Gathering, which will happen on Beltane Eve, (April 30th, also Luke's birthday) at a park in another city. They're going to be travelling light. All Zeke carries is a walking staff.

4. Luke is still trying to protest his way out of this, saying he's worried about how he'll pay the fare, but Zeke says that won't be a problem. They're going to walk! The ancient way was to follow the 'ley lines' (ancient lines of power) to get where they want to go. Luke isn't sure, but Zeke tells him it'll be fun, he'll learn a lot, and besides, he has to walk or he won't gather the correct amount of Power. Luke gestures to Luke that it's time to set off.

5. As they walk down the darkened street, Zeke points out items of interest, like a shabby tour guide. They walk down to the local church. Zeke mentions how churches are shaped to look like crosses from the air. A hundred yards from the church is a monument. Zeke explains that this was once a markstone, later replaced by this war memorial. If they line up the memorial with the church tower, that'll show them the direction they need to take.

6. They move along quickly, as Zeke wants to be clear of the neighbourhood before dawn. Luke, still not entirely convinced, wonders about what sort of mess he's going to get himself into this time. Scene change ... unknown to them, Luke and Zeke are being watched by a malevolent entity, whose name and agenda we will learn of next episode.

ends:

Make sure the synopsis is clearly identified with the title of the comic, the title of the story and, if appropriate, the title of the episode.

Each paragraph is numbered clearly so that the artist always knows which page he or she is drawing. This also helps the writer to keep track of how many comic pages have been written – one page too many in a comic story is as bad as one too few.

With this method of writing for comics, a typed paragraph represents a page of the finished art, with each sentence in that paragraph representing a panel on that comic page.

Full script

This is a full script of the first part of the story outline shown opposite, with panel breaks and page breaks indicated clearly in the script.

The first block of text describes for the artist everything that is going on in the panel. How much you write depends on how much you want to restrict the artist. You may want to show things here that will be important later on in the story, so you should tell the artist.

The first panel of a story usually contains the story logo and title. It is worth mentioning these in the script so that the artist knows to leave enough dead space. Of course, you may want to include the title and logo elsewhere in the story, which is also fine.

The term 'caption' refers to the boxes of narrative text that explain or amplify things that the characters cannot speak out loud. In this case, it is Luke's voice-over narration. Note how both captions and character dialogue are always typed in capital letters.

Publication: 2000AD
Series: The Journal of Luke Kirby
Title: The Old Straight Track Part 1 ***FINAL DRAFT***

PAGE 1
Panel 1
Establishing shot of a residential street, mid-afternoon on a sunny spring day. It's a pleasant street of well-kept houses. There are a few cars of the period parked here and there, but nothing like the amount of cars you'd see today. In front of one of the houses, a small group of kids kneel on the pavement playing marbles, Luke among them. Kim, Luke's 12-year-old cousin, sits reading her pop magazine (Fabulous, a pin-up mag with full-page colour pix of pop stars of the era).

LOGO:
TITLE: THE JOURNAL OF LUKE KIRBY
 THE OLD STRAIGHT TRACK PART 1
CAPTION: SUNDAY APRIL 24TH, 1964.
CAPTION: IT WAS THE END OF THE EASTER HOLIDAYS. MUM AND I WERE
 VISITING MY COUSIN KIM FOR A WEEK.

Panel 2
Closer shot of the marbles game. There's a chalk circle on the pavement with a few marbles in it. It's Luke's turn to shoot. His brow is furrowed in concentration as he gets ready to flick his shooter marble, with his thumb, into the circle. At his side on the ground is a large bag of marbles he's won off the neighbourhood kids. The object is to knock as many marbles as you can out of the circle. What you knock out of the circle you get to keep.

CAPTION: I DIDN'T LIKE THIS PLACE MUCH, BUT THE NEIGHBOURHOOD KIDS
 HAD LOADS OF MARBLES AND WEREN'T VERY GOOD PLAYERS.

Panel 3
Luke, momentarily distracted, sneaks a glance at Kim, who reads her magazine, oblivious to Luke.

CAPTION: AND THEN THERE WAS KIM.

Panel 4
Luke's marble shoots from his fingers and ricochets around inside the chalk circle, knocking every single marble out of the circle.

CAPTION: OTHER THAN THAT, THERE WASN'T MUCH GOING ON HERE.

PAGE 2
Panel 1
Luke and the other kids are amazed. They kneel, staring at the ground in complete astonishment.

BOY 1: WHAT...?
BOY 2: HOW DID THAT...?

Panel 2
Luke looks along the pavement and sees a tramp not 10 yards away, leaning against a tree and smiling at him. This is Zeke, whom we last saw during The Night Walker story (see refs). I think John drew him too old and the idea is that Zeke is actually about 30, but the unkempt hair and beard make him look older at first glance.

CAPTION: I'D BEEN AROUND ALCHEMISTS ENOUGH TO RECOGNIZE MAGIC
 WHEN I SAW IT.
LUKE: ZEKE?
BOY 1: YOU <u>KNOW</u> HIM?

If you want the letterer to letter certain words in bold, you should underline them.

pacing the story

Unlike a novel, a comic book's page count cannot be increased just to accommodate the length of your story – you have to tailor the story to the space available in the comic book.

Advantages of the genre

Comics are a visual, not cerebral, medium. Words and ideas that would seem commonplace in a short story or novel are impossible to use effectively in a comic strip. Yet comics, like cinema and television, which also tell stories in words and pictures, are capable of some marvellous storytelling effects. Unlike film and television, comics have the advantage that it is possible to expand or contract time for dramatic effect with

methods far less obtrusive than slow-motion filming. Another advantage comics have over screen entertainment is that they do not have a limited budget for sets, props and special effects. A scriptwriter can ask for a hundred thousand alien soldiers charging over a hill and get just that … with only a muttered complaint from the artist.

Thumbnail sketches

Before committing to draw the full-sized artwork, an artist will often rough out the page designs on a smaller sheet of paper to test that they work. Here, artist Steve Parkhouse has drawn thumbnail designs for a two-page strip to ensure that he can fit in all the action asked for in the script (see pages 72–75). Fitting this amount of story into two pages is a real challenge, but Parkhouse carries it off skilfully, and at no time does the sequence of events seem squeezed.

A classic establishing shot. From this image, the reader quickly gathers that a figure is sitting outside alone in the middle of the night.

By ensuring the reader can see the character's ear, it is clear that she has heard a noise.

Minimal dialogue to convey a fast series of events.

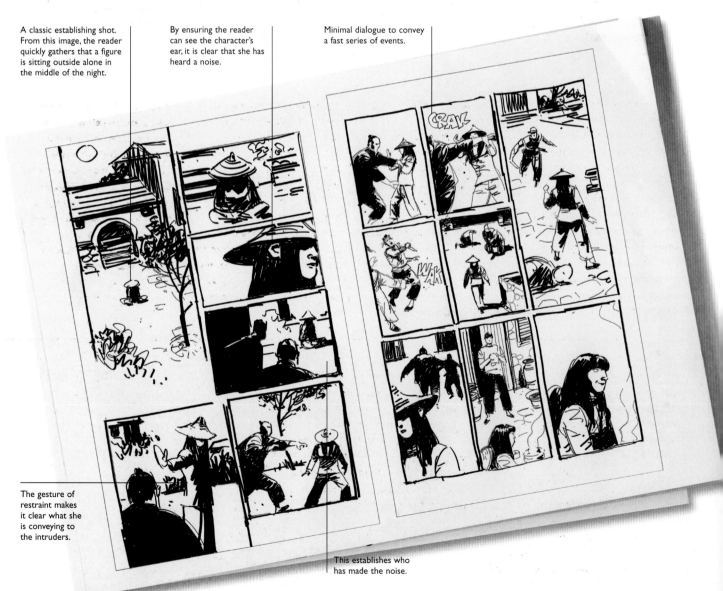

The gesture of restraint makes it clear what she is conveying to the intruders.

This establishes who has made the noise.

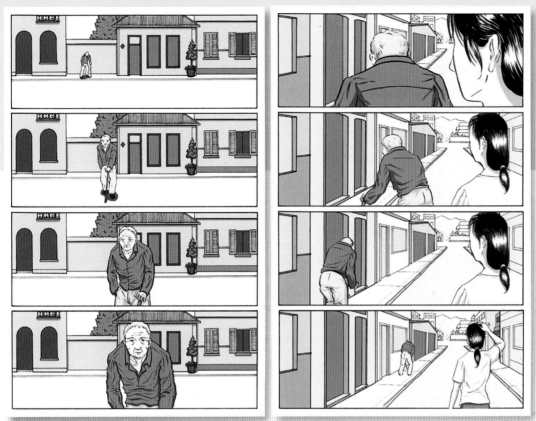

Space issues
These pages show how a simple event can be stretched out for dramatic effect, using two full pages to have a character walk past and disappear into the distance. This kind of indulgence is only possible if you have a graphic novel's worth of space in which to tell your story.

THE PAGE COUNT

The single most telling limitation on the type of story you want to tell in comic-strip form is the amount of space in which you have to tell it. This may seem like a pointless observation, but it is a common mistake among beginners to try to tell *War and Peace* in a six-page comic strip. It is important to tailor your story to the space available. In this respect, a daily continuing story strip designed for newspapers is more flexible than a complete story for a comic book.

With most US comic books, the writer has about 20 pages to tell the story. This means he or she is required to produce a story that can be dealt with in that number of pages, rather than thinking of a story and trying to cram it into the available space. However, it is possible to continue a story over several issues, an idea that became popular during the 1960s and 1970s and continues to this day. The British format, which limits the writer to five

or six pages a week, requires even more discipline, although continued stories are more popular. In certain British comics, complete stories lasting only three pages are not uncommon.

At the other end of the scale is the graphic novel. This is a term used to describe a comic strip of 60 or more pages, usually bound in a large-size paperback format. It is a misleading term, because a 60-page comics story cannot even begin to approach the kind of

depth found in a real novel. For a time, graphic novels were viewed as the next logical step in the evolution of English-language comics, but after a brief moment of popularity in the late 1980s and early 1990s, many of the graphic novels being published these days are actually just collections of material previously published in regular comic-book format.

Limitations of the genre

On the other hand, comic strip as a medium has distinct disadvantages compared to film and television. True drama does not translate well to the comics medium. Whether this is because of the limitations inherent in comics *per se*, or more due to limitations in the audience's attention span, is difficult to tell. Perhaps it is a little of both. The fact remains, however, that any comics story with a lot of talking is assumed to make pretty dull reading because all the artist would have to illustrate would be talking heads, the bane of any comic

editor's life. If you write a scene in which there has to be a good deal of talking – called exposition – it is always advisable to have the characters *doing* something while they talk – exposition on the run, if you like. However, what the characters are doing should have some relation to the story, or should throw light on their personalities.

understanding the story

Probably the most unhelpful definition of a story is that every story should have a beginning, a middle and an end. A story is much more than that, requiring a setting, characters, conflict, a theme and a plot.

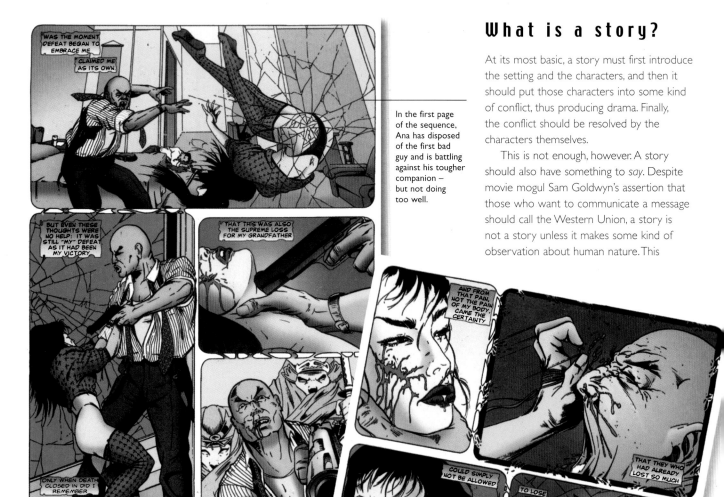

In the first page of the sequence, Ana has disposed of the first bad guy and is battling against his tougher companion – but not doing too well.

What is a story?

At its most basic, a story must first introduce the setting and the characters, and then it should put those characters into some kind of conflict, thus producing drama. Finally, the conflict should be resolved by the characters themselves.

This is not enough, however. A story should also have something to *say*. Despite movie mogul Sam Goldwyn's assertion that those who want to communicate a message should call the Western Union, a story is not a story unless it makes some kind of observation about human nature. This

Conflict and character

In this action-packed sequence from William Tucci's *Shi: The Way of the Warrior 4*, Ana (Shi) Ishikawa catches up with one of the men responsible for attacks on her family. It is this quest for revenge that defines Ana as a character and sets her apart from the really bad 'Bad Girls', like Lady Death and Vampirella.

In the second page of the sequence, Ana's memories of her family and her realization of why she is fighting this battle galvanize her into making a final superhuman effort. She concentrates all her anger into a final blow, which sends her opponent through a plate-glass window to street level.

Getting the story down

observation we can call the theme. It is what the story is *about*. When you have decided what the theme of your story is – it could be jealousy, for example – you can move on to creating the plot.

The plot of the story is the depiction of the drama and its resolution. While the plot is separate from the theme, it is often motivated by emotions underlying the theme. Thus the plot of your story could be about the solving of a murder mystery. That the murder was motivated by jealousy makes an observation about how far a human being can be pushed by such emotions. Not startlingly original, but you get the idea.

In unfolding the plot, your main aim is to convince the reader that what follows is the truth. This you do by creating such a convincing world that he or she has no alternative but to suspend disbelief for the duration of the story. That is, though the readers know they are reading a story, they temporarily enjoy the sensation of experiencing what the characters in the story experience.

To achieve this, the first order of business is to establish the background against which your story will be told. How well you establish this background in the reader's mind will affect the degree of success of your story. The idea

is to convince the reader that he or she is actually experiencing the background you have created. For example, you might want to tell your story against a background of the Russian Revolution. How well you evoke 1917 Russia will be crucial to the reader's suspension of disbelief.

Next, you need to establish the identities of the protagonist (the good guy), the antagonist (the bad guy) and the supporting characters. Much of the success of your story will stem not from how realistic the characters are, but from how likable they are – even the villains. When we turn to popular fiction for relaxation, we are not looking for a mirror-perfect depiction of reality, but rather a simplified and ordered view of the world, in which good triumphs and evil is defeated by the virtuous. Nowhere is this more true than in comics.

Archetypal story elements

Although there is no set formula for writing comic strips, you should ensure that your story contains most, if not all, of the following elements. These apply to any type of story, from a superhero caper to a courtroom drama. You can add other elements if you wish, or vary the order of the scenes, but it is best to master the rules before you decide to break them.

1. Introduce the hero by having him do something heroic, preferably low key.
2. Bring in a small mystery relating to the villain.
3. Introduce the villain by having him do something villainous.
4. Show the hero having some kind of personal relationship episode.
5. Add a bigger mystery relating to the villain.
6. Hero encounters the villain doing something else villainous and the two clash.
7. Hero gets butt kicked.
8. Hero has another personal episode, solves one of the mysteries and finds the key to kicking the villain's butt.
9. Big fight, with hero prevailing through the use of a clever insight or strategy over and above his natural abilities.
10. Final mystery is solved and the hero has final personal episode; perhaps set up a new mystery for the next issue.

FOCUS AND SUBPLOTS

In the telling of your story, it is necessary to tell it from one character's point of view. This gives the story a focus. It is common to use the protagonist as the story's focus, although it is possible to use the villain. A useful hint here is to limit the use of thought balloons to the character you have chosen to represent the point of view.

It has been said that a story is created when subplots cross over with the main plot and with one another. For example, the plot might be Captain Aluminium's battle to the death with the Human Spin Dryer; the subplot might be Captain's deteriorating relationship with his secretary, Judie. The crossover comes when

the pressure of the stale romance affects Captain's fighting abilities in the final battle with old Spinny. In comics, you need 10–12 pages to tell a story that uses subplots. Certainly, subplots avoid readers becoming bored, providing both the protagonist and the reader with more to worry about.

story and format

The kind of story you are able to tell can be constrained by the format you are working to, whether it is a three- or four-panel gag strip or a serial story that takes months to unfold.

This first panel sets up the gag and establishes the characters.

The second panel completes the set-up, and provides the reason for the punchline.

The third panel provides the action, with the main character acting on the information revealed in the set-up.

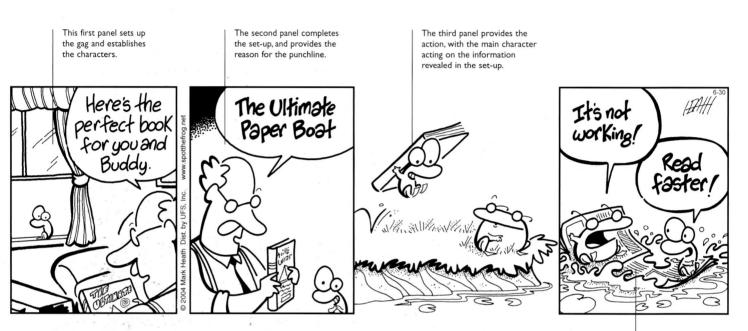

The fourth panel — obviously — delivers the punchline.

Four-panel gag strip

This kind of humorous strip uses the simple formula of 'set-up/action/punchline'. With four panels rather than three, there is the luxury of spending a little longer on either the set-up or the action. Here, the artist has used the first two panels for the set-up, and while they could have been combined into one, the extra space helps with the pacing of the gag.

Gag strips

There is nothing anyone can teach you about writing for a three- or four-panel gag strip in the style of *The Wizard of Id* or *Peanuts*. Either you have a talent for that type of writing or you do not. The formula works best in four panels, consisting of an introductory panel to establish the scene, followed by an event or a statement that affects the protagonist, then the protagonist's response to the event or the punchline, and finally the effects of the punchline. This formula has been around since the beginning of gag strips in newspapers, and was used for years by George Herrimann for *Krazy Kat*. It is not the only way a four-panel gag strip will work, but it is about the most reliable.

Milking the gag There are two distinct ways of approaching series gags, both of which are ideally suited to the format of the

newspaper gag strip. The first of these is to use a series of linked gags that tell an ongoing story. Walt Kelly, creator of the gag-strip legend *Pogo*, used this idea to devastating effect and, nearly 20 years earlier, Floyd Gottfredson also used this concept brilliantly in his *Mickey Mouse* daily strip.

The other approach to series gags is to use a situation or an object around which to build a succession of 'variations on a theme'. Charles Schulz's *Peanuts* often uses this technique as the basis for a week's material. In extreme cases, the whole run of a gag strip can be built up around a single situation – for example, Frank Dickens' office workers strip *Bristow*. The best way to learn how to do this is to study examples by the best strip creators.

Daily drama

The daily story strip is another thing entirely. To begin with, a strip editor will want to know the entire storyline in advance, and often will also want to know exactly how many episodes the story will take. Having taken care of that detail, the scriptwriter must then tackle the almost impossible task of holding a reader's attention from day to day while a story unfolds, often over several months.

The writing of a single episode should be an exercise in economy. In the space of three or four panels, the writer must establish the scene for the reader, tell some of the story, then end on a cliffhanger to bring that reader back the next day – or, more difficult, on Monday – to take up the story once more.

It is at the same time a very restrictive and very demanding format to write for. The best practical advice a beginner can receive is to

Comic books

Comic-book stories come in a variety of sizes. In the 'funny' books, typified by *Archie* comics in the US and *The Beano* in the UK, it is not unusual to find complete stories that run to only one page. These are usually gag strips of six or more panels. In the UK, comics tend to favour eight or more panels on a page, whereas in the US, with a smaller page size, six panels on a page is a more common average.

In adventure comics, stories of three or more pages are the rule. In a three-page story, the writer barely has room to introduce the characters and then set up and resolve the conflict. There is no space for subplots, for characters who do not move the plot forward, or even for characterization – just the plot. Luckily, there is little demand for complete comic-strip stories of only three pages: readers demand more, and get it.

Editors of comics in the US, UK and Japan commission lengthy serials in an effort to bring their readers back week after week, month after month. In Japan, especially, these serials may run for years and add up to hundreds of pages.

In the first strip, Dredd threatens the criminals, they shoot at him and then Dredd retaliates with well-placed shots, commenting that nothing is as accurate as a judge's handgun, or 'Lawgiver'.

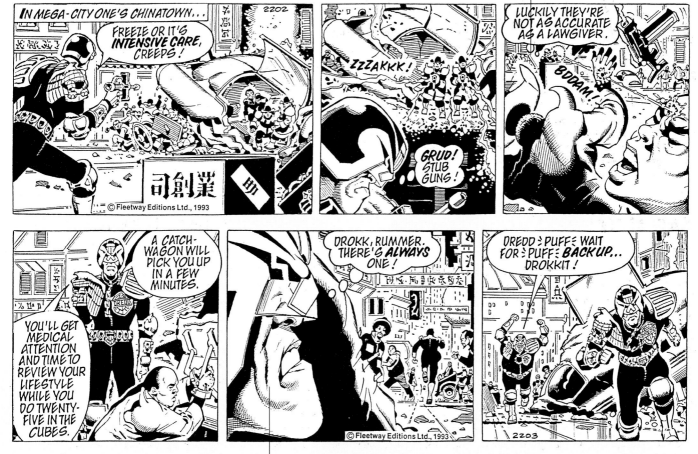

© Fleetway Editions Ltd., 1993

study some of the many volumes of collected daily comic strips available, to see how other writers have used the format. Collections of many of the best newspaper adventure strips include *Terry and the Pirates*, *Flash Gordon* and *Garth*.

The second strip is mostly set-up, but still manages to be a complete scene – the episode after this would follow Dredd as he chases the criminal – so even this episode has a 'self-contained' aspect to it. Note the lettering mistake, or 'literal', that snuck through. Dredd should have been saying, 'Drokk, runner. There's always one!'

Series action strip

With a dramatic action story, you have to tailor the story to the space allowed. In this example of the daily *Judge Dredd* strip, scripted by Alan McKenzie, the story is told in three-panel chunks, each of which, like a gag strip, has a set-up and and pay-off. You would never, for example, have a character's dialogue continuing from one episode to the next.

Eight-page comic-book story

This example of the final chapter of a classic *Johnny Nemo* story by scripter Pete Milligan and artist Brett Ewins had to fit into the eight pages assigned to it. The story is recapped in the first panel, with Nemo's narration explaining the plot points so far. The lesson here is that the story being told must be tailored to the space available. There is no room here for any kind of subplot. Milligan and Ewins had a sparse eight pages to resolve the plot and get Nemo back to his own milieu, and that is precisely what they do, with economy and humour.

Page 1: This is an establishing shot of the main character Johnny Nemo, who explains that he is awoken from 300 years of cryogenic stasis to find Earth under the control of invading aliens.

Page 2: Nemo is captured by the same aliens and then freed by the Human Resistance.

Page 3: The humans make short work of the aliens by disintegrating their ship in the first panel. Ewins uses a panoramic full-width panel to show the explosive action. Transported into the humans' ship, Johnny discovers that the humans are members of The League of Adam. Here, Ewins cuts between the General and Nemo as realization dawns on Johnny.

Page 4: Nemo tells the League of Adam that they are the idiots responsible for the war. They get mad and push Nemo through an airlock. He lands safely on a squishy alien and escapes through a time portal.

Page 5: Arriving back in his own time, a few hours before he originally went into cryo-stasis, Nemo sets off to recover the Orb of Harmony.

Page 6: Nemo catches up with the League of Adam agents who have stolen the aliens' Orb.

Page 7: Nemo is summoned to Councillor Stevens' office where he is given the mission to recover the Orb of Harmony to prevent war with the Sirians. He astonishes the councillor by handing him the Orb.

Page 8: Mission accomplished, Johnny lights a cigarette in time-honoured private eye fashion while making a wry comment. Johnny leaves his client, the councillor, with the recovered prize as he make a quiet exit. The loose ends are tied up. The councillor is overjoyed to recover the Orb, the future war is averted, Nemo is getting paid and he heads off to spend a relaxing evening with his beautiful robot assistant.

breaking down the story

While the breakdown of a story into comic strip is a definite stage in the creative process, it is a chore that can be executed by (a) the writer, (b) the artist or (c) both, depending on the writing techniques employed.

Breakdown techniques

With the full-script method (see page 50), much of the breakdown is in the hands of the writer, because the contents of each panel are set down in the script, sometimes to the extent of describing whether a panel should be a close-up or long shot, high-angle or low-angle, large or small. Only the placement of the panels on the page is left to the artist. On the other hand, if the artist works from a synopsis supplied by the writer, as with the Marvel method (see page 50), much of the breakdown is left to the artist, although some writers who use this method give indications to the artist in the way they write the synopsis. The commonest way of doing this is to use one sentence to describe a panel and one paragraph to describe a page. Thus, each paragraph has the same number of sentences as the comic page will have panels.

Selected highlights When it comes to the mechanics of deciding what will be shown in each panel of a comic strip, it is useful to use movie analogies. In a strip of film, the viewer is shown 24 frames per second – too fast to distinguish individually, giving the illusion of continuous movement. With comics, the rate at which the frames pass the eye is a good deal slower. Thus, the reader is required to fill in what happens between comic panels with his or her own imagination. It is the writer's and the artist's job to supply the reader with a stream of panels that show

selected highlights from the action of the story. The selection of these highlights forms the core of the breaking down of a story. Whether this job is done well or badly is

crucial not only to readers' enjoyment of the story but also to their very understanding of it. So the breakdown must have *clarity* as well as *creativity*.

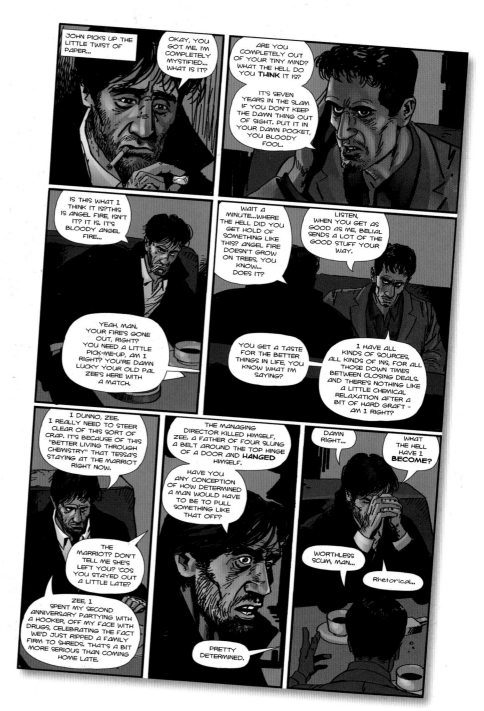

Too much text

Here, we have rewritten the dialogue on a page of *Angelfire*, a graphic novel by Chris Blythe and Steve Parkhouse, to demonstrate what comics look like with too much text on the page. It should be stressed that the real *Angelfire* is not at all like this.

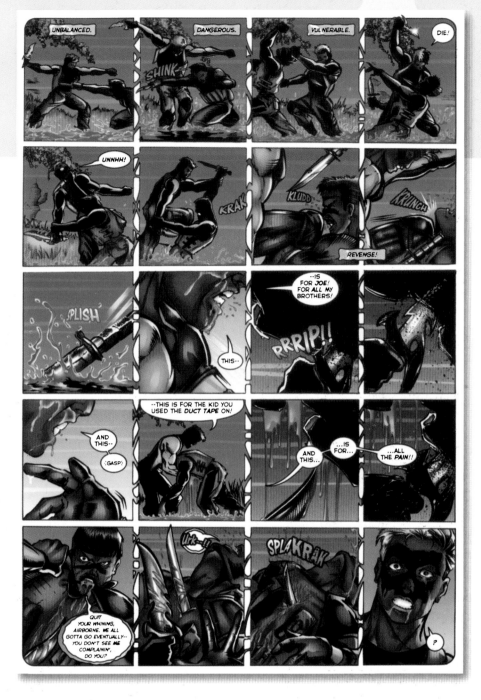

Minimal dialogue

In this rapid-fire fight sequence from *Shi: The Way of the Warrior 11*, William Tucci depicts a brutal action sequence in a series of 20 small panels. This has the effect of making the choreography fast and furious, but at the same time plays down the violence. Another typical Tucci trademark is the way each panel is joined to the next by tendrils of art.

TIP KEEP IT QUICK

As far as the reader is concerned, the time span of your story is purely subjective – that is, the action in a comic strip occurs at the same speed as your audience reads it. You therefore should not clutter up action sequences with dialogue or captions. Words just slow the action down to a snail's pace.

CHOOSE YOUR WORDS CAREFULLY

It should be remembered that the comic-strip panel is designed to contain the dialogue that the characters speak as well as the actions they make. Thus, the breakdown of a story into panels depends quite heavily on how the dialogue is written.

A good rule of thumb is to arrange it so that there is only one exchange of dialogue (a character's speech and another's reply) per panel. As speech balloons should contain no more than about 20 words, no panel should contain more than a total of 40 words. This is not a rigid rule, and it is broken all the time by professional comics people, but these word counts should be treated as an upper limit to keep your comics from being too 'wordy'.

Then there are going to be many panels that contain no dialogue at all. Never be afraid to have panels in your comic strip with no words: some of the best comic strips work because they have no words.

A warning to any comics professional about the danger of too many words is the story of an old-time artist who saw a boy reading one of his comics in a barbershop. He watched the youngster for a few moments before realizing that the child was reading only the top tier of each page. He took it upon himself to explain to the boy that he should read the whole page to get the full flavour of the story. The child replied: 'I know, but it's quicker this way.'

the panel

Panels, or frames as they are also known, are the individual units of the comic-strip story. They are snapshots of the action, rather like selected images from a movie reel.

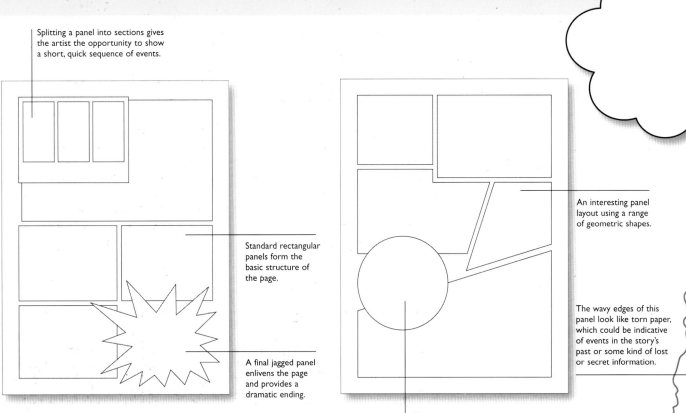

Splitting a panel into sections gives the artist the opportunity to show a short, quick sequence of events.

Standard rectangular panels form the basic structure of the page.

A final jagged panel enlivens the page and provides a dramatic ending.

An interesting panel layout using a range of geometric shapes.

The wavy edges of this panel look like torn paper, which could be indicative of events in the story's past or some kind of lost or secret information.

The circular overlapping panel can be used to depict an event that is key to what is happening in the other panels.

Panel designs

The shape, number and layout of panels all contribute to the storytelling process, allowing the writer and artist to convey mood and meaning with great economy.

Number of panels

Once you have settled on what is going into the panels of your comic story, you still have other decisions to make. First, the number of panels on a page. In a US-style 171 × 260mm (6¾ × 10¼in) comic book, a sensible average number of panels per page is six. Of course, this is a guide rather than a rule, and some pages will have less than six and some more, but if you tried to draw a whole 20-page story at eight or nine panels per page, the overall effect would be one of unpleasantly cramped, busy storytelling. In a larger sized British or European comic, you have a bit more room to play with, and sometimes you can push the number of panels on a page to seven or eight.

So a key part of the storytelling process is the number of panels you use on a page and their relative sizes. For the most part, the importance of the moment depicted in a panel determines its size. For dramatically important scenes, you may want to choose a full-page panel for maximum impact. Remember that this is a relative factor, so a full-page panel would have less impact in a 20-page story than in a six-page one.

Even in a regular six-panel page, you should try to vary the panel sizes with the peaks and troughs of the story. If you draw a page where all the panels are the same size, this would give your story a monotonous and somewhat old-fashioned feel.

Of course, you can use more panels on the page for dramatic impact. Jim Starlin sometimes used as many as 20 panels on a page during his 1970s stints on *Captain Marvel* and *Warlock*, but always balanced them with single-panel pages and occasional pages with only two or three panels.

However many panels you decide to draw on a page, make sure there is sufficient room within each one to accommodate the amount of text – captions, dialogue and sound effects – stipulated in the script.

Using a scroll-shaped panel could indicate that a separate part of the story is being related, perhaps a historical event that sheds light on the current situation.

Jagged panels indicate violence or noise, or an event of great impact.

Cloud-like panels denote that the event within is taking place in a character's imagination or is part of a character's narrative.

Index card-shaped panels indicate that the story is being told from some kind of files, perhaps police files.

Types of panels

The way a panel's borders are drawn can be used to convey certain feelings to the reader. The standard rectangular panel is the most used and therefore the most neutral. A cloud-like panel border indicates that what is shown is in some character's imagination or is part of a character's narrative. A jagged panel border conveys impact, noise or violence. A wavy panel border can denote events in the story's past or future, or in a separate reality such as a parallel dimension. Having no panel border at all is useful at the emotional highpoints of the story.

WHAT TO FRAME

Let us take a simple familiar scene. A bad cowboy pulls a knife on the sheriff. The sheriff pulls a gun and shoots the knife wielder. The bad guy falls down dead. If you simply depict this event in three panels using a static point of view from the middle distance so that the cowboy's and sheriff's full figures are in frame and you do not vary the angle, you will have a dramatic event told in a not very dramatic way.

Now consider this as an alternative. The first panel shows the bad guy, Tex, pulling his knife, unaware that his opponent has a gun tucked in the rear of his waistband. The sheriff gives Tex a stern look, as if to say, 'I wouldn't do that if'n I were you, Tex.' Tex is too enraged to notice, so our hero pulls the gun and shoots him. The viewpoint from the sheriff's gun in the second panel adds impact to the suddenness of the violence. The final panel is looking down at the dead Tex from the hero's point of view. The top view of the hero's head emphasizes that he is still standing while Tex is deceased. The end result of a winner and a loser is stressed.

Increasing drama

The strip above featuring full-figure characters is static and uninteresting, but the drama can be greatly increased by varying what is shown, as in the example below.

Although the key event of the story – the shooting – is clear here, it lacks the immediacy and drama of the second version, where the viewpoint is that of the gun.

Viewing the scene from above the hero's head emphasizes that he has triumphed over his foe.

This viewpoint emphasizes that the reader has information that the villain does not – the gun in the sheriff's waistband – which is not apparent in the first version of the strip.

laying out the page

The comic page is generally read from left to right, down the page, although it is possible to vary this for dramatic effect. It is important to arrange the panels in the correct order so that the reader may follow the story without confusion.

Planning the page

The way the panels fit together to make a page depends on several factors, including the order in which the artist wants them read. The size and shape of the page and the action to be shown can all affect the number of panels and the way they fit together on the page (see also pages 64–65).

The natural instinct is to make sure that the comic page is as tightly filled with drawing as it can be – if only to reassure editors that they are getting all the drawing they have paid for. Yet careful use of areas of 'white space' can enhance the telling of a story. By manipulating the width of the spaces between panels, the artist can achieve a number of effects, from scene changes to narrative timing to eye-pleasing page design.

There is no reason why an artist should not strive to achieve page designs that are easy on the eye. There are many ways of doing this. Artists such as Will Eisner, Jim Steranko and Frank Miller are all noted for their exceptional page designs. British artist Dave Gibbons created some interesting symmetrical designs in DC Comics' *Watchmen* series, although to judge by the way the whole series is written, scriptwriter Alan Moore may also have had a hand in the designs.

Wide-screen panels

This story from *Rebellion* drawn by Mark Harrison is related through a series of images overlying a central location shot. Each inset panel mimics the ratio of a wide-screen movie frame. Varying the colours of the panels' borders from black to white is a small detail, but helps to prevent the panel layout from becoming monotonous. The layout of the panels on the page has a rhythmic flow that leads the reader's eye through the story.

Design motifs

This page of 'Bad Girl' comic *Dawn* is so full of clever design resonances that it is hard to know where to begin. The story is titled 'Three Tiers', which is clearly a pun on the markings of three tears on Dawn's face. Artist Joseph Linsner then uses the motif of three tears on the three panels at the right-hand side of the page, in which the dialogue consists of Darrian explaining how it was he who made Dawn cry. And, of course, it is rendered beautifully.

Emotional eloquence

In this elegant dream sequence, also from the 'Three Tiers' story, Darrian is once again before Dawn, begging her forgiveness. The monochrome rendering adds to the otherworldly feel, but it is the first panel of Darrian on his knees before Dawn's throne that encapsulates every emotion he is feeling at that moment. The simple and powerful design captures the very essence of the story.

Split-screen technique

In this page from a graphic novel by Si Spurrier and Steve Parkhouse, the two parallel sequences mirror each other Note how the telephone conversation from the first sequence spills over into the second one, and in a way comments on the second one. It is an effective and clever way of showing readers two incidents happening at the same time, a comics version of cinema's split-screen technique.

Parallel storylines

The idea of two narrative threads running simultaneously has been used many times in comics. Neal Adams presented two scenes simultaneously during his stint on Marvel Comics' *The Avengers* by using the top half of the page for one scene and the bottom half for the other, over several pages. Will Eisner used the idea in *The Spirit* strip of the late 1940s in his much-loved story 'Two Lives' (1948; reprinted in full in Eisner's *Comics and Sequential Art*, in Harvey's *Spirit 1* and in Warren's *Spirit 9*).

This kind of page really must be planned at the scripting stage. The layout is less important than the juxtaposition of the parallel panels. How well this works mostly depends on the wits of both the writer and the artist. Notice how even the speech balloons are similar in each of the story sequences.

This scene change aspires to be arty. The dialogue from the previous scene continues as a voice-over, denoted by the quotation marks, so the reader is aware of what the scripter intended. By the time we get to the fifth panel, the quotation marks have been dropped and we know that it is The Terrorist's voice-over.

Scene changes

Comics lend themselves readily to clever scene changes. Some creators, like Alan Moore and Jim Steranko, have made scene changes their trademark. In this sequence, the first scene change uses the Inspector's dialogue of '…exquisite stitching', referring to the garment left behind by The Terrorist, to overscore the scene change to the image of The Terrorist sewing up the wound in his own stomach. Then, at the end of the page, is a clumsier version of a scene change signalled by the simple caption box, 'Later…'

Changes of scene

Scene changes can be handled in a variety of ways. Many people prefer scenes to be contained in multiples of whole pages; a scene can change halfway through a page just as easily, but when this happens it should preferably be between tiers.

The most basic type of scene-change device is a caption box on the first panel of the new scene: 'Meanwhile, back at the ranch…' This is a primitive and clumsy way of going about it. If the artist is doing his or her job properly, it will be obvious to the reader that the scene has changed, making that type of caption box redundant.

Another technique, which relies on the reader recognizing a scene change without help, involves the trick of overlapping the end of a speech from one scene into the next. Alan Moore, British writer of *From Hell* and

Image Comics' *League of Extraordinary Gentlemen*, uses a similar idea – so much so that it has almost become his trademark. Moore will have a character's speech or a narrative caption continue across a scene change, with the words superimposed over the new scene having some connection with the new scene.

Here, we see the sort of scene change that people who do not read comics would expect to see if they did. It is artless, it is lazy – fine in comics of the 1940s when no one knew any better, but not really acceptable today.

putting it on paper

Every artist takes a different approach to the task of breaking down a page. Some artists design the page straight onto the final artwork board, but this is time-consuming and wasteful of drawing material if you do not have the experience to get it right first time.

Thumbnail sketches

Joe Kubert, a veteran DC Comics artist who has drawn *Sgt. Rock, Hawkman* and *Tarzan,* designs his page layouts on typewriter paper. 'I take a sheet of typewriter paper,' he said in an interview, 'and do breakdowns into what I feel will be an interesting panel layout, not forgetting I don't want to sacrifice legibility for design. Primarily, I feel our job is storytelling. If you confuse that by composing your page so

that it's difficult to read, then regardless of how pretty the picture is, you've defeated your own purpose.'

Another experienced comic-strip artist, Gil Kane, who has drawn *Starhawks* for newspapers and a host of characters in comic books, also uses layout paper. He has said: 'I generally work through the entire book with half-size breakdowns and then go back to draw

the panels. Nearly always, when I work with thumbnail sketches it removes certain inhibitions and I find I carry through my thumbnails 80 per cent of the time. When I was working on my newspaper stuff, we worked out thumbnails every week for the entire week.'

However, the best advice you will ever get is: do it the way that suits you.

Preliminary sketch

Often sketched on a scrap of typing paper, the preliminary sketch gives only the broadest idea of what is going to go in each panel. The artist may transfer this sketch to a larger size via a projector or lightbox, or by scanning it into a computer.

Rough draft

With this kind of rough draft, the artist will work a little larger, probably at the same size the art will finally be printed. Here, there is a more definite indication of what the characters look like and what will be in the backgrounds.

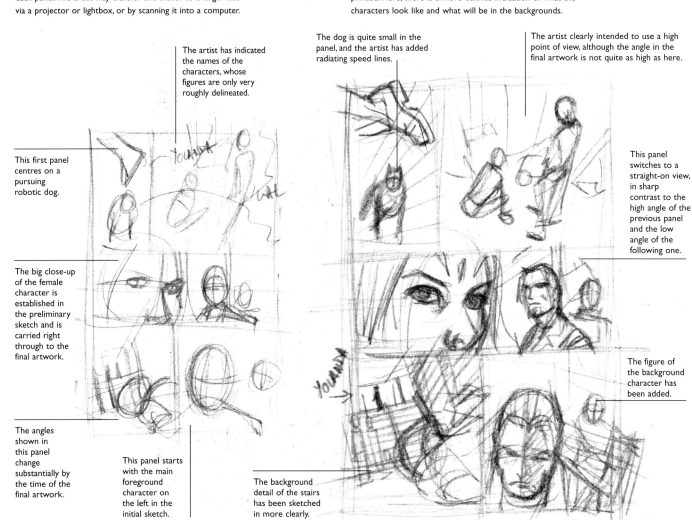

The artist has indicated the names of the characters, whose figures are only very roughly delineated.

This first panel centres on a pursuing robotic dog.

The big close-up of the female character is established in the preliminary sketch and is carried right through to the final artwork.

The angles shown in this panel change substantially by the time of the final artwork.

This panel starts with the main foreground character on the left in the initial sketch.

The dog is quite small in the panel, and the artist has added radiating speed lines.

The artist clearly intended to use a high point of view, although the angle in the final artwork is not quite as high as here.

This panel switches to a straight-on view, in sharp contrast to the high angle of the previous panel and the low angle of the following one.

The figure of the background character has been added.

The background detail of the stairs has been sketched in more clearly.

Final artwork

In the final rendered version of the page, you can see that the concepts artist Dylan Teague laid down in both the preliminary sketch and rough draft have been mostly carried through, with some enhancements here and there.

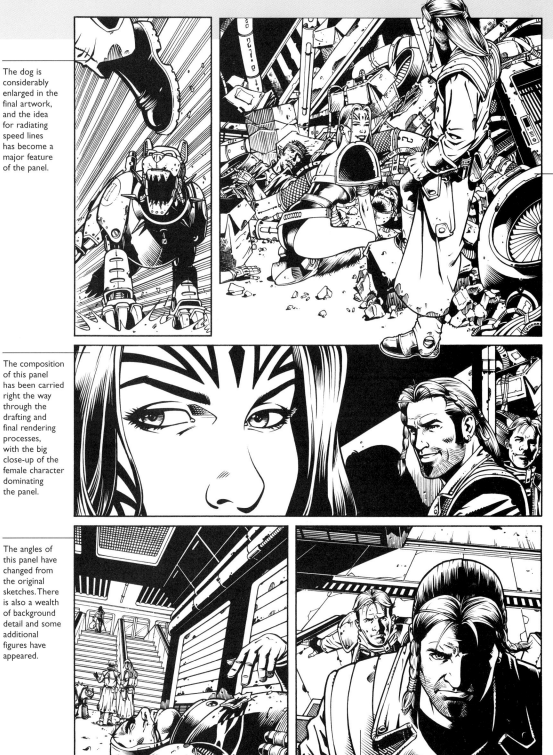

The dog is considerably enlarged in the final artwork, and the idea for radiating speed lines has become a major feature of the panel.

The rough draft had no indication of the level of detail the artist was planning to put into the pile of junk behind the characters. Note also how the main figure in the panel breaks out of the confines of the panel to give a more 3D effect.

The composition of this panel has been carried right the way through the drafting and final rendering processes, with the big close-up of the female character dominating the panel.

The angles of this panel have changed from the original sketches. There is also a wealth of background detail and some additional figures have appeared.

This panel has been flipped so that the main character is now on the right of the panel and the secondary character is on the left. This was probably done because the artist realized that the smaller background character will be speaking first and the changed layout will aid the letterer.

sample script and breakdown

Just as it is not possible to tell anyone how to think up stories, I can only describe how I came to write this sample script to demonstrate some of the processes involved in comic-strip storytelling.

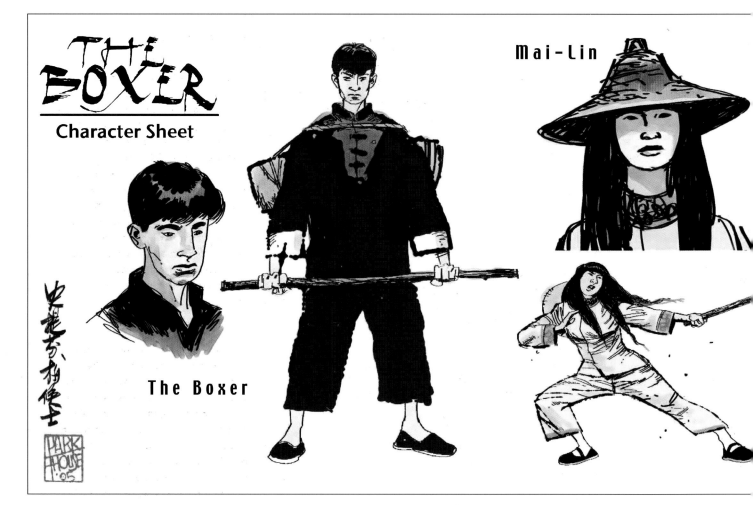

The Boxer

Artist Steve Parkhouse and I created the character The Boxer in the late 1980s. It was originally destined for Marvel Comics' second volume of *Savage Tales* (later cancelled) under the editorship of Larry Hama. I had met Larry before and I knew he was a big martial arts fan, so I shamelessly crafted a kung fu hero who used real kung fu, as opposed to the pastiche of Hong Kong movies. Set in 1899 in mainland China just before the Boxer rebellion, The Boxer was a man of action in a lawless environment – effectively a parallel to the cowboy of the Wild West.

Really short story

My first idea was to have The Boxer fight one of the odd characters I knew inhabited rural China at the time. I wanted to have a 'David and Goliath' fight between The Boxer and a rice paddy overseer on stilts. Often the foremen who supervised the workers in the rice fields would wear stilts so that their feet would not get wet, and I thought it would be a fun situation to have The Boxer fight someone twice his height.

However, with only two pages for the demonstration, the problem was that I did not have enough space to set up why the overseer deserved a pounding and how

The Boxer could leave the village in a better state than he found it. Logically, the owners of the rice paddy would just send nastier overseers and the villagers would be worse off – and that would not have been a satisfying outcome.

Girls in charge

Then I started to think about making the story about The Boxer's blind companion Mai-Lin. I figured most aggressors would not see her as a threat and could receive a rude awakening when they tried to push her

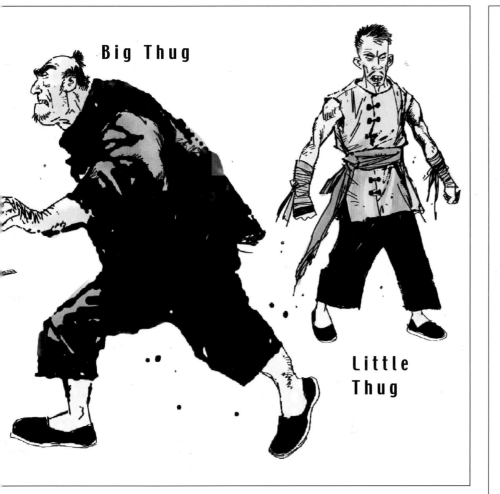

Big Thug

Little
Thug

around or harm her in some way. Next I produced a two-paragraph outline of the story using the Marvel method of plotting – one sentence describing a comic panel, one paragraph describing a comic page – to see if my story idea would fit onto two pages (see panel, right). I thought that it would, so I moved on to writing the full script.

That script is reproduced on pages 74–75, and it should give you a pretty solid idea of how much you need to write in order to give artists enough to work on, but not constrain them so as to stifle their creativity.

The Boxer character sheet

Normally, a character sheet would only be created as a prelude to a new series, as part of the pitching package to convince an editor to commission the work. The sort of thing that would be included are two or three character studies of the main protagonists, full figure and a couple of head shots, along with some character studies of villains or other secondary characters.

STORY OUTLINE

The following outline is the sort of thing I would do to establish in my own mind the pacing and breakdown of the story. For me, it is a prerequisite before I put down the final script on paper. This way, I get to see a 'bird's-eye view' of the story before committing to the longer task of a full script.

Coincidentally, this is also the format a writer would use to outline a story for an artist to follow when using the Marvel method (see page 50). The writer would only add the dialogue when the art comes back from the artist. When writing a full script, the writer completes the dialogue so that the artist can see how much space to leave for speech balloons and captions.

PAGE 1

Nighttime. Mai-Lin sits crosslegged, outside in a courtyard, in the moonlight, enjoying the silence. She hears a noise and it's a couple of thugs come to burgle the house where she and The Boxer are spending the night. The burglars leer at her because she's young and pretty and they don't care that she's blind – in fact, it's a bonus because she won't be able to identify them. She patiently explains that she owes a debt to the owner of the house for letting her spend the night and she's not going to stand for any of their nonsense. One of them lunges for her.

PAGE 2

Mai-Lin, needless to say, makes mincemeat of the thugs, kicking seven colours of hell out of them. They limp away, thoroughly beaten. Next morning, The Boxer emerges and asks Mai-Lin if something happened in the night, as he thought he heard some noises. She smiles and says that there were a couple of animals sniffing around but she chased them off.

PAGE 1

PANEL 1

Nighttime. It's a full moon. High-angle establishing shot of a prosperous-looking house with outbuildings around a courtyard somewhere in rural southern China. In the foreground, an owl perches on a branch. We may be able to see the tiny figure of Mai-Lin sitting crosslegged in the moonlight in the courtyard near one of the outbuildings, but it's not crucial.

Logo: THE BOXER

Title: TO COME

Caption: HUNAN PROVINCE, SPRING 1899…

PANEL 2

Now we're in the courtyard. Mai-Lin sits crosslegged in the moonlight, enjoying the silence. She's serene.

Caption: IT'S A WARM NIGHT AND MAI-LIN, THE BOXER'S BLIND TRAVELLING COMPANION, IS ENJOYING THE SILENCE…

PANEL 3

She hears a noise, and although her head doesn't turn towards the sound, it tilts slightly, like she's looking with her ears – which, of course, she is.

FX: SKLCH

Caption: …WHILE IT LASTS.

PANEL 4

It's a couple of thugs – one big guy, one ratty little man – come to burgle the house where she and The Boxer are spending the night. They're leering at her because she's young and pretty and they don't care that she's blind – in fact, it's a bonus because she won't be able to identify them.

Little Thug: WELL, WELL… THIS IS A MUCH BETTER FIND THAN ANYTHING WE COULD STEAL FROM THE HOUSE.

Big Thug: SHE'S PRETTY, HUANG!

Big Thug: I'M GOING TO ENJOY HER.

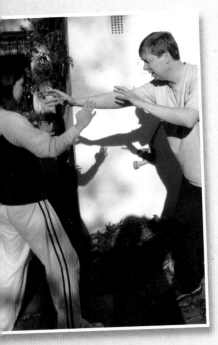

PANEL 5

Mai-Lin stands, but she doesn't look quite at them as she speaks. She holds up a hand as though to stop them from coming any nearer.

Mai-Lin: THE PEOPLE WHO LIVE HERE HAVE BEEN KIND TO US. YOU ANIMALS WILL NOT HARM THEM … OR ME!

Big Thug: AND WHO'S GOING TO STOP US?

PANEL 6

The big guy lunges for her.

Big Thug: A BLIND GIRL?

PAGE 2

PANEL 1

Small panel. Not one to let an attack go unchallenged, Mai-Lin blocks the big guy's one-handed grab (see photo ref supplied).

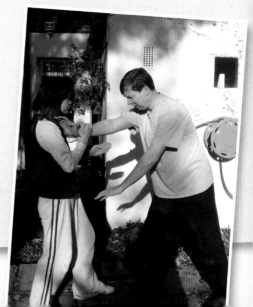

Full script

This script is in exactly the format I would use for any professional scripting assignment. I try to make sure that the panel descriptions are something the artist can understand quickly and easily. Normally I would include my contact details on the first page of the script so that an artist is able to contact me if he or she needs to query some story point outside the publisher's office hours. You can find the artist's thumbnails for this script on page 54 and the final artwork on pages 120–121.

| Big Thug: | HEY… |
| FX: | THWPP! |

PANEL 2

Small panel. Mai-Lin swivels on her heel and brings up her elbow to contact the underside of the big guy's extended arm (see photo ref supplied). The big guy's elbow is bending the wrong way as Mai-Lin dislocates his joint. He is in real agony. (Steve: Remember we want to get across that kung fu is not a game, it's nasty and has real consequences.)

| Big Thug: | …EEEIIH! |
| FX: | CRAK |

PANEL 3

Mai-Lin stands back, ready for another attack. The big guy's on his knees, nursing his shattered elbow joint. Tears of pain are on his face. The little guy is stepping forward to attack, pulling a knife from behind his back.

| Little Thug: | GIRL, I'M GOING TO MAKE YOU VERY SORRY. |

PANEL 4

As the little guy steps forward, Mai-Lin kicks low to the little guy's knee (see photo ref supplied). He's buckling under the attack, his knee, dislocated, bending outward at an unnatural angle.

| FX: | WAK |

PANEL 5

Mai-Lin stands over the two thugs, who are both on the floor. She points, indicating the direction they should take when they leave.

| Mai-Lin: | NOW GET OUT OF HERE, AND BE THANKFUL YOU RAN INTO ME INSTEAD OF MY SI-HING*. |
| Footbox: | *Literally 'Elder Brother', but refers to one's senior in martial arts terms. |

PANEL 6

Mai-Lin listens as the two thugs limp away, the big guy supporting the little guy with his remaining good arm.

| Big Thug: | SHE HURT MY ARM, HUANG… |
| Little Thug: | JUST SHUT YOUR STUPID MOUTH. |

PANEL 7

Next morning, Mai-Lin is cooking something in a pot over a small fire. The Boxer emerges from the outbuilding where he's been sleeping and asks Mai-Lin if something happened in the night, as he thought he heard some noises.

Boxer:	GOOD MORNING, SI-MUI*. DID THOSE NOISES IN THE NIGHT DISTURB YOU?
Mai-Lin:	NOT AT ALL, SI-HING. I WASN'T SLEEPING ANYWAY…
Footbox:	*'Younger Sister'.

PANEL 8

Close head shot of Mai-Lin as she smiles, her blank eyes slightly disconcerting.

| Mai-Lin: | IT WAS JUST A COUPLE OF ANIMALS SCAVENGING – BUT I CHASED THEM OFF. |
| Footbox: | The End |

Chapter 4
Drawing the Story

Once you have plotted, broken down
and scripted your story, it is time to
sharpen the pencils and get drawing.
The pencilling, along with the scripting,
are considered by many to be the
most creative parts of comic
storytelling, but it should never
be forgotten that comics are
essentially a collaborative medium.

pencilling

Pencilling is the part of the process in which most of the real drawing is done. How much or how little of the pencil drawing you complete depends on whether or not you plan to ink the pencil marks yourself.

Dramatic pencilling

The artist has pencilled the figures in a dramatic, realistic style. Note how the blacks are fully filled in. This is usually only done if a different artist will be inking the artwork. When pencillers intend to ink their own work, they simply indicate the areas of solid black with a small 'x'.

Cartoon pencilling

Cartoon-style artwork generally tends to be more simplistic than realistic art, with cleaner and more defined outlines. It is more common for pencillers of humorous or cartoon art to ink their own work.

The foundation of comic art

These days it is commonplace for the artwork to be prepared using a division of labour between two or more artists. In some instances, a strip might be laid out by one artist, pencilled by a second and inked by a third, with a fourth collaborator – the letterer – adding the words. In addition, more than one artist might be involved at each of these stages.

Consider the inker If the penciller and the inker are to be the same person, the pencil work can be little more than an indication, or rough sketch, for the inks. However, if the work is to be inked by a separate artist, the pencil work will need to be 'tight' – that is, it needs to be a finished drawing, perfectly

legible, with nothing additional required: it has to be drawn so that the inking artist can see exactly where he or she should put the ink lines. So, no turning your pencil on its side and blocking in areas of grey in varying tones. In fact, well-known artist Gene Colan *does* pencil like this, but his work looks good only when he gets a talented inker who can bring his or her own artistry to the work – and, of course, Colan has been in the business for years and gets away with habits that would not be tolerated in a newcomer. Apart from anything else, editors like to be able to look at a page of pencilled art and have a good idea of what the finished inks are going to look like. It never hurts to spell things out for

everyone down the chain, from editors to inkers to letterers.

Develop an original style The penciller is *the* key person in the art team. Only those pencil artists with the most dynamic and original drawing styles stay around long enough to become famous. Jack Kirby, co-creator of such comic megastars as *Captain America* and *The Fantastic Four*, comes at the top of the list. Top men like classic *Superman* artist the late Curt Swann, and John Buscema, who drew the definitive 1970s and 1980s versions of Marvel's *Conan*, *Silver Surfer* and *The Avengers*, come a respectable second. These top names turn in pencil art that is immediately legible to editors and inkers,

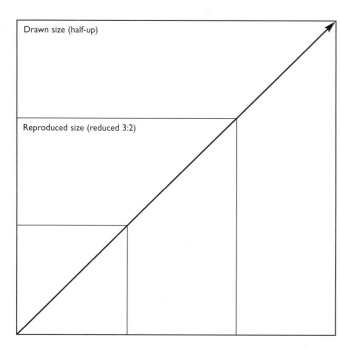

Drawn size (half-up)

Reproduced size (reduced 3:2)

Sizing your artwork correctly

A quick and easy way to ensure that your drawing will scale down in proportion to the required printing size is to use the diagonal line method. If all the corners fall on the diagonal line, everything is correct.

and their own art techniques shine through. There is no way an inker, no matter how strong a style he or she has, can overwhelm the highly stylized pencil art of, say, Jack Kirby.

Tempting as it might be to a beginner to raid the technique of one of the 'greats' in the hope that some of the greatness might rub off, it is not an advisable practice. It is a bit like cheating at solitaire: you will probably get away with it, but in the end who are you fooling? Far better to try to develop an original style of your own.

Bleed, trim and type

The type area is the area of the printed page covered by the artwork, often with a margin of space around it to avoid anything being lost when the pages are trimmed. Imagery that is to bleed off the edges of the page must extend beyond the page limit by a specified amount. This is to allow for slight inaccuracies in the positioning of the guillotine when trimming the page.

TIP KEEP IT CLEAN

The best artists try to make sure that the pencil artwork they hand in for inking is clean and free from smudges, fingerprints, coffee stains and so on. One of the best ways to end up with clean pencil art – short of wearing surgical gloves – is to start at the top left of the page (assuming you are right-handed) and draw from left to right, down the page. It can help to place a small square of paper – say, 15 x 15cm (6 x 6in) – beneath the heel of your drawing hand.

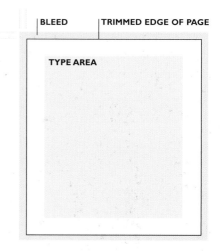

BLEED **TRIMMED EDGE OF PAGE**

TYPE AREA

SIZE AND BLEED

The first responsibility pencil artists have is to make sure they are drawing their artwork to the correct size. Most comic-strip artwork is drawn 'half-up' – that is, 50 per cent larger than it will appear in print. The terminology is somewhat confusing, because the 50 per cent referred to applies to the lengths of the sides of the board or paper. In fact, half-up artwork has about *twice* the area of the printed result. If you are submitting samples to a publisher, simply measure the material that the publisher is already producing and multiply the dimensions by 1.5.

In recent years, due to the change from the old letterpress style of printing to the newer litho printing, publishers have started to print comics with 'bleed'. This is where the artwork 'bleeds' off the edge of the page or into the spine. The art board supplied by the companies is always marked up to show the bleed limit – where artwork should be drawn to – as well as the trim limit – where the guillotine will trim the comics after printing.

what to draw

What you draw is sometimes less important than what you leave out. The fact is that comic-strip art is a kind of visual shorthand. The best kind of comic-strip artwork is not a photographic representation of reality, but a kind of schematic, or diagram.

You can draw too much

During the 1970s, there was a vogue among many of the younger artists whereby they cluttered up their artwork with as much extraneous detail as they could muster. They seemed to think that the more detailed the drawing, the closer to reality it is. This is a mistake made by many young and inexperienced artists.

In fact, the average person has a great deal of trouble absorbing visual detail, as any police officer who has tried to get descriptions of criminals from eye-witnesses will tell you. Most people will, at best, note that a drawing has a lot of detail, but will stop short of analyzing and absorbing the detail. Moreover, too much visual detail, just as when a comic strip is

overloaded with words, slows the reading pace right down so that the story drags.

Focusing the reader One way an artist can focus the reader more firmly on the characters – perhaps to make an emotional impact or some other important point – is to ensure that there is no background detail to distract the attention. Thus it is perfectly

Dramatic emphasis

In this marvellous action page from 'Bad Girl' comic *Dawn*, Joseph Linsner chooses the most telling moment of the battle as his centrepiece and places the other panels around it. There is no mistaking where the reader will look first as they turn over to this page. Emphasizing the importance of the central frame, Linsner has kept background detail to a fuzzy minimum, so that the reader will not be distracted from the main and all-important battle image.

It's a frame-up

The classic stand-off can be treated in a number of ways. The framing of an event like this is crucial to its effectiveness, as the artist wants to convey the maximum emotional impact, getting the reader to care just as much as the police officers about whether the kid gets it.

✗ This shot is too far away. Sure, we can see the police officers, guns at the ready, though helpless. However, we cannot see the fear on the gunman's face. It's his nervousness that makes him unstable, and the reader needs to be shown that.

Framing the panel

acceptable for an artist to leave out background details from an occasional panel and merely draw the characters against a white background – *provided* the background details have been established in an earlier panel. The readers are left to fill in the necessary backdrop using their own imagination, with the establishing panel as a reference.

Another way to lead the reader through your story is to take care over how the panels are framed. Just as a movie director can choose between long-shot, mid-shot and close-up, so can a comic-strip artist. It therefore makes sense to consider how best to frame each shot based on its relative importance within the story – for example, important moments should be larger, perhaps even a full page. The artist can also use the framing to draw the reader's attention to a story detail that perhaps the hero does not see – for instance, the villain might be reaching for a concealed weapon, unknown to the hero, and by bringing it to the reader's attention, an artist can crank up the tension to breaking point.

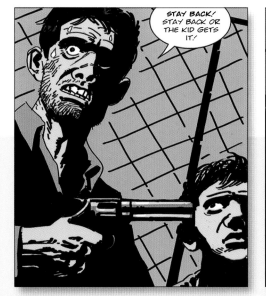

 This shot is perfect: close enough to see the gunman's expression the menacing shape of the gun and the boy's wide-eyed fear. That we cannot see the police is less important and, no doubt, their presence would have been established in an earlier panel.

✗ This panel is too much of a close-up. Two vital elements are missing: the expression on the gunman's face and a clear view of the gun held to the kid's head. Without these, the drama is greatly diminished, and we have a less effective scene.

LESS IS MORE

Joe Kubert is well known for producing excellent artwork that tells the readers everything they need to know to enjoy the story – no more, no less. 'When I draw *Tarzan*,' he said in an interview a few years ago, 'I want to generate the same kind of excitement in my readers as the strip did in me when was a kid. I tried to analyze the elements in the old *Tarzan* strips by Hal Foster to find out what it was that had this effect on me. I decided it was a matter of simplification and directness. By eliminating all extraneous artwork and riveting into what was the most dramatic part of that particular panel, I got what I felt would actually hold the reader from panel to panel. In addition, I tried to get the drawing construction as fundamentally sound as possible, so that the characters would appear absolutely real. The composition of the page is of lesser importance to me than the planning of dramatics and continuity.'

the characters

When it comes to designing characters, the most valuable tools comic artists have are their powers of observation. As with writers, artists can find the best and most interesting fictional characters in the world around them: relatives, neighbours and even pets.

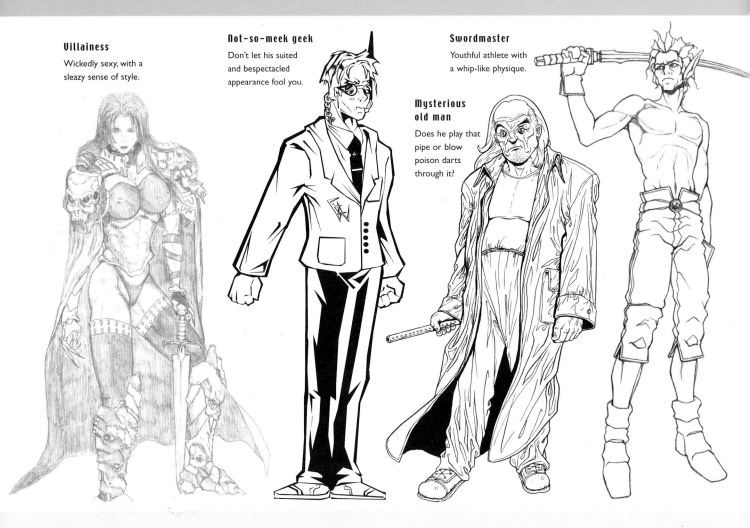

Villainess
Wickedly sexy, with a sleazy sense of style.

Not-so-meek geek
Don't let his suited and bespectacled appearance fool you.

Swordmaster
Youthful athlete with a whip-like physique.

Mysterious old man
Does he play that pipe or blow poison darts through it?

Developing characters

The concept of presenting readers with characters who appear to be 'real people' is one of the most challenging aspects of creating comic strips. In real life, it is almost impossible to get to know every facet of another person's character, regardless of how intimately you may know them. It is even harder for a writer to give readers a genuine insight into characters in a novel, despite there being virtually unlimited space. Think, then, how much harder the same task is for the comic-strip creator.

Elements of character Comics are a medium of action rather than words, and it has been said that you can get a better understanding of a character's personality by paying attention to their actions rather than to their words. However, comics have limited space and even the most sophisticated comics have to content themselves with two-dimensional characters. Indeed, some of the most successful comics characters can be summed up with two fundamental characteristics each. For example:
- Spider-Man – An arachnid-powered youth with an ailing aunt.

- Batman – Athletic detective who fights an obsessive war on crime.
- Captain Marvel – A small boy who, with a magic word, turns into a costumed hero.
The rule to remember when trying to create believable personalities is that *characters display characteristics* – bad temper, jealousy, dishonesty, sense of humour and so on. It is possible – even common – to have two characteristics in one person that seem to contradict each other. For example, a character can display a sense of humour or no sense of humour at all at different times, or over different matters.

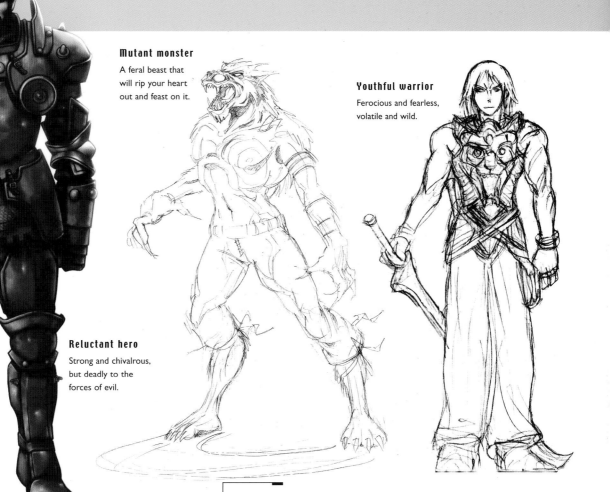

Mutant monster
A feral beast that will rip your heart out and feast on it.

Youthful warrior
Ferocious and fearless, volatile and wild.

Reluctant hero
Strong and chivalrous, but deadly to the forces of evil.

TIP ANALYZE YOURSELF

To determine the various characteristics that make up a personality, try to analyze the personality of someone you know well or, even better, yourself. However, avoid the temptation to make every character you create an idealized version of yourself. This is self-indulgent, boring for the reader and will not make people you know like you better…

IT'S IN THE SCRIPT

If the artist is working from a script by a separate writer, he or she should find some clues there. For example, one way in which the writer could help the artist is to describe the characters in terms of known personalities. Thus, it is helpful to pigeonhole a character by referring to her as a 'Marilyn Monroe type' or a 'Ruth Gordon type', provided both writer and artist add something extra to these descriptions.

However, no script can ever convey a complete picture of the characters to the artist, and this is where the artist's imagination comes into play – because characters are so much more than mere physical attributes. A character is more clearly identified by his or her personality traits. How do we judge a person's personality? By what they say and do. Fortunately for the artist, what a character says is provided by the scriptwriter. Yet the artist can put flesh on the verbal bones by making sure the characters' actions complement their words – or, in some cases, contradict their words.

sample character design

Here, three artists have designed a character known as Spring Heel'd Jack, based on actual 19th-century accounts of a man with a hideous face and glowing eyes who could leap huge distances. Wearing a long cloak and tall hat, he was reported to have steel claws and breathe noxious blue fire into his victims' faces.

A close-up of Jack's face, revealing jagged teeth and glowing eyes – a scary face to meet on a dark night.

Demon in hiding

'Jack's natural animal-like posture betrays his demonic origins, but he tries hard to appear as a human being, assuming a more upright stance when he stalks the streets at night and covering his claws and legs with a long cloak. When stripped of his cloak, strange bone-like feathers can be seen on his legs, and it is hard to tell if his claws are part of his body or artificial extensions of very, very small hands hidden inside evil-looking leather gloves.' Simon Valderrama

Keeping Jack's coat in black shade helps to emphasize the tendrils of noxious blue fire spewing from his mouth.

The artist's concept for the character is already evident in this initial sketch, with the main part of Jack's figure in shadow to emphasize his glowing eyes and steel claws.

Deranged automaton

'I thought it would be more effective as a threatening image to focus on the basic shape rather than specific detail. On the premise that the unknown is scarier than the known, the main part of Jack's figure should always be in shadow – emphasizing his eyes and his claws – and thereby (hopefully) evoking the primal fear of the predator. Jack seems to be a typical Victorian creation – a godsend for the tabloids of the day. The mechanistics of his weaponry reflect an age of iron and steam. Underneath his cape he is probably riveted together. I distinctly saw him as part-automaton, like an early Terminator.' Steve Parkhouse

Jack has a gorilla-like appearance when seen from the front – but not as attractive.

Jack's hair is a wig that he uses to hide his demonic nature, giving the illusion that he is human.

Side view of a cloakless Jack. His posture is animalistic and strange things sprout from between his trousers and boots.

The initial head sketches were not scary enough – too Phantom of the Opera.

Jack's cloak has holes for arms, but he cannot use them because they would reveal his claws and abnormally long arms. The lower part of the cloak is an extension to hide his strange legs.

Pointed ears, sharp teeth and jutting chin produce a more effective demonic appearance.

Making Jack a satyr character with a goat's hind legs gives him the muscle power to make giant leaps.

The traditional Victorian costume does little to disguise Jack's demonic origins.

Profane satyr

'I started by doodling a couple of demonic-type faces to get into it. The first one didn't really look that scary; the second one was a bit more like it. When it came to the full-figure shot, the goat-type legs helped a lot in making him look more demonic. I also got rid of his nose to make him look less human. I drew the rough in a sketch book; as usual, it got quite messy. I scanned it into the computer, converted it to a light blue and then printed it out on good-quality board. I did a little bit of tidying up, inked it, then scanned it back into Photoshop and coloured it.' Dylan Teague

facial expressions and body language

The faces that characters pull and the postures their bodies assume are absolutely vital in conveying what they are thinking. In real life, the average person tells everyone what they are thinking whenever they move the muscles of their face.

Exaggerated body language

Glen Hanson and Allan Neuwirth's strip *Chelsea Boys* uses exaggerated body language for comic effect. The different physical types and the way that each character moves with slightly different body language ensures that no character can be mistaken for another.

Close-up

Shanth Enjeti's art for *Springball* makes good use of facial expressions. The slightly cartoony art captures the subtleties of the human face with surprising effectiveness.

The right expression

The challenge for the comic-strip artist is that the human face is the most familiar object of all. We look at human faces more than we look at anything else. We know intuitively the meaning of every expression a face can make, and just as you cannot be fooled by real-life facial expressions that are not quite right, nor can the readers of any comic you might draw. Similarly, we all recognize the arm gestures used to communicate such emotions as grief and mirth.

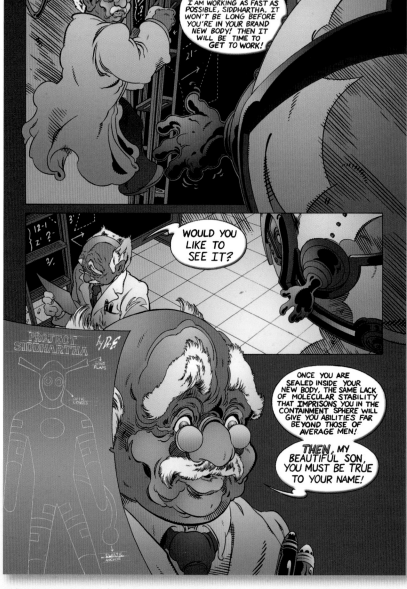

It is therefore absolutely vital that a comics artist can create the correct expressions called for by the script. Sometimes in comics a character's speech can be ambiguous, because dialogue is of necessity rather clipped, and this is where an artist's grasp of body language becomes an invaluable part of the storytelling process. In extreme cases, a comic-strip story can be told relying entirely on body language and facial expression, without resorting to dialogue of any kind.

Emphasizing the human

This page from *Springball* by Shanth Enjeti is essentially
built around the two big close-ups of Sally at the centre
of the page. Enjeti uses a big emotional moment as the
page's centrepiece and frames it with the build-up and
the pay-off.

**TIP THE ART
OF OBSERVATION**

Some people can show facial expressions
and postures that have nothing whatever
to do with what they are thinking. Usually,
such people are called liars – although the
smart ones go legitimate and become
actors. Why not make use of them by
watching television with a sketch pad and
a pencil handy. It is even better if you have
access to a video or DVD player. You can
sit down with some of the greatest actors
in the world to study, frame by frame, and
sketch some of the postures they have
adopted and the faces they have pulled.
Alternatively, you may find photographs
from magazines and newspapers of some
use, but your scope will probably be
limited by the narrow range of expressions
found there. One of the best reference
works on the subject of body language and
facial expressions is Desmond Morris's
Manwatching. Although you may find the
text a little difficult, the pictures are an
absolute treasure trove of human
nonverbal communication.

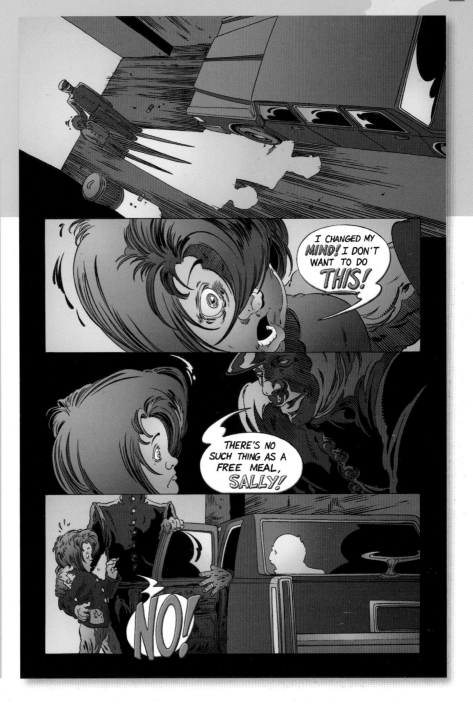

TO EXAGGERATE OR NOT

There are lots of ways an artist can
learn about facial expressions. One
way is to sit in front of a mirror
and pull faces. The only drawback
here is that people who are
inexperienced in the craft of acting
tend to go over the top. This can
result in exaggerated expressions,
or 'mugging' – fine if you are
drawing gag strips, but characters
overacting in straight adventure
stories can be irritating, not just

for the readers but also for the
scriptwriters, who end up having
ham actors rather than characters
in their stories.

For example, in an adventure
strip the story elements should be
drawn in a naturalistic way. An
artist must be able to distinguish
between 'mild surprise' and
'shock-horror', and successfully
convey that difference to the
audience. On the other hand,

in the context of a humour strip,
exaggeration is quite permissible,
and probably desirable:
considerable comedic effect can
be gained from having characters
over- or under-react. However,
this requires no less sensitivity
on the part of the artist than
the naturalistic adventure strip.
A humour artist needs to know
exactly how to convey a natural
reaction before he or she can

exaggerate or underplay it.
In other words, the best humour
artists must already have mastered
the naturalistic techniques
of storytelling, so that their
distortions of reality for humorous
effect are believable.

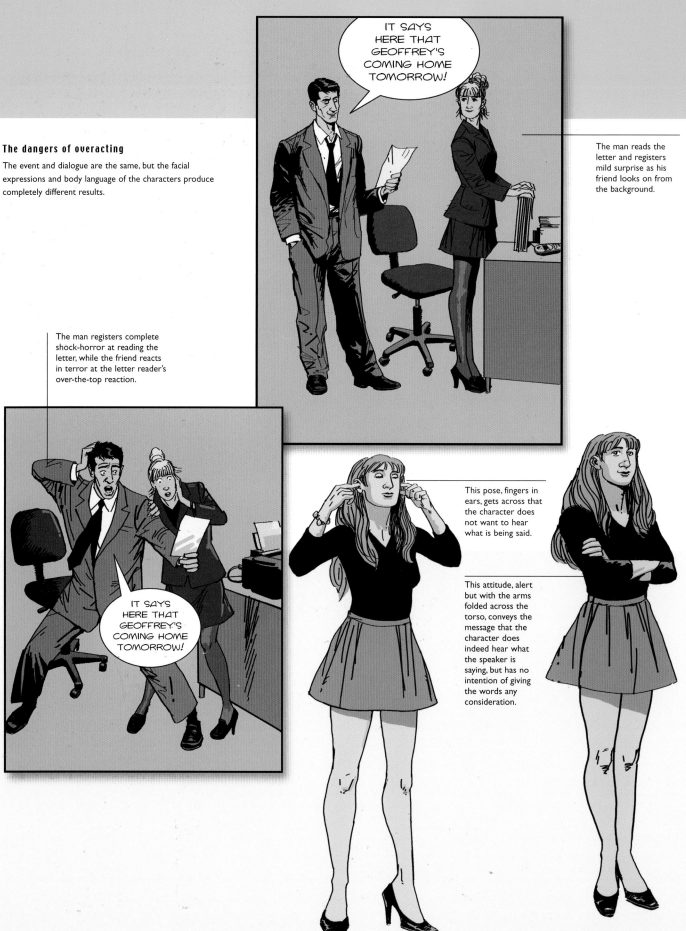

IT SAYS HERE THAT GEOFFREY'S COMING HOME TOMORROW!

The man reads the letter and registers mild surprise as his friend looks on from the background.

The dangers of overacting

The event and dialogue are the same, but the facial expressions and body language of the characters produce completely different results.

The man registers complete shock-horror at reading the letter, while the friend reacts in terror at the letter reader's over-the-top reaction.

IT SAYS HERE THAT GEOFFREY'S COMING HOME TOMORROW!

This pose, fingers in ears, gets across that the character does not want to hear what is being said.

This attitude, alert but with the arms folded across the torso, conveys the message that the character does indeed hear what the speaker is saying, but has no intention of giving the words any consideration.

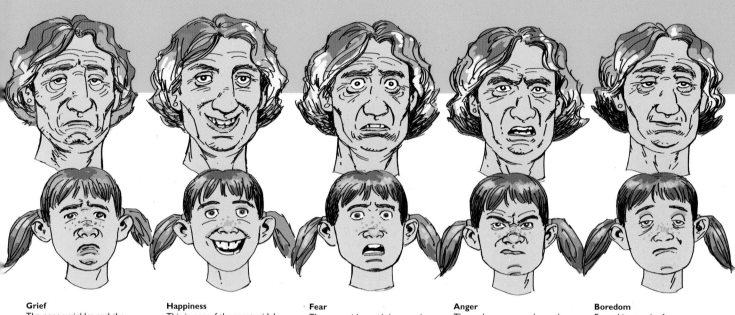

Grief
The nose wrinkles and the bottom lip trembles a little.

Happiness
This is one of the most widely recognized emotions, regardless of culture.

Fear
The eyes widen and the mouth opens, ready for a sharp intake of breath.

Anger
The eyebrows come down, the mouth compresses into a thin line and the nostrils may flare.

Boredom
Everything on the face droops – eyelids, eyebrows, corners of the mouth.

Different characters, same emotions

No matter what the character's physical appearance, the common facial expressions associated with the main human emotions do not vary much. Above, two very different characters express the same five emotions. Generally, younger characters tend to be less guarded about how they express their emotions.

Although this attitude appears to be attentive and open, the subtle placing of the right arm across the torso indicates that this character wants the speaker to believe she is listening with an open mind, but there is that telltale closing off of the character from the speaker's words.

This gesture, literally pushing away the speaker's words with the palms of the hands, is saying openly that this character is not interested in what the speaker has to say.

'I hear what you're saying'

By using different body language, an artist can reinforce or refute the words a character is uttering.

props

The word prop is an old theatrical expression, used also in films and television, that is short for properties: it means any inanimate object that might be required by the characters in a story in order to advance the plot. For our purposes, it means any object other than a character.

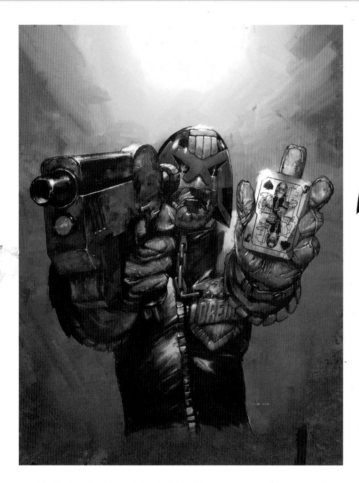

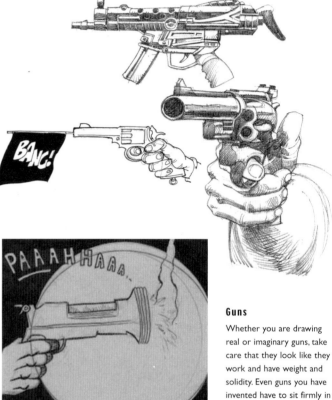

Guns

Whether you are drawing real or imaginary guns, take care that they look like they work and have weight and solidity. Even guns you have invented have to sit firmly in the characters' hands and look like they were designed for practical use.

Everyday objects

The way in which an artist draws the inanimate objects in a comic strip goes a long way towards establishing in readers' minds exactly what the function of each object is. For example, an automobile can be drawn in several different ways. If drawn from a low angle, rushing towards the reader, with headlamps blazing, it can be made to seem very sinister and menacing. However, if the same car is drawn standing still, facing away from the reader with one of its rear doors open, it appears to offer an escape from danger. In brief, great consideration should be given to what the story demands the *function* of a prop to be, after which the artist should do his or her best to

convey that function in the way they draw the prop.

The trick when it comes to drawing objects is to use the best reference material you can get your hands on. If you simply make up an automobile out of your head, it will look just like, well, an automobile you have made up in your head. Grab a glossy magazine and leaf through the motor ads. Find a car that suits your purpose and look at how the light reflects from its paintwork. If you take this kind of detail into account, you will end up drawing a car that the reader can recognize as the kind of car they have seen before – and they will accept it as part of the world you are creating for them.

It cannot be stressed enough that the props used by the characters in your comic strips have to be as convincing as the characters using them. Even the most seasoned professionals have been known to skimp on doing their research when a deadline pressed. Do not fall into that trap.

Cars

Drawing cars convincingly is where many artists fall down. Readers are likely to be very familiar with what cars look like, so you better make sure you use good reference.

TIP SNAP IT

As well as assembling a file of images clipped from magazines and newspapers, consider photographing a variety of objects yourself. Digital cameras are getting cheaper all the time, and you would only need an entry level camera for taking reference pictures.

A cheap digital camera is ideal for taking quick reference shots.

COMPILING THE RIGHT REFERENCE

Sometimes it is possible that an artist's idiosyncratic style can compensate for his or her shortcomings as a draughtsperson. Nevertheless, a reader is always more drawn into a story when the artwork is not full of glaring inaccuracies. In order that they always have references to hand, many artists keep picture 'morgues' – files of pictures from newspapers and magazines of everyday objects and locations.

It is simply not possible for an individual to memorize the exact shape of every conceivable object he or she might have to draw,

so most comic artists build comprehensive files, containing all sorts of photographs and artwork, which they maintain in some sort of logical order so that they can find the necessary references with the minimum of time-wasting.

Whether or not you think it is cheating to use photographs is a matter only you can decide, but

you should keep in mind that time is money, and anything that saves time has obvious advantages.

Build up files of photos and artwork to use as reference for drawing props.

backgrounds and composition

Making sure the background is accurate and convincing will go a long way to pulling your readers into the story and suspending their disbelief, and the way in which a character or object is framed within the panel is of vital importance to a reader's perception of the story.

A highly detailed opening panel establishes the time and place for the whole story.

The Disney-like opening background sets the mood for the story.

Setting the mood

In this classic page from *The Journal of Luke Kirby*, artist John Ridgway has lovingly crafted a startlingly Disney-like vista of the countryside as a backdrop to Luke's journey to meet his mentor Zeke.

Establishing time and place

In this early episode of *The Journal of Luke Kirby*, scripted by Alan McKenzie and drawn by John Ridgway, the artist provides a wealth of background detail in the opening panel so that the reader has an immediate sense of time and place.

What's that behind you?

How well you capture the background behind your characters will dictate how well you communicate a sense of setting to your readers. One of the first tasks in starting a story is to determine where and when the story is taking place. This is conveyed to the reader by using the old movie standby of an establishing shot. So whether the story you are drawing takes place on a space station in the year 3020 or on a battlefield during the Napoleonic wars in 1812, the reader should automatically have a sense of where they are and which era the story is set in.

Minimalist or detailed One of the masters of conveying a sense of setting without lavishing hours of work on his backgrounds was Carmine Infantino during his seminal run on DC Comics' *The Flash* in the 1960s. Infantino was able to suggest weird environments with just a few lines, carrying his readers away to remote worlds with his remarkable evocation of alien landscapes. Indeed, the whole DC Comics house style of the 1960s seemed to demand clean, uncluttered art with little crosshatching and strong, simple figure work. However, the rise of Marvel Comics artists like Jack Kirby and Steve Ditko, with their powerful, dynamic figures and complex machinery and environments, turned the tide away from the clean and the simple, and offered darker, more detailed art in keeping with their darker and more detailed stories.

Minimalist background

In this Judge Dredd story, scripted by Alan McKenzie and drawn by Anthony Williams, the artist has drawn minimal background detail. To highlight the threatening stature of Dredd in the fourth panel, the artist has omitted the background altogether.

The omission of background detail from this panel is in stark contrast to the others, helping to emphasize the importance of the scene.

Detailed background

In this page of *The Journal of Luke Kirby*, artist Steve Parkhouse has provided comprehensive backgrounds for each panel, but tellingly left out background detail from the fifth panel for dramatic effect.

Omitting the background in this panel – in an already minimalist strip – emphasizes Dredd's stature.

TIP DON'T TAKE A TRIP

Just as you should compile a reference file of images of different props, you should also gather a variety of location shots. If called upon to draw a New York city street, an artist living in Edinburgh can save the cost of a plane ticket – or even of a trip to the library – by having his or her own clippings file.

Composition

The way in which a character or object is framed within the panel is of vital importance to a reader's perception of the story. This is not a question of close-ups or long shots, but of where in the panel each of the elements of the scene is positioned. In panels where there is only one element required, it is normal practice to place that element at the centre of the panel. However, panels containing only one element lack drama and should be used only when the artist is trying to focus the reader on that element for a reason.

Things start to get a little more complicated when the artist is called upon to frame more than one element in a panel.

In this respect, the panel becomes an individual picture, with drama and dynamics all of its own. The traditional concepts of picture composition apply just as much to a comic panel as to an oil painting, an individual shot in a movie or TV show, or a photograph.

Many books have been written on composition, but none of them is of much use to the aspiring comic-strip artist except in the most general terms. This is because, in comics, a panel should not be composed to be a separate and complete unit of art, like an oil painting; rather, it should lead the reader's eye on to the next panel. How this can be achieved is best conveyed by looking at examples rather than description.

inking

Inking refers to the act of going over the pencil lines on the page with black Indian ink, a vital step if the artwork is to reproduce properly when placed under the printer's camera.

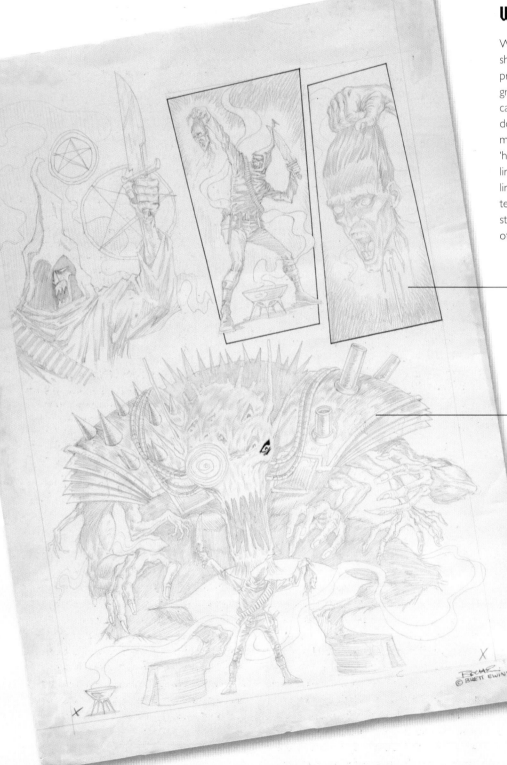

Why we ink

With a pencil, an artist can render images in shades of grey, but with the cheap printing processes formerly used for comics, these greys did not register under the printer's camera. So, in inking, an artist must break down the greys into blacks, whites, or mixtures of the two, the latter achieved by 'hatching' or 'feathering' (close-set parallel lines of black ink) or 'crosshatching' (crisscross lines of black ink). In this way, artists can add textures to their work, determine the lighting styles and control the overall dramatic effect of the comic story.

The penciller has indicated that these two panels should have borders. Although the inker is free to ignore this advice, panel borders make sense on this page as it already has two vignettes.

This image has huge impact and has been drawn as a vignette with minimal background. Again, the inker could add a panel border and background, but why bother when the drawing works brilliantly as it is?

It's in the pencils

This page of pencil art was drawn by top *2000AD* and *Deadline* artist Brett Ewins. During his stint as editor of *Deadline* magazine, Brett used this piece to test the inking abilities of young hopeful artists. As it is intended to be inked by a separate artist, Brett took care to indicate the blacks fully and provide hints about how the shading should be applied.

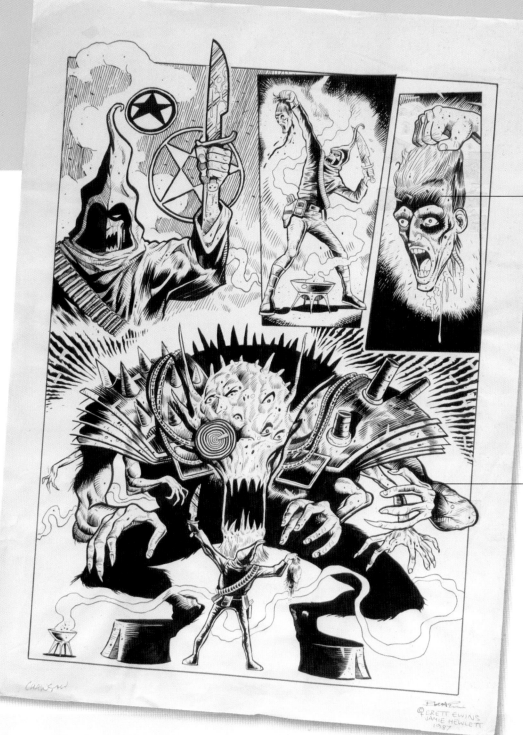

The inker has added some texturing here to help the two vignettes fit together, yet at the same time remain two separate panels.

One decision the inker made for himself was to black in the monster's legs. This has the effect of moving them farther into the background and highlighting the small figure of the magician at the bottom of the page.

Secrets of the inkers

Here, the page has been inked by then newcomer Jamie Hewlett who went on to enjoy a glittering career with *Deadline*, *2000AD* and DC Comics. Even this early in his career, you can see that Jamie instinctively applied the correct weight of black ink to the page.

The art of inking

There is a running gag in the Kevin Smith movie *Chasing Amy* where the inker of the *Bluntman and Chronic Comic*, played by Jason Lee, is constantly infuriated that everyone refers to the art of inking as 'tracing'. Nothing, of course, could be farther from the truth. Even if they are 'merely' inking someone else's pencil art, inkers must be accomplished artists in their own right. A talented inker can bring quality to a mediocre pencil job, just as a poor inker can destroy the artwork of a top-class pencil artist.

The best artists, of course, are able to wield pencils and inks with equal ease. There are a few artists who have earned reputations for being equally adept at either inking others' pencil art or providing pencil art for a separate inker; Sal Buscema and Joe Staten are two such artists. For the most part, comic-book artists specialize in one or the other – although there are a few who habitually ink their own pencils, like pioneer *Spider-Man* artist Steve Ditko, and in British and European comic books the trend is for artists to pencil

and ink their own work. In newspaper strips, however, it varies from artist to artist as to whether they employ assistants or not. Certainly, novices in the newspaper-strip business have to pencil and ink their artwork. Thus it pays to be able to handle both pencil and ink to a professional standard, no matter where in the comics business you intend to earn your living.

making your mark

There is no 'correct' way to ink over pencil art. Every artist has his or her own technique – and usually swears that it is the best. If you are just starting out, you should try as many different techniques as you can, and do not feel you have to settle for just one.

Brushing aside

Traditionally, the commonest inking tool has been the sable brush, usually something between a 0 and a 3. Winsor & Newton seems to be the most popular brand of brush, much to the surprise of some professional artists. Harvey Kurtzman, the creator of *Mad*'s and *Playboy*'s Little Annie Fanny, once said, 'I'm constantly amazed and perplexed at the dominance of Winsor & Newton sable brushes. Something has got to be done! How long is this monopoly going to go on? But they're the only ones that work.'

The fact is that inking with a brush has become popular because a brush holds more ink (which means you dip less often) than the types of dip pens used for inking artwork. Also, a brush gives a more varied line.

Fine airbrush

Coarse airbrush

Dry brush

Watercolour wash

The famous Winsor & Newton brushes come in various sizes. Inkers often use a size 0 or 00 for fine linework, such as feathering and hatching, and a larger brush, like a 3, to fill in areas of black.

TIP WASH YOUR BRUSHES

It is vital to keep brushes clean if you are to preserve them for any length of time. During use, wipe the ferrule clean of ink with paper towels. When you have finished with the brush, wash the bristles thoroughly with warm water and soap.

BRUSH RULING

If you prefer to ink with a brush and you have to draw straight lines within the panel as part of the artwork, you should learn to draw straight lines with your brush using a ruler. It is a tricky technique to master, but straight lines drawn with a brush look far less mechanical than those put down with a pen, and they blend into the artwork better.

1 Tuck the fingers of your left hand (assuming you are right-handed) under the drawing edge of the ruler, so that the ruler makes an angle of about 45 degrees with the paper.

2 Holding the brush between your thumb and forefinger, and using the first knuckle joint of your third finger as a support against the top surface of the ruler, draw the ferrule of the brush along the raised straight edge of the ruler.

3 Vary the thickness of the line by increasing or decreasing the pressure of the brush on the paper.

1

2

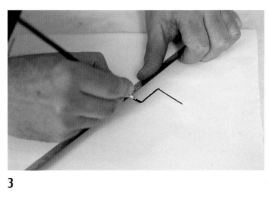

3

Pick a pen

The best way to choose a pen is to try out the different marks you can make with them. It will then come down to a matter of personal preference.

Dip pens Far more popular in the days before digital art, dip pens take some degree of control to wield effectively. Aside from the fact they have to be dipped in ink every few strokes, the work that goes into finding the perfect nib can be exasperating for some artists.

Felt-tipped pens Some artists ink with felt-tipped pens. Neal Adams, the top comic-book artist of the 1970s and also a successful advertising artist, uses a Pentel for preference. 'I came round to using a Pentel after a lot of experimentation,' said Adams in an interview. 'I found it helps me in storytelling. It briefens the technical difficulties. The idea of having to keep the pen clean, the brush pointed, or getting angry when my brush is splitting hairs and other problems that keep holding me back don't happen with a Pentel.'

Markers Artists who use markers for inking include Alex Toth and Gil Kane, probably two of the best artists in the business. Both

Calligraphy pen

Stippling

Crosshatching

Felt-tipped pen

Fine-point hatching

RULING PANEL BORDERS

For ruling panel borders, it is probably best to use a pen. A technical pen is ideal for this, though there is a danger that ink may 'bleed' because of capillary action between the ruler and the board. In other words, ink can be sucked into the microscopic space between the ruler and the board due to what is called surface tension. The best way to avoid this is to increase the gap between the ruler and the board. Many rulers are manufactured with a bevelled edge, so that you can simply use them upside-down to prevent ink bleed.

1 Draw the lines of the border, using the ruler as a guide to keep them straight. Extend the lines slightly beyond the edges of the panel.

2 Paint out the excess lines with process white.

3 The result will be perfectly sharp corners.

1

2

3

TIP DON'T MESS UP

The big problem you get with marker pens is that, if you make a mistake, you cannot cover it up with process white, because the ink from such pens bleeds through. You can use patch paper, but this is ugly and you can see where the line passes from the board to the patch, even after the artwork is printed. The simplest answer, if you insist on using markers for inking, is not to make mistakes.

have worked in newspapers and comic books. Gil Kane points out that there are limitations inherent in the use of markers for inking: 'Because I've been a pencil artist most of my life, I never developed the precision and delicacy that most people evolve when they're using a pen or a brush. Using a marker, I can get a range of effects and find them very satisfying. But I wish it were possible for me to use a pen or brush more effectively, because I find certain limitations with a marker. I take advantage of my limitations and further my technique as far as I can. I find I am able to work quickly. I'm never going to be the kind of artist that does long and highly evolved drawings. It's simply not what I'm concerned with. I'd like to have a piece of work as finished as possible, but I like to deal with dramatic ideas.'

Technical pens It is probably best to resist the temptation to ink with technical pens (Rotring is probably the best-known brand in this line). Although such pens run on Indian ink from a self-contained cartridge, which means they do not have to be dipped in ink like brushes, the nature of their nibs means that the lines they draw are of constant width, a decided advantage when they are used for what they were designed for – mapping and draughting – but the last thing a comic-strip artist wants, except perhaps for ruling panel borders and drawing speech balloons. Lines of constant width are *boring*. They tire the eye and make everything you draw look like a cardboard cutout rather than a solid, three-dimensional object.

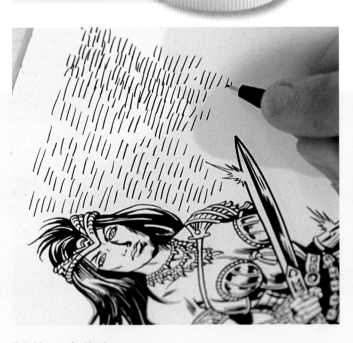

Hatching or feathering

When you are using Indian ink on white board, remember that you cannot water your ink to produce shades of grey. Printers cannot water their ink, so you must compromise and achieve your shades of grey artificially. This can be done by hatching, the use of closely spaced parallel lines to achieve an effect of greyness. Harvey Kurtzman, creator of *Mad* and EC's war comics, defines hatching as 'shorthand for a changing tone. Instead of making an actual gradation of tone, you paint in pure black, a series of parallel pointed strokes that suggest gradation.'

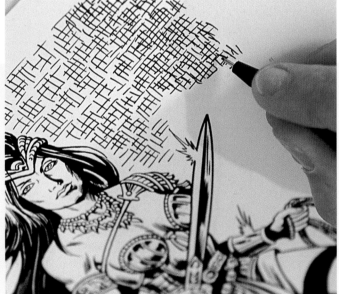

Crosshatching

This technique involves hatching first in one direction and then hatching again on top of that, usually at an angle of 90 degrees. The classic partnership of Jack Kirby and Joe Simon, who created *Captain America* and *The Newsboy Legion*, invented another kind of comic-book shading. Explains Joe Simon: 'The crosshatching we did was at three angles – you'd wind up with lots of little triangles if you looked at the art under a microscope. The lines would be heavier in the dark areas, lighter in the paler areas, so we'd achieve varied tones.'

A final point

Whether you are inking your own pencils or someone else's, try to imagine that the pencil lines are not there, and that you are drawing directly onto the board. If you merely trace the existing pencil lines with your brush, the results will look flat and uninspired. You have to *draw* while inking. Anything less is just a mechanical skill.

Dick Giordano says, 'Any kind of drawing is a technical exercise. But I think inking is more of a personal expression than pencilling. A penciller is bound by the rules of perspective and anatomy, which are already established by the time the work comes to the inker. That's why I like inking some artists better than others. They allow me more leeway in being Dick Giordano, which is important.'

TIP DON'T LET IT BLEED

Unlike bevelled plastic rulers, both sides of steel rulers are flat. Put a couple of layers of masking tape on one side of the ruler, ensuring that there is a gap of about 2mm (⅛in) between the edges of the tape and the edges of the ruler. Use the ruler taped-side down to draw lines. The tape will create enough of a gap between the ruler and board to prevent the ink from being pulled under the edge of ruler by the capillary effect known as 'bleeding'.

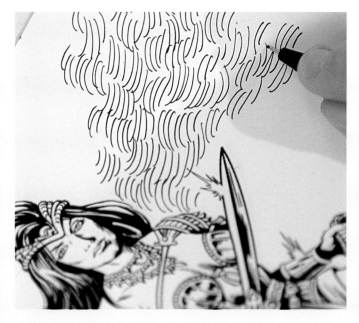

Curved hatching

There are countless methods of hatching. You can use straight lines, curved lines, long lines, short lines … in fact, whatever it takes to achieve the effect you want. Here, using wavy or curved lines achieves a kind of fluid or smoky effect that could be used to denote either cloud or water. An interesting variation on the regular method of putting down black parallel lines on white board is to put down an area of solid black ink, let it dry and then hatch on top of it with process white.

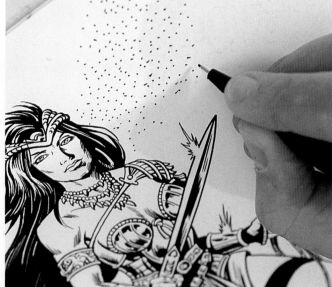

Stippling

During the 1930s, stippling was a popular way of achieving grey tones. It consists of achieving gradation through making areas of black dots, using a brush or a pen. Stippling became popular again during the 1970s with the rise to prominence of the artwork of the British comic-strip artist Frank Bellamy, responsible for the *Daily Mirror*'s comic strip *Garth*. Top American comics creator Howard Chaykin, creator of such comics as *American Flagg* and *Black Kiss*, uses the stippling technique to good effect.

mastering textures

The most difficult part of inking comic-strip art is achieving the correct textures on the various surfaces on which you are asked to draw. Obviously, the audience must be able to distinguish between fur and feathers, wood and water, and so on, and the only clues the reader has are those provided by the inker.

Hair

Joseph Linsner's painting technique conveys Dawn's hair beautifully. Goddess that she is, her hair is coloured and styled perfectly, and we can see that immediately due to Linsner's mastery with the brush.

Clever use of shadows enables the tiger to merge with the jungle, just as it would in the wild.

It is the attention to detail that 'sells' the illusion of hair to us. The highlights, the flicked curls and the deep shadows around Dawn's neck all contribute to convincing us that we are looking at a woman's hair rather than some coloured marks on paper.

Foliage

In this panel from a vintage *Tarzan* strip, artist Burne Hogarth plays with the similarities between the tiger's stripes and the jungle foliage surrounding it. Check the art in context on page 11.

On the surface

Explaining how to achieve these differences is difficult in words. While it is useful to study real-life examples of textures like folded cloth, metal, fur and so on, it is also worthwhile examining the work of professional comic-strip artists to try to understand how they have solved the problems of depicting such materials within the context of comic-strip art.

In all the examples presented here, the pencil, ink and paint art in each have been done by the same artist, but it is worth noting that, while some textures can be established quite strongly at pencil art stage, like folds in cloth and foliage, some textures, such as fur, water and fire, rely on the skill of the inker.

Drapery

In this character study, the way the coat drapes over the figure convinces us that not only is the fabric real, but it also has substantial weight.

Never forget that there is always something underlying folded cloth. Use this fact to give the reader a hint of the shapes that lie beneath.

Fire

Master artist Brian Bolland draws Judge Dredd better than just about anybody, but it is the flames engulfing Dredd's arm that draw our eye.

Water

Water is only seen when the surface is disturbed. In this illustration, the ripples on the surface are shown by controlled use of highlights and shadows.

Reflections are also vital in creating a convincing texture of waves on the surface of water. Don't just dash off meaningless scribbles; try to understand the shapes in the water that are creating the distortions in the reflections.

Flora and fauna

This is an idyllic view of the countryside, with a mass of flora and fauna.

In this detail, we can still make out the shape of Dredd's arm beneath the flames, but see how the reds and yellows, lights and darks, give the flames form and shape.

Lights and darks define the foreground and background, while the composition and exquisite detail draw the eye back to the figure of the boy.

Chapter 5
Lettering & Colouring

Lettering and colouring are often seen as ancillary activities, somehow not as important as the writing or drawing part of the process. However, good lettering and colouring can bring a comic strip to life and the contributions of the letterer and colourist should never be underestimated.

lettering: tools of the trade

Lettering can be done by typesetting or stencilling, but by far the most popular method is the simple hand-lettering system. The good news is that anybody can become a good letterer, provided they are prepared to put in a lot of practice using the right tools and techniques.

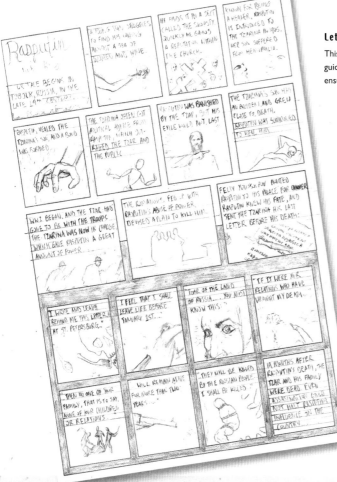

Lettering guidelines

This page-in-progress still has the guidelines used by the letterer to ensure even spacing and legibility.

Ames guide

An Ames guide is a useful tool for drawing lettering guidelines.

Drawing evenly spaced lines

Draw evenly spaced lines by placing your pencil point in the appropriate hole of an Ames guide, then draw the line by pulling the Ames guide along a ruler.

The pen is mightier...

When it comes to hand lettering, there is less room for manoeuvre when it comes to choosing tools for the job than with other types of ink work.

Line drawing The first step in hand lettering is to lay down the parallel guidelines between which the words will sit. This requires a T-square, a ruler, a sharp HB pencil and an Ames guide. An Ames guide is a transparent plastic tool consisting of a movable dial with holes punched in it. The letterer puts the point of a pencil through the appropriate hole and draws the line by using the pencil point to pull the Ames guide along the edge of a ruler, using a T-square to keep the line straight.

Balloons The letterer is responsible not just for straightforward lettering, but also for creating the balloons and the caption boxes. Technical pens really come into their own for this part of the process. The best speech balloons are drawn freehand, because freehand balloons have the same kind of spontaneity and dynamism as the actual artwork. If absolutely necessary, you can use elliptical templates for making balloons, but this type of balloon is less desirable because it tends to look very mechanical when superimposed on freehand-inked artwork.

Lettering Assuming we agree that no one would try to letter with a sable brush, that leaves us with dip pens, technical pens,

Pentel-type markers and – an additional choice – fountain pens: Will Eisner, creator of *The Spirit*, uses a fountain pen loaded with specially thinned Indian ink for his lettering (distilled water is the best thinning medium). When it comes to Pentel-type marker pens, keep in mind that the type of ink used in them is difficult to cover up with process white. This is a matter of some importance, because you are going to make more mistakes while lettering than in any other part of the comic-strip process.

Typesetting

Although hand lettering is the most popular method, an easier option is to have the lettering for your balloons and caption boxes typeset, or you can do it yourself using a computer. Some editors and artists prefer this, although most comics editors will tell you that comic strips and typesetting do not mix. Whereas hand lettering is done all in capital letters, typeset copy in comic strips is always in upper and lowercase. *Mad* magazine often uses this method, originally adopting it to give the publication a more 'adult', magazine-style look, and to distance it from its colour comic-book cousins. If you do not have a computer, you will have to know how to mark up type in order to convey your instructions to the typesetters. It may be possible to delegate this responsibility to your editor, but if you have to do it yourself, you can probably get a lot of help from the typesetters who are doing the work. Even so, you should know the basics.

Measuring type Type height is measured in 'points', and a good readable size of type for comic strips is about 10 points (this text is set in 9-point type). If you are planning to put typesetting onto the original artwork, which is presumably drawn half-up, you will need to have the text set in 15-point type. Type width is measured in 'ems', sometimes called 'picas'. An em is one sixth of an inch. At any good art-supply store you can buy rulers and typescales with em-scales printed on them.

Casting off Something else to keep in mind when setting balloon and caption text in type is that you have to mark it up so that it fits into the space available. The art of 'casting off', so that text is set to fill a certain space, largely comes down to arithmetic. Any typesetter will supply you with examples of various sizes of type. From these it is a simple matter to count how many characters fit into any given space.

Stencil lettering

Another method of lettering, called LeRoy lettering, although little used these days, involves a kind of template with an alphabet punched into it, all in capital letters. This system was used extensively in the great EC comics published by *Mad*'s William Gaines during the 1950s.

Tracing lettering guidelines

If you cannot find an Ames guide to draw your lettering guidelines, you could draw them digitally. Print them out, then place them over a lightbox and trace them onto the artwork, ready for lettering.

Shout it out!

These four balloons show the same lettering set in different size type. Type size can be used to indicate the volume of the speaker, from bellowing (top) through shouting and a normal speaking tone to whispering (bottom).

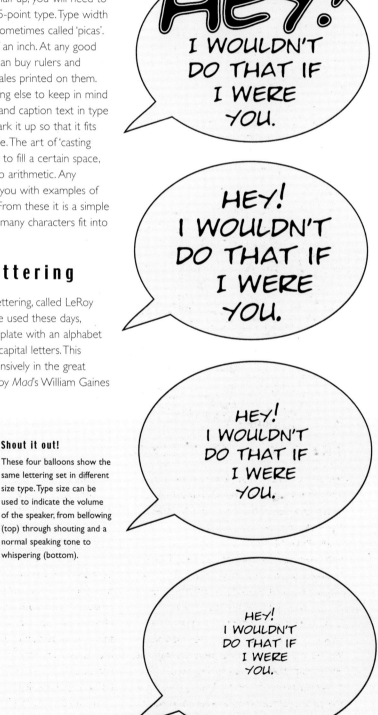

hand lettering

Hand lettering relies almost entirely on the steady hand and eagle eye of the letterer. While all letterers have their own style, there are some conventions of lettering for comic books that should be observed.

Ground rules

Like so many things, laying the proper foundations for hand lettering can go a long way to making the actual work as easy as possible. Start by using an Ames guide to rule the parallel lines that keep the lettering straight and even. Place the pencil point in the appropriate hole of the Ames guide, then draw pencil and guide across the paper using a T-square to keep the line straight (see page 104). For drawing guidelines on half-up artwork, set the Ames guide to about 3½, which gives guidelines about one seventh of an inch apart. The distance between the upper and lower guidelines will be larger than the gap between the lines of lettering, but the difference is left to the letterer.

A letterer's most economical method is to rule up sufficient guidelines for three or four lines of lettering right the way across the top of each tier of panels on a page, rather than to put the lines on each panel individually. The guidelines are erased before the art is put under the camera.

TIP MEASURING GUIDELINES

If an Ames guide is unavailable, a regular ruler can be used to determine the distances between the lines. A good rule of thumb to remember for half-up artwork is about one seventh of an inch for the letter height, and about one twelfth of an inch for the gaps between the lines of lettering.

Alphabet soup

Once you have drawn the guidelines, you can get down to the nitty-gritty of lettering. The first rule of hand lettering is to be aware that you are *drawing* the letters individually, rather than writing down the words. Keeping this in mind will help you to avoid making typographical errors (called 'typos' or 'literals' in publishing circles) and to make sure that the letters are consistent. The act of hand lettering is therefore a good deal slower than the act of handwriting.

Type styles You can indicate a character's tone of voice or manner of speaking in the lettering itself. Walt Kelly, creator of the famous *Pogo* newspaper strip, used many different styles of lettering, sometimes within the same daily episode. Thus, an 'Olde English' sort of script could indicate a character's old-fashioned nature, computer-style type could indicate the speech patterns of a robot and so on.

Different type styles

Here are a few examples of the same text set in different type styles, demonstrating the different effects that are produced.

CHANGE THE MOOD BY CHANGING THE STYLE.

Change the Mood by changing the Style.

CHANGE THE MOOD BY CHANGING THE STYLE.

CHANGE THE MOOD BY CHANGING THE STYLE.

CHANGE THE MOOD BY CHANGING THE STLE.

CHANGE THE MOOD BY CHANGING THE STYLE.

CHANGE THE MOOD BY CHANGING THE STYLE.

LETTERING CONVENTIONS

Legibility is the prime consideration when hand lettering, and there are some simple guidelines you can follow to ensure that you get it right.

Round tops

Letters with round tops – C, G, O, Q and S, for example – should hang on the upper guideline.

Horizontal strokes

Letters that contain horizontal strokes – A, E, F, G, H, L, T and Z – are drawn so that the horizontal strokes rise from left to right.

Peculiarities

The remaining letters in the alphabet likewise have their little peculiarities when hand lettered.

Lowercase

In general, lowercase letters are avoided because the descenders – the tails of the g, j, p, q and y – tend to clash with the ascenders of the b, d, f, h, l and t.

The ascenders and descenders of lowercase letters can interfere with one another.

The letter 'd' has an ascender above the main body of the letter, while a 'g' has a descender below the main body of the letter. An 'a' has neither ascender nor descender.

Roman
Roman type is the most common type style used.

Italic
Italic type adds emphasis or is used for narrative boxes.

Bold
Bold type is even more emphatic and is used for shouted dialogue.

Roman versus italic versus bold

Roman is the term used to describe 'upright' letters. Roman lettering is used for most speech balloon lettering. This is the easiest of all type styles to read. Italic is the name given to lettering that slopes to the right. Italic lettering is used in speech balloons to add emphasis, or in caption boxes to distinguish them from spoken dialogue. Bold is the name given to text drawn with heavier lines than either roman or italic. Bold is also used to add emphasis to speech balloons or to denote that dialogue is being shouted.

balloons

Balloons are those little bubbles that contain the dialogue in comic strips. There are lots of different types of balloon that can be used to denote different sounds within the 'spoken' words of the strip.

Splitting the text

The letterer has split the text into connected balloons to fit the space available.

Who speaks first

The convention is to have the first speaker's balloon appear first in the panel. In the example on the right, this is easy because the first speaker appears first in the panel, but this is not the case in the example below. The letterer has solved the problem by placing the first speaker's balloon at the top of the panel.

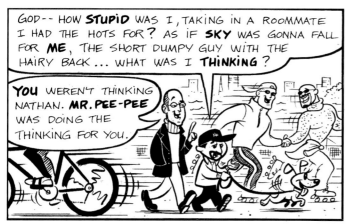

All about balloons

When it comes to the balloon as a unit of lettering, there are several factors the letterer must consider. First, all balloons in a panel must be positioned not only so that no important portions of the artwork are obscured, but also so that the balloons read in the correct order, keeping in mind that the natural tendency is to read from left to right and from top to bottom. You should not have to worry about the positioning of caption boxes, because these are usually placed at the tops or bottoms of panels.

Avoiding confusion You are bound by comic-strip convention to place a character's balloon as close to the speaker as possible. This eliminates confusion. If you are presented with a panel in which the character on the right is supposed to speak before the character on the left, you are in trouble. You could try putting the right-hand character's balloon above the left-hand character's head, and vice versa, and crossing the tails of the balloons over each other – but you would never get away with it. In this situation, the only workable solution would be to have the whole panel redrawn. Of course, this is a hypothetical situation that should never arise.

Fitting it all in Another and more likely problem is that you may be asked to put more lettering into a panel than will fit there. This, of course, would be a result of either poor scripting – all writers have a tendency to overwrite – or poor editing. Short of cutting out some of the words, there is not much you can do – and cutting other people's copy is not the letterer's job and is definitely not advisable. However, sometimes a 'wordy situation' can be alleviated by splitting one speech balloon or caption into two: that way you can make the best use of the space.

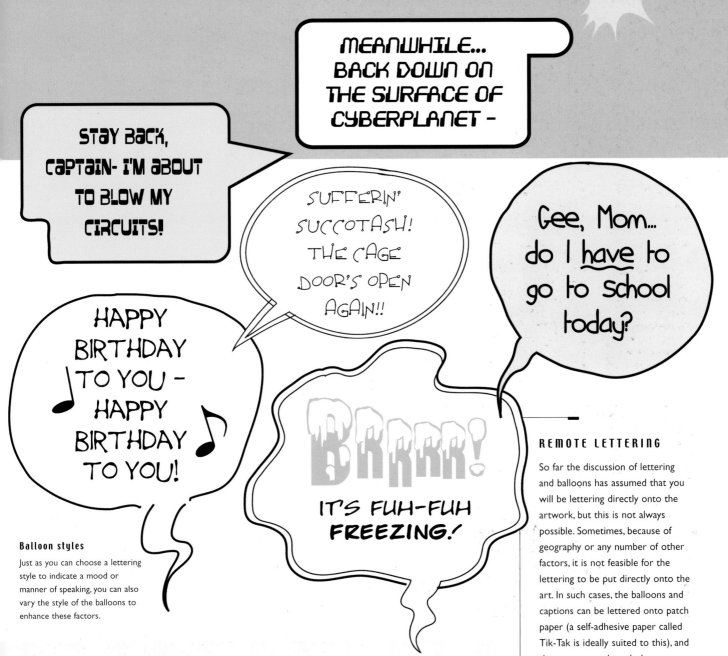

Balloon styles
Just as you can choose a lettering style to indicate a mood or manner of speaking, you can also vary the style of the balloons to enhance these factors.

A range of bubbles

Different styles of balloons are used to perform different functions. Most balloons will be for characters' dialogue, spoken at a normal conversational level. These are referred to as 'speech balloons' for obvious reasons. Then there are balloons designed to contain a character's thoughts. These resemble little clouds and are called 'thought balloons'. A type of speech balloon with a jagged border is used to indicate that the words are coming from a telephone, radio or some other electrical contrivance, but can also be used to show that a character is shouting. A reader must be able to tell the difference between these two applications of the same device by the context. Another way to show

a character shouting is to letter his or her dialogue bigger (see page 105).

There are other variations on these themes. For example, if you wanted to indicate that a character is speaking in an icy tone, you might show the lower edge of the speech balloon dripping with icicles. Of course, you can make up your own graphic devices and apply them where appropriate.

REMOTE LETTERING

So far the discussion of lettering and balloons has assumed that you will be lettering directly onto the artwork, but this is not always possible. Sometimes, because of geography or any number of other factors, it is not feasible for the lettering to be put directly onto the art. In such cases, the balloons and captions can be lettered onto patch paper (a self-adhesive paper called Tik-Tak is ideally suited to this), and then cut out and stuck down onto the artwork at a later stage. The only problem with this is that cutting around speech balloons with a scalpel is a laborious and boring process. Cutting around thought balloons is even worse. Jagged speech balloons are the worst of all. This method is therefore used only in emergencies – for example, when the job is running late and the lettering has to be done at the same time as the inking.

display lettering

Display lettering is the term used to describe the sort of lettering that is used in strips for sound effects and story titles as well as for the title logos of actual magazines.

Creative lettering styles

Display lettering gives you the chance to get really creative, using the style of the lettering to complement the meaning of the words and create interesting visual shapes.

Chelsea Boys

Display lettering includes title logos such as this *Chelsea Boys* logo, sound effects and any other type of lettering required.

Causing effects

There are no particular rules about this area of lettering, so studying examples of work by established professionals – there are plenty scattered around this book – will tell you more about the subject than any verbal instruction ever could. Good examples to study would be any of the post-World War II *Spirit* strips by Will Eisner. Eisner did his own lettering on these strips and always ensured that the lettering integrated into the story.

During the 1960s, DC Comics' foremost letterer was Gaspar Saladino, who lettered almost every title from *Justice League of America* to *GI Combat*. By far the best letterer of the period, however, was Irv Schnapp, who created the highly distinctive

look for the lettering on DC Comics' covers of the period.

Later, Marvel Comics artists like Walt Simonson and Howie Chaykin would incorporate the lettering in their comic strips as part of the artwork. Simonson's still highly regarded comic-strip adaptation of the movie *Alien* was an excellent example of comic art and comic lettering seamlessly combined. Chaykin took it a step farther with his work on the groundbreaking strip *American Flagg* for First Comics during the early 1980s, by having letterer Ken Bruzenak closely involved with the creation of the final pages so that art and lettering flowed effortlessly together to created an integrated whole.

Sound-effects storytelling
In these two pages by Mark Harrison, the story is told entirely by the artwork and sound effects, with no character dialogue.

TIP A WORD OF CAUTION

If you plan to submit samples of artwork depicting an established character to a publishing company, it is best not to include a hand-drawn version of that character's logo. Your version can only suffer by comparison. Original logos for characters are drawn many times the size they will finally appear, and are reproduced photographically by the publishers when required. This means they have a perfection of finish that you will never be able to achieve working only half-up.

HOW IT'S DONE

There are two distinct ways in which sound effects are added to a comic strip. The first way, most favoured in the United States, is that the effects lettering (and the speech balloons and captions) are added before the pencil art is inked, usually directly onto the art board. Thus, these components are an integral part of the artwork.

The other way, more common in the UK, is that the lettering is created on patch paper, like Tik-Tak, and then carefully cut around and stuck down on the finished, inked art. This means that if the lettering is removed, there will be finished, inked art beneath.

e-lettering

It is relatively simple to produce lettering on a computer. You can do this with even the most basic computer, although you will need additional hardware and software if you want to create your own original computer lettering.

Starting off

The easiest way to utilize e-lettering is to buy a comic-lettering font from a supplier, such as ComiCraft, install it on a computer and off you go. The only problem with this is that the result will not be *your* lettering – it will be someone else's. However, if your budget can stretch to some additional software, you can transform your own hand lettering into a computer font.

First, you have to draw an alphabet in your hand-lettering style. It is even better if you write each letter three times (see tip box below). You should also think about creating a range of numbers and punctuation marks. There may even be some special characters you want to have in your font. You are then ready to convert your hand-drawn letters into a computer font.

TIP VARYING YOUR ALPHABET

When creating your own font, it is a good idea to letter your alphabet three times. In real hand lettering, no two renderings of the same letter are ever exactly identical, so if you only have access to one version of each letter in your comic-lettering font, the result is going to look almost as mechanical as template lettering, or even regular typesetting. With three versions of each letter, you can assign one version to the capital letter keystroke, one version to the lowercase keystroke and one to some other key combination – say, 'option'-keystroke. When you come to type out the lettering, if you vary the versions of the letters you use, your computer-generated lettering should be almost indistinguishable from the genuine, hand-rendered article.

HOW IT'S DONE

Once you have drawn your alphabets, you need to scan them and open the scan in Photoshop (or whichever photo manipulation software you use). Save each letter as a single file. If you have opted for the three-alphabet version, you will end up with 78 files just for the letters A–Z. If you added numbers and punctuation marks, it will be more.

WHAT YOU NEED

✱ A scanner

✱ Adobe Photoshop

✱ Adobe Streamline

✱ Macromedia Fontographer

Also useful

✱ Adobe Illustrator

1 Choose 'Open' from the 'File' menu in Adobe Streamline, then choose the letter you have saved as a .psd (Photoshop) file.

2 The window that opens up should look like this.

3 Now choose 'Convert' from the 'File' menu to turn the bitmap image into a vector.

4 Select 'Save art' from the 'File' menu to save the letter as a Fontographer-compatible file.

5 Switch to Fontographer and choose 'New font' from the 'File' menu. It brings up a window that looks like this. Here, the first three letters of the alphabet have already been imported. If the box for the letter you are going to import is not highlighted, select it by clicking on it.

6 Now choose 'Import' and then 'EPS' from the 'File' menu.

7 This will bring up the 'Open' dialogue box. Select your letter .eps file and click the 'Open' button.

8 Fontographer then pops the letter into the box you selected earlier. You are ready to move on to the next letter.

traditional colouring techniques

For many years, comic books and Sunday newspaper strips were coloured using the most primitive of methods. Then, in the 1970s and 1980s, new methods of colouring were introduced, so that comics could reproduce fully painted art.

The development of colour

Colour was never an artistic consideration in the earliest comics. An artist might indicate the colours of a main character's costume, but the backgrounds and incidental characters were largely left to the printers to choose – often at random. Prior to the 1980s, all comics used the primitive 'mechanical separation' method of colour. Essentially, there were four colours in the palette – cyan (blue), magenta (pink), yellow and black. Tints were only available in increments of 10 per cent and the screen (the coarseness of the dots) was about 80 lines per inch, which gave rise to the characteristic 'dotty' look exploited by pop artist Roy Lichtenstein.

Litho printing As sales of comics fell during the late 1970s, it became apparent to publishers that the old letterpress method of printing was becoming less viable. They began to look at ways to print smaller quantities more economically and settled on the more modern lithographic printing process. An interesting side-effect of this was the ability to print photographically separated colours, from fully painted artwork if desired, and a period of experimentation began.

Marvel full-colour comics As the 1970s drew to a close, Marvel Comics was experimenting with different formats of magazines. An obscure back-up strip called *WeirdWorld*, a fantasy in the vein of *The Hobbit*, was selected for the big budget treatment. The black line artwork was scanned and printed in pale blue ink, the blue linework was painted in full colour, then the black linework, copied onto clear film, was laid over the top and the whole lot scanned. The effect was startling and revolutionary: black line artwork with full painted colour.

Gravure and overlays In the UK, comics needed large print-runs to survive and

Muddy colours

This page by Robert Bliss suffers because the colours have become muddy due to tiny quantities of darker pigments finding their way into the lighter paints. In all fairness, the absorbent paper used by *2000AD* also led to 'dot gain' – the spreading of the ink dots as they soak into the paper – at printing stage, which also makes the artwork appear darker.

Bright colours

Glenn Fabry's *Slaine* seems cleaner and brighter by comparison to the previous artwork. Even the dot gain has not darkened the colours too much. The moral of the story: keep your brushes clean.

TIP REMOVE PENCIL MARKS FIRST

The one thing to be especially careful about with both inks and watercolours is that all pencil lines are erased before you start colouring. Pencil marks beneath a layer of ink or watercolour cannot be erased.

publications like *The Eagle* and later *TV21* were printed by the gravure process – used for grown-up magazines like *Woman's Realm* that printed over a million copies a week. Gravure allowed the use of full-colour artwork, and artists like Frank Bellamy and Don Lawrence made their names on comics that used full-colour artwork.

2000AD switched to fully painted artwork around 1990 and found that the easiest way to work was to have the lettering and balloons put down on a transparent overlay. The artwork and overlay were then put on a scanning drum at the reprographic house and scanned together. Finally, the lettering layer was scanned again separately as line artwork, so that the letters would not have a half-tone screen applied. The two sets of film were combined so that artwork was half-tone and lettering was crisp line.

Colour today These days most comics are printed lithographically and most colouring is done digitally, saving publishers a great deal of money on reprographic fees. Digital artwork can be output straight to film and requires no expensive scanning, so if you are planning on selling your art to professional publishers, you are going to need to know how to colour digitally (see pages 116–119).

HOW IT'S DONE

There are lots of ways to add colour to your linework. Top graphic designer and comic artist Rian Hughes has been known to use felt-tipped markers. For his *2000AD* series *Really and Truly*, he drew the linework on one side of thin paper and then coloured the artwork on the reverse of the sheet so that the ink soaked through. That way the spirit-based coloured ink did not make the black linework run or 'bleed'.

Famed UK artist Don Lawrence, best known for *Trigan Empire* and *Storm*, was reputed to use standard wooden colouring pencils for his *Trigan* work, but so skilful was his colouring that it is almost impossible to tell from looking at the printed art.

Acrylics (top) A more conventional method of colouring is painting in acrylic paints. Acrylics are easier to handle than oils, but they produce opaque colours and are therefore unsuitable for use on black linework because the overlaid colour will obscure the ink lines. Thus acrylics are more suitable for fully painted artwork.

Watercolours (middle) Watercolours work well over Indian ink drawings, but they are highly challenging to work with, requiring a lightness of touch that might seem, at first, not in keeping with the straightforward, in-your-face nature of comic art. However, top artists like Neal Adams and, more recently, Alex Ross appear to prefer watercolour for their colour work.

Coloured inks (bottom) Black linework can also be coloured with inks like Pelikan, the favoured ink of legendary artist Frank Bellamy. Pelikan inks are transparent but permanent. The best effect is achieved by applying several coats of ink to each area. This ensures that, when the pages are scanned on a printer's drum scanner, the colours remain intense and are not faded by the laser-driven process. However, Pelikan inks are highly unforgiving and very difficult to remove in case of mistakes.

digital colouring

Just like with home decorating, most of the work in digital colouring is in the preparation. Prepare it right and you will save yourself all kinds of problems farther along in the process.

Scanning at the right resolution

Black linework has to be scanned at a reasonably high resolution, such as 300dpi, so that the lines are smooth and clean in order to hold the colour layers together. Compare the 300dpi scan shown here to the higher and lower versions.

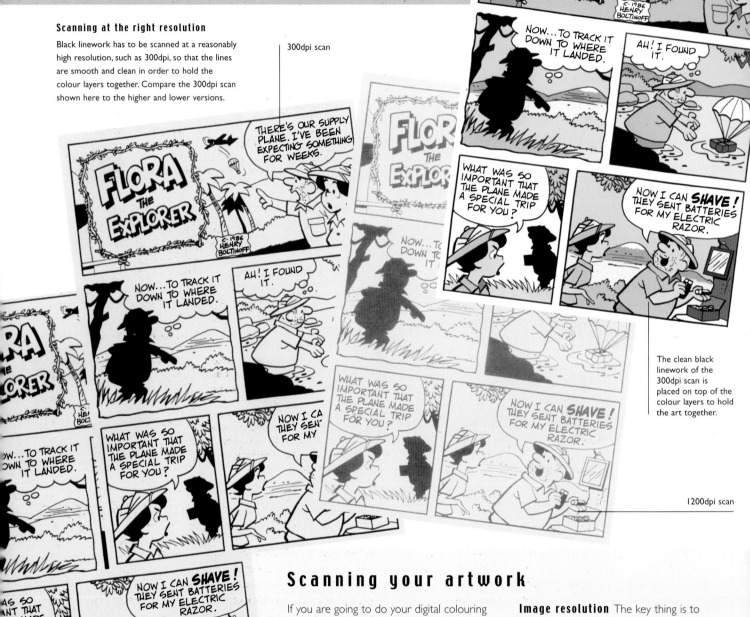

300dpi scan

The clean black linework of the 300dpi scan is placed on top of the colour layers to hold the art together.

1200dpi scan

150dpi scan

Scanning your artwork

If you are going to do your digital colouring on artwork you have created on paper with ink, you will need to convert the art into a digital file and the only way to do this is to use a scanner. The domestic A4 scanners available these days are very cheap, very fast and have high-resolution capacity. This is a little limiting if you prefer to create your traditional artwork at a larger size, but not a catastrophe, because larger art can always be scanned in two halves and joined digitally within Photoshop.

Image resolution The key thing is to capture a high-resolution image of your linework – 300dpi (dots per inch), for example. This is vital because the lines need to be smooth. Scan at a resolution that is too low and you will have ugly bitmapping where the black line meets the white background. Also, scan in 'grayscale' so that your scanner does not pick up unwanted colours.

Comics are printed in CMYK colour (cyan, magenta, yellow, black), so it makes sense to work digitally in CMYK. However, some Photoshop filters, like 'Lens flare' and 'Ocean ripple', are only available in RGB mode (red, green, blue), so you could work in RGB and then convert to CMYK at the end. Be aware that the colours will change subtly when you convert, though.

Fill the black linework with solid black to reinforce it.

Preparing the linework

Once you have your scan, you need to do some work on the line art before you can begin colouring. Mostly, you need to clean away the grey tones and boost the contrast and brightness to ensure that you have clean black lines, though some colour artists feel that leaving some of the pencil lines gives the art a more hand-rendered, organic look. You will also see that your scan is composed of black linework on a white background. You have to knock out the white background so that you can build up the layers of colour and place the black linework at the top of the stack of colour layers, so the black linework holds the art together.

3 Switch back to the 'Layers' tab and then choose 'Inverse' from the 'Select' menu. Make sure the foreground colour is set to black, then choose 'Fill' from the 'Edit' menu. This reinforces the black linework with solid black. Choose 'Mode' from the 'Image' menu and select CYMK to convert the image from grayscale.

'Layers' palette

1 Using the 'Layers' palette in Photoshop, duplicate the background layer by dragging it to the 'Create a new layer' icon. Rename the new layer line art and delete the original background layer.

Background layer

'Create a new layer' icon

'Padlock' icon

4 Now click on the 'Padlock' icon in the 'Layers' palette to lock the line art so that no more changes can be made to it. Then create a new layer beneath the line art layer called white background and fill it with white. This is so that you can see the colours as you put them down.

2 Switch to the 'Channels' tab and click on the 'Load channel as selection' icon. This selects the white background. Press the 'Delete' key so that all the white disappears, leaving a transparent background.

'Channels' tab

'Load channel as selection' icon

Undo Delete Scenes	⌘Z
Step Forward	⇧⌘Z
Step Backward	⌥⌘Z
Fade...	⇧⌘F
Cut	⌘X
Copy	⌘C
Copy Merged	⇧⌘C
Paste	⌘V
Paste Into	⇧⌘V
Clear	
Check Spelling...	
Find and Replace Text...	
Fill...	⇧F5
Stroke...	
Free Transform	⌘T
Transform	▶
Define Brush Preset...	
Define Pattern...	
Define Custom Shape...	
Purge	▶
Keyboard Shortcuts...	⌥⇧⌘K
Preset Manager...	

Fill a new background layer with white so that you can see the colours clearly as you apply them.

LAYERS AND SELECTIONS

Most drawing, painting and photo-editing programs allow you to select particular areas of an image and experiment with different effects by using layers.
Layers Layers can be visualized as pieces of transparent film stacked on top of one another. When you make a drawing or scan in an artwork, it appears as a background layer called the canvas. If you create a new layer on top of this, you can work on it without

altering the underlying image because layers are independent of each other; similarly, you can work on the canvas without affecting any images on other layers. By organizing the linework and different colours onto separate layers, you can make amendments more easily later on.
Selections To colour a particular area of your artwork, you first need to select it. There are a number of tools for selecting

various parts of the image, all of which are found in the toolbar. The 'Marquee' tool is useful for simple geometric shapes; the 'Lasso' tool for drawing around chosen areas; and the 'Magic wand' for selecting areas where the colour or tone is distinct.

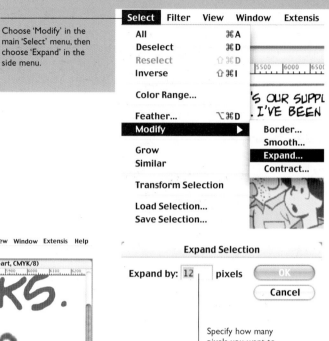

Choose 'Modify' in the main 'Select' menu, then choose 'Expand' in the side menu.

Laying down colour

Now that your line art is ready to receive colour, you should start by laying down flat colours and grouping each colour or each type of item together on separate layers. This will help when it comes to touching in bits of colour you have missed at the end of the process.

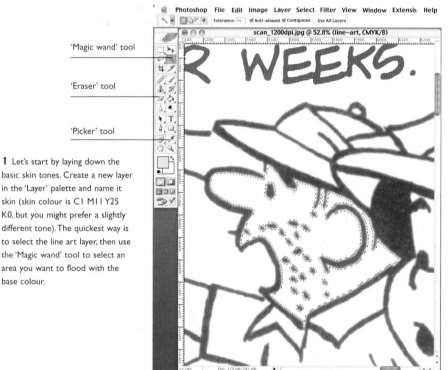

'Magic wand' tool

'Eraser' tool

'Picker' tool

1 Let's start by laying down the basic skin tones. Create a new layer in the 'Layer' palette and name it skin (skin colour is C1 M11 Y25 K0, but you might prefer a slightly different tone). The quickest way is to select the line art layer, then use the 'Magic wand' tool to select an area you want to flood with the base colour.

Expand Selection

Expand by: 12 pixels

OK
Cancel

Specify how many pixels you want to expand the flooded area by.

2 Now choose 'Modify' from the 'Select' menu and go to 'Expand' in the side menu. In the dialogue box set the 'Expand By' value to 4 pixels and click 'OK'. This expands the flooded area so that the edges are slightly under the black linework. If necessary, redo with a slightly larger 'Expand By' value. If you still have pale fringing between the black line and the colour, you might need to clean up the edges of the black line with the 'Eraser' tool.

Finishing touches

When you have added flat colour to all the areas, you need to double-check your work and then add a few finishing touches.
Retouching Click off the line art layer to see if you have missed any areas or little spots. If you need to touch up any areas you have missed, make sure you do the retouching on the right layer.
Highlights and shadows The next thing to do is to add highlights and shadows to give

the finished art more of a 3D feel. The best way to do this is to create a new layer above the layer you are planning to place highlights on. So, to add highlights and shadows to the skin layer, create a new layer positioned above the skin layer. Call it skin tones. With the new layer selected, use the 'Airbrush' tool to add highlights and shadows as needed.

SELECTING COLOURS

You can either select colours from a palette or create new 'custom' colours in Photoshop. There are three ways to do this: selecting from a standard or personalized grid of colour swatches; mixing colours using sliders or by specifying the CMYK values (that is, percentages of cyan, magenta, yellow and black); or picking from a rainbow colour bar. It is also very easy to match a colour in your work by clicking on the 'Picker' tool, and then clicking on the colour you wish to match.

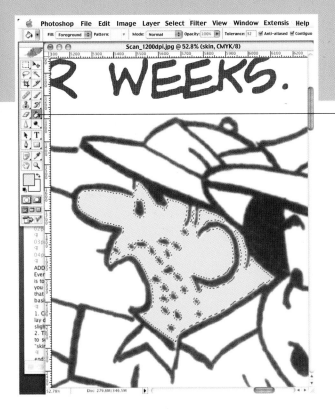

'Paint bucket' tool

3 Now click on the skin layer and use the 'Paint bucket' tool to flood the area with skin colour. Then just repeat the process with the various areas of the artwork until you have the whole page blocked out with basic colour fills.

Final coloured artwork

Once the flat colour work is complete, make any finishing touches you require and ensure that the line art layer is on top of the colour layers.

TIP SUIT YOURSELF

Everyone has different ways of doing things in Photoshop. One method is to lay down each colour on a separate layer, but if this becomes unwieldy, you may want to put certain colours together on shared layers. Do it the way that suits you.

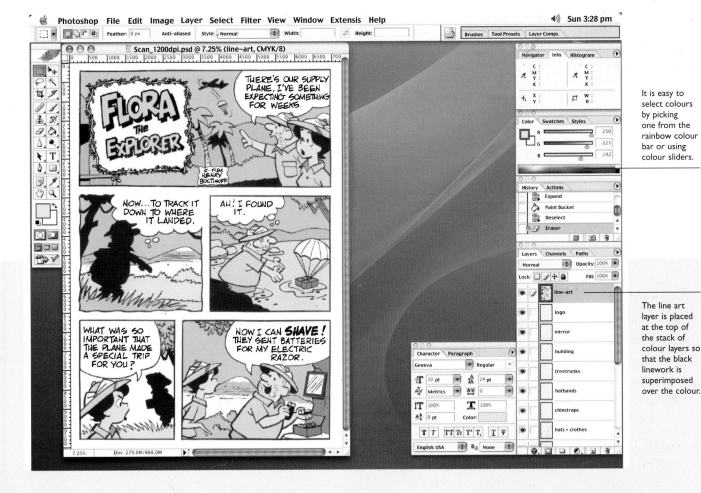

It is easy to select colours by picking one from the rainbow colour bar or using colour sliders.

The line art layer is placed at the top of the stack of colour layers so that the black linework is superimposed over the colour.

putting it all together

Once the colouring is complete, the various components need to be combined to produce the final Photoshop file that the printers will work with. This is usually done by the publisher's art department, but it does not hurt for you to know how it is done.

Adding the lettering

Hopefully the letterer has been working to the same dimensions as you. Some artists produce artwork that is the same size as the finished printed article. In the past, artists only worked at a larger size – twice-up until 1968, then half-up after that – so that the lines would tighten up when the printer reduced the artwork for printing. With digital artwork, there is no need to work at the enlarged size. In Photoshop you only need to hit 'apple+' to enlarge the image on screen so that you can see more clearly what you are doing.

Adding the lettering layer should be simple. All that should be needed is to add the lettering layer above the line art layer, but this assumes that the lettering layer is black line lettering and balloons, with the body of the balloons filled with white. If the balloons are not filled, that is not a big problem. You can fill them with white yourself by using the colour fill process outlined on page 117. However, the letterer should really have done this already.

The lettering sits on top of the other layers. Just below the lettering is the white backing fields for the speech balloons.

Combining the elements

This is the culmination of the process we started back on page 72. After writing the script, designing the characters, laying out the pages, pencilling, inking, colouring and lettering, this is the result.

Sometimes the sound effects are part of the artwork layer, sometimes part of the lettering layer. There is no hard and fast rule about this.

The final piece

The artist has done a great job of fitting eight panels onto the page without it looking cluttered. Normally, this many panels would be avoided, but telling a complete story in two pages is a tricky job.

It can be effective to have speech balloons sometimes break out of the panel for the sake of variety.

TRANSFERRING LAYERS

Transferring layers from one digital file to another is pretty straightforward in Photoshop. The simplest way is to have the final artwork page and the lettering file open on screen at the same time, then simply drag the lettering layer from the lettering file to the finished artwork page. The lettering is copied to the final artwork page as a new layer.

You can also 'Select All' on the lettering file, then 'Copy', click on the final artwork page, and 'Paste'; the lettering will appear as a new layer. If the lettering layer is in the wrong place, simply drag the lettering layer up the levels until it is at the top of the layers list.

Delivering the work

It is probably best to leave the artwork as separate layers. Burn the files to CD and leave the flattening of the Photoshop files to the publisher's production department. Most publishers will be very quick to tell you the format in which they want the artwork files delivering, so make sure you read their production notes carefully. When burning the files to CD, always choose 'PC and Mac' in the CD burning application, because it is possible

that your publisher is using PCs rather than Macs – as unlikely as this seems. Again, the publisher will tell you what format they are working on.

Chapter 6
Selling Your Work

There are two routes you can take to bring your work to market: either you can try to sell your talents to one of the established professional publishing companies, or you can plunge into the turbulent waters of self-publishing. Whichever route you choose to follow, this chapter provides some advice and tips to steer you through.

getting in the door

Learning to draw comics is just half the battle. If you want to get into the industry, you have to be smarter and more professional than the other ten thousand hopefuls trying to get in at the same time as you.

Get to the editor

The first thing you have to keep in the forefront of your mind is that editors are extremely busy people, and even if they are not, they *think* they are. This means that, if you send unsolicited work to an editor through the mail, he or she will put it at the bottom of the pending file and, within a week, lose it. This is why almost every magazine published carries a notice in it somewhere to the effect that the editorial staff can take no responsibility for unsolicited manuscripts, artwork or picture material. By far the best way to get editors to look at your work is to show it to them in person. It will not make them look any more favourably on your artistic efforts, but at least you will get an immediate answer.

Prepare your portfolio Once you have your appointment, what are you going to show

the editor? Well, do not show drawings you did 'a few years ago'. An editor wants to see what you are doing *now*. Nor should you hand over your artwork with an apologetic 'This isn't very good' or 'I can do better when my sprained wrist heals'. If it is not your best work, you should not be showing it to anyone. All that will get you is the door. An editor wants to see only your very best work. If you are really serious about earning a living as a comic-strip artist, you will want *only* your very best work to be seen.

Newspaper strips There is very little market these days for the adventure strip in the newspaper arena, unless it features established characters from other media – like *Star Wars* – or it has itself been established as a newspaper strip for years or even decades – like

Steve Canyon, *Modesty Blaise* or *Tarzan*. If it is adventure strips you want to do, pitch them at the comic-book publishers.

Which leaves, so far as newspapers are concerned, gag strips. The point about gag strips is that the gag is everything. As Mort Walker, creator of *Beetle Bailey*, once pointed out: 'The idea is the most important ingredient in a cartoon. A poor cartoonist with a great idea will succeed where a great artist with a poor idea will fail.' In other words, there really are no techniques to be learned for drawing gag strips.

What a newspaper-strip editor, or a syndicate editor, wants to see when you are submitting samples is finished examples of your strip idea. A couple of weeks worth of strip is a suitable quantity. If your idea is good enough, the editor should grasp it after reading five episodes. Even so, it is advisable to draw up a 'model sheet' of the regular characters you plan to include in the strip, along with short notes on their personalities, peculiarities and functions. Keep this brief – remember, editors are under the impression they are very busy.

Comic books Most people, when they think of comic books, think of superheroes. This is a dated concept. Although superheroes are still the dominant force in the comic-book industry, their stranglehold is not what it was a decade or two ago. With the rise of independent publishers in recent

years, a more varied crop of comic genres is springing up.

Whatever the genre you are aiming for, the requirements for your 'audition' with the editor remain much the same. Most editors want to see a page or two of pencilled art, drawn to the same kind of format as the material they are already publishing. Check out one of the company's current publications to get an idea of how many panels to put on a page and the general shape of the page itself. You should include as part of your presentation a page or two of finished work, taken to ink stage but unlettered (although a sharp-eyed editor will spot whether you have had the presence of mind to leave 'dead' space somewhere in every panel for speech balloons). The best mixture is to show one pencilled and one inked page of one of the company's characters in action, and one pencilled and one inked page of something of your own.

Alex Storer
Tony Bates

www.fatdog-comics.co.uk
www.fatdog-comics.co.uk

Business cards

Having business cards printed up demonstrates that you are serious about being professional. It is not expensive, and a printed card is less likely to be lost or thrown away by an editor than a phone number scrawled on a piece of paper.

TIP GET THE EDITOR'S NAME

Never ring up a publishing company and ask to speak to 'the guy in charge of *Nifty Adventures*'. First, ask the switchboard operator for the name of the editor of *Nifty Adventures*. That established – we'll call our imaginary editor Ed Hackett – you can ask to speak to Mr Hackett's secretary. Assuming that the company is doing well enough to be able to afford a secretary for Mr Hackett, you should make an appointment with the secretary to show Mr Hackett some artwork samples. If you fail to mention that these are your artwork samples, chances are the secretary will think you are an agent rather than a 'hopeful' – or, even worse, a fan. This might sound deceitful, but it is no more misleading than editors telling themselves, or you, that they are busy.

PITCHING NO-NOS

✶ *Don't* try to impress the editor with a wildly original idea, concept or drawing style, especially if he or she is working for one of the big established companies. It is hard enough for long-time professionals to get startlingly original ideas into print, let alone beginners. The truth is that most editors do not want new ideas. They want old ideas dressed up to *look* new. If that sounds cynical, just remember that it is easier to change the establishment from the inside.

✶ *Don't* overload your portfolio, or your target editor, with material. He or she will have made up their mind after seeing those first four pages. Anything more is inviting boredom.

✶ *Don't* hang around for a chat afterwards. Remember? Editors think they are busy people, so just get in, be polite, show your artwork, then get out.

✶ *Don't* criticize the editor's current stable of artists. You will not impress the editor and it is just plain rude.

✶ *Don't* show an editor your artwork before you have reached an acceptable level of skill. Like a cat, you only have so many 'lives'. If you become known to an editor as a substandard artist, the label could stick.

PITCHING BY MAIL

If you absolutely have to (and distance problems are the only excuse), you can submit your samples to the editor of your choice by mail – but be prepared for a long wait.

The first point in mailing submissions is *don't* send originals. If you do and they are lost, you're sunk. The responsibility is yours, by virtue of that little 'no responsibility accepted' notice. Good-quality photostats will be acceptable for a preliminary submission, although it might help to include tearsheets of your work from some kind of publication, even if it is a fanzine or amateur publication. The very fact that you have had work published, even in a nonprofessional capacity, will score you points with any editor.

Every piece you submit, even if it is only a photostat, should be clearly marked with your name, address and telephone number. This saves an editor from having to rummage through files trying to find a contact point for you when he or she rediscovers a piece of your work previously consigned to the 'must return sometime' file and – on second thoughts – thinks it is brilliant.

You must include a covering letter with your submission. This should tell the editor a few relevant details about yourself. Your age will help the editor to assess your progress as an artist and how much potential you may still have. You could mention that, while you have submitted samples of superhero art because that is what the editor's company publishes, you have a yen to draw a Western strip. You never know, the editor might just be thinking of reviving the genre. Keep your letter brief and pertinent – no more than one side of an A4 sheet, preferably typed or, if you really want to show off, hand lettered.

Make sure your package is secure. There is no point in your samples arriving looking as if they have passed through a mincing machine on their way to the publisher's office; that would *not* inspire confidence about future transactions. At the same time, it should not be so 'secure' that the poor editor cannot get it open.

Always include a stamped, self-addressed envelope, big enough and with sufficient stamps on it to make sure your submissions can be returned. This will not *guarantee* you get them back, but it gives you a better chance. When mailing submissions to foreign countries, do not stamp your return envelope; instead, include International Reply Coupons in the package. Your post office will tell you how many International Reply Coupons you need to send.

Finally, it is a good idea to follow up your package with a phone call a week or so after you calculate the package should have arrived; say you are just checking to make sure your submissions got there. In reality, of course, you are jogging the editor's memory, reminding him or her that you are not going to be fobbed off too easily. If an editor pleads that he or she has had no time to look at your work, tell them you will call back in a week or so … and then *make sure you do*. Eventually, the editor will look at your stuff and give you an answer, one way or the other.

It is possible to email art submissions to an editor if you know their address. Most publishing companies conceal individual email addresses from the public to avoid this very situation, but even if you manage to discover an editor's email address, beware of sending scans of your artwork with large file sizes. The last thing companies want is their email system being clogged with half-a-dozen 20Mb scans you have sent in on the off-chance.

Portfolios

Organizing your work into a portfolio means that you are able to transport your artwork safely and display it to editors in the best possible light. There are many comic shows and conventions with editors in attendance.

commercial considerations

Part of taking a professional approach to your comics work is understanding a little about the business side and keeping an eye on commercial trends within the industry.

Selling your work

An important point to keep in mind is that you should not go into the comic-strip business with the idea of becoming a millionaire. While it is true that a few – a very few – have amassed fortunes out of their creations, mostly on the newspaper side of the comic-strip business, there is generally nothing more than a comfortable living to be made out of comics. Also, it does not really pay to haggle about money with editors when you are first starting out. Remember that there are dozens of others trying to get into the business the same week as you and they are not being pushy about money. No reputable company is going to rip you off. It simply would not be worth their while.

What are you selling? That said, you should pin down editors on exactly what the company is buying for its money. The history of comics is littered with stories of unfortunate creators who, little realizing the value of their creations, signed away all rights for a meal and a place to sleep. Instances that spring to mind include the tale of Jerry Siegel and Joe Shuster, who only received any kind of royalties at the end of their careers after a long legal battle, and Jack Kirby (and Stan Lee, for that matter) who co-created almost the entire Marvel Comics line of characters for the regular page rate.

What is your share? In newspapers, most syndicates act as a kind of agency for your work. This is, usually on a *sole* agency basis, with the syndicate getting 50 per cent and you getting the other 50 per cent. This applies wherever they sell your material at home or abroad. You might be able to stipulate that the syndicate has the rights to sell only to newspapers or periodicals, thereby keeping the potentially lucrative book rights for yourself. Alternatively, you could try to sell your strips directly to regional newspapers, but this would be almost a full-time job in itself, and probably a poor money-maker.

The big established comics companies, like Marvel and DC Comics in the US and Fleetway and D.C. Thomson in the UK, buy all rights to your work for the page rate. However, in recent years, all the US companies have been operating a kind of royalty scheme on copies sold over a certain number, and *2000AD* in the UK does pay reprint fees. However, these payments are looked upon by the companies as bonuses, not as the kind of royalties creators are entitled to by law, and so they could be terminated at any moment at the discretion of the company.

TIP KEEP UP WITH THE NEWS

To keep tabs on what is going on in the marketplace, you should buy one of the comics news magazines regularly. In the US, *Wizard* and *The Comics Journal* bracket the two ends of the comics business effectively, and *Comics International* is a comprehensive monthly journal of the comics industry in the UK.

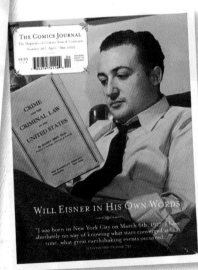

The Comics Journal

The Comics Journal combines in-depth analysis of the comics world with hard-hitting criticism and probing interviews to make the best magazine of its kind available.

Copyright

It is worth noting that *copyright* – that is, the legal rights to the stories and the characters – belongs to the author(s) until it is actually signed away to a third party. So, even if you sell your strip to a publisher and they print it with the customary copyright notice in their imprint, it matters not a jot unless you have signed a contract transferring your copyright to the publisher. In the absence of a contract, the property is still yours. This applies in both the US and the UK, both countries being signatories to the Berne Agreement on International Copyright (1985). It is also EEC law and is not open to argument or interpretation.

It is possible for creators to retain copyright on their work, provided this condition is negotiated with the editor in advance. However, most publishing companies take the stance that, because they are taking all the financial risk in publishing a project, they prefer to own the copyright unless they find they have to waive ownership to attract the services of a big-name creator.

The only game in town

As far as the UK is concerned, *2000AD* is the only comic that publishes material on a par with the best US commercial output. *2000AD* is often seen as a training ground by US publishers, and indeed many British artists now working in US comics started on *2000AD*.

What are moral rights?

There is also the question of *moral rights*. It is not unknown for a publisher to promise the *possibility* of inviting sums of money at some distant point down the line if you will sign away all your rights in a character, including your moral rights. Under no circumstances should you do this. If you do, it means that the company can do whatever they want with your creation. They could, for example, make a pornographic movie featuring your character, put your name above the title and *you* would be the one who would have to carry the stigma of being a 'pornography writer'. Even worse, they could take your name off and claim the character was created by someone else.

THE MARKETPLACE

The best way to see what is selling to editors in the various fields of comic art is to examine what is currently being published.

US newspaper strips The only way in is usually the gag strip, and in the gag strip, many major successes have displayed a surfeit of cuteness: *Peanuts* is cute, *Garfield* is cute and their creators make many thousands of dollars out of the merchandizing spin-offs of their characters. Cute seems to be selling. However, to a lesser extent, there is a market for cynicism, too. Strips like *Dilbert* and *Doonsbury* come under this heading.

US comic books The recent – heartening – trend has been for well-written comics. In the late 1990s, Brit writer Grant Morrison took DC Comics' *Justice League of America* back to basics with a creative tour-de-force run on the comic that saw it consistently outsell market leaders Marvel Comics for an unprecedented three-and-a-half years. Marvel Comics have sought out and signed star writers for their recent comics. Film director Kevin Smith wrote *Daredevil* for a while, *Babylon 5* creator J. Michael Staczynski is the current writer of *The Amazing Spider-Man*, and *Buffy the Vampire Slayer*'s Joss Whedon is writing one of the *X-Men* titles. Mention should also be made of Marvel's hugely successful revamping of its main characters under the 'Ultimates' label.

Star artists are also able to sell comics by the cartload – witness Jim Lee's artwork providing a much needed shot in the arm for DC Comics' two core titles *Batman* and *Superman*.

However, there are companies, like Vertigo (a spin-off imprint of DC Comics) and Caliber, who are far more amenable to truly original ideas and unexploited genres. Vertigo's big successes have included *Swamp Thing*, *Hellblazer* and *Preacher*. So, if you absolutely *have* to produce a comic strip about tin mining or 1920s dance marathons, these might be the people to approach.

UK marketplace In the UK, things are altogether grimmer. The best-selling comic, Fleetway's science-fiction comic *2000AD*, is still the only real British form for the kind of storytelling that is the acceptable norm in the US. The UK arm of Marvel Comics seems to be doing almost no British-originated comic strips, and D.C. Thomson is apparently still able to make money out of comic-strip concepts that are, to be charitable, 50 years out of date.

Europe European publishers, like the US independents, are far more inclined to try new and different ideas, so, if you really want to be original, you might try France or Holland.

your first professional job

Believe it or not, getting into the comics business is a good deal easier than staying in it. The first two hurdles faced by a creator are to produce material (a) that an editor likes enough to publish and (b) to a deadline.

Staying focused

Supposing, after all your efforts, you get an assignment to draw a comic strip. It does not matter whether it is a newspaper strip or a comic book; you still have to deal with the mechanics of getting the job done before the deadline set by the editor. Sounds easy, right? Work late a couple of nights and the odd weekend and, presto, you are a comic-strip professional.

Forget it. *Nothing* is ever that easy.

Pleasing your editor This is not an easy task. Every editor has his or her own beliefs about what makes a good comic. Many editors do not even know what they like. Quite a few *think* they know what they like, but change their minds halfway through the job. A few talk loudly about what the public likes. This type of editor is dangerous and should be shot on sight. *No one* knows what the public likes. Except for the public ... and not always them, either.

The best editors are those who recognize good work when they see it and leave the writers and artists alone to get on and produce their best efforts.

Pleasing the public Your work also has to please the public. As mentioned above, there is no way to second-guess your audience. There has never been a creator, in any artistic field, who has had the inside story on what the audience wants.

The best course to take, therefore, is to produce work that pleases you. At every stage of the creative endeavour, you should be asking yourself, 'Is this my best effort?' If the answer is not 'YES!' then you have some work to do. If you ever look at your work and say 'That'll do', you should immediately know that it will not. Only perfectionists succeed in this business.

It is often a matter of blind luck whether a comic strip catches on or not. However, as long as you turn in your very best effort and keep your fingers crossed, you know you have done everything you reasonably can to make it all work.

FINDING THE TIME

Assuming you are in full-time employment already, you have to accommodate your freelance assignments in your free time. Realistically, this will give you a maximum of four hours per evening and whatever time you can spare from eating, sleeping and necessary chores over weekends. If you are determined to create freelance while employed full-time, you may have to give up your social life for months – which is difficult, but not impossible.

Of course, one way to increase the time available for freelance assignments is to give up your daytime job. This is not a decision that should be rushed into. You should be working steadily in your spare time for at least six months before you seriously consider this bold move. The figure of six months is purely arbitrary, but a period of that order would give sufficient time to judge whether or not you would be able to secure enough work to pay all your bills and allow you to maintain or improve your existing standard of living.

An artist producing a newspaper strip for a syndicate has to produce six strips a week. Although some newspapers appear only five days a week, enough still put out a Saturday edition to make six strips necessary. A Sunday page would generally be optional, although the syndicate might insist on it.

Ultimately, a good rate of production for the comic-book artist to aim for is a page, pencilled and inked, per day, or two pages of pencils. Or two pages of inks. Keep up this rate and you should make enough money to live on. This means that you will be drawing about five pages of completely finished art a week, or 20 pages a month – which just happens to be the rate at which the average comic book eats material.

It should be mentioned that there are comic-strip artists who produce material at far greater rates, and some who are slower. Most comics editors are happy to accommodate slower artists, especially if the quality of their work merits it. What editors will not tolerate is your agreeing to turn in two pages a week and then only turning in one, or erratic output, where you supply three pages one week and just one page another. Like any other field of publishing, comics live by deadlines and regularity. It is essential that an editor can rely on an artist to come up with the goods, on time, and at a rate that can be relied on.

The speed at which newspaper-strip artists work has little bearing on how much they earn. Their income is dictated by how many newspapers subscribe to the strip. Only in comic books are the fastest workers rewarded.

Page 5

Panel I
In the foreground, the bodyguard walks away from the fallen mugger and The Boxer and Mai-Lin, in the background. He's walking towards the reader, his whole body posture saying 'despair'!

CAPTION: ...THEY CAUSE <u>DESPAIR</u>...

Panel I
In the foreground, The Boxer's hand picks up the flower the Japanese woman had bought. It's a bit crushed now. In the background, the bodyguard kneels beside the body of his mistress, his head bowed.

CAPTION: AND DESTROY EVERYTHING OF BEAUTY.

Panel 2
The Boxer's hand holds out the flower. Mai-Lin's hands cup the petals tenderly.

MAI-LIN: BUT THERE WAS A FIGHT. WHY IT'S A FLOWER!
BOXER: YES, IT DESERVES BETTER CARE THAN THE
 SAMURAI GAVE THE LADY WHO BOUGHT IT...

Panel 3
The Boxer and Mai-Lin move off, leaving the bodyguard standing over the body of his fallen mistress. A small crowd is beginning to gather around the Japanese. Perhaps we should angle this final scene like we're looking down on it.

MAI-LIN: BUT I DON'T UNDERSTAND...
BOXER: NEVER MIND, LET'S EAT. AND AFTERWARDS,
 I'LL TELL YOU THE WHOLE SAD STORY.

FOOTNOTE: THE END.

Even if you have done your job properly, and produced the best artwork of your life, do not hold your breath waiting for a congratulatory phone call from the editor. The best compliment you will ever be paid is a new script arriving in the post for you to illustrate.

The creative process

From the moment you take the script out of the envelope until the moment you pack up the finished artwork to send to the editor, it is all about putting your very best into every task.

Beat the deadline

In order to produce your best effort, you need *time*, so do not agree to a ridiculously short deadline in order to impress your editor. While editors may be impressed when artists say they can produce 20 pages of art over the weekend, they are decidedly *less* than impressed when the work fails to materialize at the agreed time. Remember that along the line there is a whole chain of people – colourists, film makers, printers – depending on

your turning in your work when you say you will. Mess up your deadlines and your first professional job may well turn out to be your last.

It is very difficult to decide upon an average rate of work. With newspaper strips, the artists are usually writing their own material and writing cannot take place until inspiration hits. You may find yourself sitting in front of your computer for *days* waiting to get an idea. Sometimes

an idea comes, but sometimes it does not. All writers have in their files half-finished stories that will probably never have endings.

With comic books, artists are more likely to work from another person's script – at least at first. Very few artists begin in comic books by writing their own material as well. When working from another person's script, it is possible to get something down on paper without struggling for inspiration, even if the artist

draws only what the writer has asked for and no more.

However, the mark of a true artist is someone who makes a creative contribution to the whole. You should always be striving to bring ideas and innovation to any job you are working on. When you reach the stage where you can surprise and delight the writer, the editor and the audience, then there is no limit to what you can achieve in this business.

staying creative

Anyone in an artistic job has to deal with the difficulty of being creative on cue and to a deadline. Comics eat up ideas at a frightening rate, so it is vital that you find some sources of inspiration.

Desperately seeking inspiration

There are no easy answers to the problem of coming up with a constant stream of fresh ideas – in fact, there are no answers at all, really. However, you might find it helps the flow of creative juices if you stick to a regular schedule of work habits. It can help to have another project on the back boiler that you work on when you find the going heavy on your main job. As the saying goes, a change is as good as a rest.

Go to the movies Comics writers may find that watching movies gives them a lot of usable notions. This does *not* mean that you should merely lift ideas and incorporate them into your stories or artwork, but rather that you should use the images you see in other media as springboards for your own concepts. To give you an example,

in the spaghetti Western *The Good, the Bad and the Ugly* (1966), there are a couple of scenes in which Clint Eastwood rescues Eli Wallach from the hangman by shooting through the rope. After watching it, it occurred to me that the scene could be turned on its head, so that Eastwood shot Wallach before the hangman had a chance to execute him. Using this concept as a springboard, I wrote a story in which The Boxer (the star of our demonstration comic strip on pages 72–75 and 120–121) stops an execution so that he can himself execute a condemned prisoner – the man responsible for the death of his sister.

Use real life Admittedly, taking clichés and turning them inside out might seem like an easy

way of coming up with story concepts, but it is what you bring to the idea and how well you execute it that separates the hack from the artist.

Real life can provide its share of inspirations, too. Joe Orlando, ex-EC artist and later a senior editor at DC Comics, tells a story about the mid-1970s revival of the character The Specter, a kind of costumed avenging spirit. 'I had just been mugged in broad daylight on upper Broadway, where I was living at the time,' remembers Orlando. 'The feeling of helplessness and anger and loss of my manhood (my wife was with me at the time) as I

watched the muggers strutting away with my wallet gave me the Walter Mitty idea of fantasy revenge. 'That's what I'll do to you bums. I'll bring back The Specter. The Specter will rid the world of evil vermin that preys on upstanding, hard-working, middle-aged comics editors.' From the reaction and sales on that book, I have a suspicion that a lot of muggers are reading *The Specter*.'

In short, the secret to inspiration is input. The more you put into your brain, the more you will get out of it.

Collaging different styles of images together, as well as pieces of type, can create interesting juxtapositions that trigger new ideas.

Travel memorabilia can be a great source of ideas.

Scrapbook

Compile a scrapbook of all kinds of visual material – perhaps printed bits and pieces that remind you of a particular place, or of a particular time period. You could also include newspaper items that you can use later as springboards for developing a story.

Words and pictures

If you are a writer, carry a notebook with you so that you can jot down ideas for use later in stories. If you are an artist, carrying a camera is a great way of collecting references and visual ideas.

Don't forget to carry a notebook so that you can write or sketch every idea down as you get them. These ideas can be a godsend at a later date when you are struggling to develop an idea and a deadline is looming.

Photographs you have taken yourself can make great reference material for drawing all kinds of everyday objects, but these days, digital cameras are so cheap and so many images can be stored on CD that traditional photos are losing their appeal.

SCHEDULING YOUR WORK

If you are working on your comic strips part-time, the question of scheduling hardly arises: you work whenever you have time – *any* time. However, coping with the realities of full-time freelancing has proved the downfall of many young hopefuls.

Keep it balanced There is a tremendous temptation to work late into the night and sleep it off the next day. While there is nothing actually *wrong* with this practice, doctors tell us that the 24-hour day is actually unnatural for most people – it is antisocial and leads eventually to a situation where the freelancer is working during the hours of darkness and sleeping during the day. This means that you are awake when everyone else is asleep, and vice versa, and so you lose contact with your friends, relatives and loved ones.

The most successful freelancers evolve a working habit not unlike a regular nine-to-fiver … having breakfast, working, having lunch, working, having dinner, relaxing, going to sleep. Just like in real life. Unfortunately, it is not easy – it requires discipline.

Famous horror novelist Stephen King follows a regimen where before lunch he works on his current project – actual writing. After lunch, he fools around developing future projects. Then, at five o'clock, he leaves his study and spends time with his wife and children. It is this kind of discipline that marks the most successful of creative talents.

Take up a sport An important point for freelancers concerns outside interests. Sitting all day and every day in front of an art board or a computer can play havoc with your health and fitness. A couple of years of no exercise at all and you could be heading into heart-attack country. Freelancing can also be a lonely business, especially if you live on your own. You just do not get the opportunity to meet people. A good idea is to look around for a sport you can take up that requires the discipline of performing two or three times a week, and at set times. You can use the sport as a sort of clock by which to time your work periods; moreover, it ensures that you have regular contact with other human beings. Of course, you could go jogging every morning to keep fit, but it is advisable to select a sport in which other people are involved. Not only does this ensure that you actually do it – you cannot leave your partner or team in the lurch by not turning up – but it also makes sure that you do it *at set times*, and so have, as it were, an anchor on reality.

self-publishing

Selling your artwork or scripts to an established publisher is the commonest way of seeing your work in print. However, with the recent proliferation of specialist comic shops, it is becoming more and more feasible for comics creators to control their own work by publishing it themselves.

Hitting the small time

Self-publishing is not such a daunting prospect as it might at first appear, especially if you are prepared to forego profit and publish your comic on a non-money-making basis. The first thing you need to do is to establish a format for your comic. For the purposes of amateur publications, with print-runs in the three-figure area, colour is out of the question, except perhaps on the cover. Unless you are an exceptionally talented artist with an exceptionally saleable idea, you would do best to keep your first print-run small. You can always reprint if you sell out overnight.

Size and price The most popular sizes for self-published efforts, referred to as fanzines (fan magazines), are 149 × 210mm (5⅞ × 8¼in) and 203 × 279mm (8 × 11in). The cheapest, and the most popular, style of binding is saddle-stitching in which sheets of paper are stapled through the centre (the spine) and folded in half. If we say that your hypothetical comic book will

be 203 × 279mm (8 × 11in) with 32 black-and-white interior pages plus a full-colour cover, with a print-run of 1,000 copies, then you are looking at a print bill of somewhere around £700. Don't be worried about asking several printers for quotations – it costs nothing to ask. It is up to you what you charge for individual copies of your comic, but keep in mind the spending power of your market.

Printing processes The only way to print such a magazine economically is with the sheet-fed litho process. Commercial magazines are printed on web-offset printing machines that feed paper to the printing plates from a huge roll of paper – a bit like a giant toilet roll. This method is feasible only for large print-runs, because it prints so quickly. If you were to try to print a 1,000-copy run on a web machine, you would have to stop the printer almost before you started it.

With the sheet-fed litho process – the method used by all print shops – your 203 ×

279mm (8 × 11in) magazine would be printed on 406 × 279mm (16 × 11in) paper that would then be stapled and folded in half. Leaving aside the cover, which would probably be printed on a heavier paper than the rest of the magazine, the first sheet printed would therefore have pages 32 and 1 on one side with 2 and 31 on the other. The next sheet would have 30 and 3 on one side with 4 and 29 on the other, and so on. Your magazine would be made up of nine 406 × 279mm (16 × 11in) sheets in total – eight for the insides plus one for the cover – folded in half to make 36 pages, including the cover.

The artwork

You have to make sure that your artwork is drawn to the correct proportions. Drawing artwork larger than the printed size allows the printer to reduce the artwork so that your drawing looks more detailed and professional.

Let us assume, still, that you want your magazine's format to be 203 × 279mm (8 × 11in). Remembering to allow for a border of white space around the area actually covered by artwork, perhaps your best bet would be to draw on board that is exactly half-up from 203 × 279mm (8 × 11in) – that is, 406 × 279mm (16 × 11in). If you

Page order

This is how the pages of a magazine fit together. For small print jobs, money can be saved if you print and staple the pages together in the order shown.

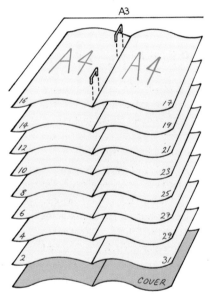

leave a 25mm (1in) border between the edge of the artwork and the edge of the board, the printed comic will have a border of 17mm (⅔in) between the edge of the artwork and the edge of the page. In printing jargon, the area covered by the artwork on the printed page is called the 'type area'. Where artwork runs off the edge of the page – which should happen only when you want it that way – the effect is called 'running to bleed'. However, this is difficult with the sheet-fed litho process and is best avoided in such print jobs.

TIP NUMBER PAGES CAREFULLY

You should take care that your artwork pages are numbered clearly so that the printer gets them in the right order in the finished magazine. There is no use complaining after the magazine is printed. Printers seldom admit liability for mistakes, even where it is their fault. They are much less likely to where, really, the fault was yours for not giving them clear instructions.

WHY PUBLISH IT YOURSELF?

Publishing is a risky venture, especially when even people who have spent their entire careers in publishing admit to not knowing why one thing is commercial and another thing is not. The problem with most existing publishing companies is that they are not interested in truly original ideas; what they want are old and established ideas dressed up to look original. The problem with new ideas is that they have not been tested on the public before, and so a publisher has no way of knowing how audiences will respond. This is why so many comics publishers these days are keen to license well-known properties and characters from other sources.

Marvel's US operation publishes comics based on toys like Transformers and G.I. Joe. Marvel's UK office has put out comics based on Zoids and Care Bears. Even publishers like DC Comics and the UK's IPC Magazines, previously resistant to licensing deals, have published *Star Trek* and *Barbie*, respectively. Although this is a sure route to creative constipation, it makes clear commercial sense. So, if you have a truly original idea and you want to see it published without any kind of interference from well-meaning editors or – worse – accountants-turned-publishers, your only path is to publish the material yourself.

Printing in colour

If any part of your comic is going to be in colour – and it is pretty much a requirement that the cover, at least, is in colour – you will need to understand something about the way in which colour printing is achieved.

Modern colour printing uses four colours of ink to create the illusion of full colour on the printed page. Each colour is laid down by a separate plate: one each for cyan (blue), magenta (pink), yellow and black. The paper is passed over each of the four printing plates in the printing press, so that the colours build up like the layers in Photoshop, as we saw back in Chapter 5. Every colour you see in a printed comic book can be produced using a combination of these four colours. The easiest and cheapest way to produce the required four printing plates is to take the images directly from a Photoshop file, which is the method used by the big professional comic companies. Most local print shops can handle artwork when supplied as Photoshop files, but you should phone ahead to make sure.

Getting it out there

Assuming you get your magazine printed without mishap, the next big problem you face is getting the copies of it out to an eager public. One way is to sell it directly by mail order. This way you do not have to give wholesale discount to retailers or distributors, and can therefore sell your product at a lower cover price. An advertisement in one of the many comic fanzines might bring good results.

If you do not want to be bothered with mailing out 1,000 copies (if you are lucky) of your comic, you could try wholesaling it to specialist comic distributors. This entails giving a discount of at least a third off your expected cover price – well, there is no such thing as a free lunch. Certainly, you are saving yourself a lot of work selling your magazine this way.

Making the potential audience for your comic aware of its existence is a vital step in marketing your product, and so review copies should be sent out to the various existing fanzines. If all else fails, you always have 1,000 copies of a magazine to burn to keep you warm over the coming winter.

You can find a few useful addresses for marketing and selling your work on pages 136–137.

Four-colour printing

The separate primary colour components that make up a four-colour print job are yellow, magenta (pink), cyan (blue) and black. The final colour page is made by printing each colour on top of the last – yellow first, then magenta, cyan and black.

publishing online

If you want to minimize the risk in publishing your own comic strips, then publishing on the world wide web could go some way to saving you a big chunk of your initial capital outlay. Web space is a good deal cheaper than paper.

Why publish online?

It does seem to fly in the face of the *point* of comics, doesn't it? There are probably far fewer comics readers than there are comics collectors. Most collectors will justify the expenditure by telling themselves that their hoard of comics is a sound investment. So, if you take to publishing virtual comics, what is there to collect?

Save money However, the strong argument in favour of web comics is that you can actually obtain web space for free, so in theory you could get your comic story in front of people at no cost to yourself. Of course, that is not strictly accurate because you would need a computer and image-editing software package, but if you are creating comics in the currently accepted way, you would need that stuff anyway.

Get animated A bigger advantage is that, with such clever software applications as Macromedia's Flash, you can have your comics do more than just lie there looking pretty. Flash provides the opportunity to make your comic art interactive.

You can use Flash to make really great stuff happen, like adding sound effects – not just lettering but actual sound effects. Or you can have speech balloons appear over the artwork one by one in the correct order, giving your readers a glimpse of the artwork without bubbles all over it. If you have theatrical aspirations, you can even voice the dialogue yourself and add it to the Flash file, so that your readers do not even have to read. Ultimately, depending on how much time you have, you can animate the artwork, so that your comics can come to (limited) life. How fantastic is that?

Another advantage of publishing online is that you are freed from the constraints imposed by the printed format. While ideally your page shape should be similar to that of a computer monitor (in proportion to 800 × 600), there is no real limit on the number of pages or panels you can use to tell your story. Comic stories published on the internet can be as long or as short as you want them to be.

So what's the downside?

Well, not really a downside, but a pretty big limitation: it is really hard to make money from content on the web. The big internet downturn in the year 2000 happened partly because would-be entrepreneurs thought they could get their 'customers' to pay for information and entertainment over the internet. It just did not happen. People were used to getting stuff for free over the web and, when the bill came due, they did not want to pay. Even now, despite the best efforts of the music industry, hardly anyone wants to pay to download tunes, and so it is with comics.

That means you should not look at web comics as a surefire way to your first million. Far better to treat the web as what it is: a fantastic opportunity to market your comic stories. You could publish first on the web and gauge the reaction to your work. If you get an overwhelmingly positive response, then you can more safely approach the business of printing real comics and offering them for sale, possibly over the same internet.

Animated artwork

Happy Tree Friends (www.happytreefriends.com) goes beyond comics and ends up as Flash animation, although the packaging points to its comics roots. The site also offers DVDs of past episodes for sale.

WHAT YOU NEED

* A domain name
* Some space on a web server
* Macromedia Dreamweaver and Flash

HOW IT'S DONE

The hows of setting up a website are way beyond the scope of this book – we would need a whole other book to do that – but here are a few pointers. The first piece of advice is: Google is your friend. Just about anything you require to set up a web comic can be found online as long as you know what you are looking for. So, using Google, you need to search for:

Free web space There is loads to be had on the web, so cast around and find a site where you can post your files for nothing.

Macromedia Flash and Dreamweaver Actually, you can download 30-day trial versions of these essential programs from the macromedia.com website. You can also find all kinds of great tutorials online for these applications.

Free Internet Service Provider Didn't know you don't have to pay for your ISP? Well, a few ISPs do offer free internet connections. All you pay for is the phone call. However, a better solution is to splash out for broadband. If you are spending a lot of time online, having broadband means you do not pay for the connections to the internet. In addition, broadband is a whole lot quicker than that doddering old 56K modem.

Web comics The best way to learn how to make great web comics is to look at what other creators are doing. Some good examples are:

www.brokensaints.com A brilliant example of how to do gorgeous comics online.

www.nowheregirl.com No monsters, no superheroes, just characters interacting…

www.borderwalker.com An online magazine that features a number of different online comics.

www.topwebcomics.com A portal for a huge variety of online comics, covering adventure, drama, fantasy and humour.

TIP BUY A DOMAIN NAME

If you are on a tight budget and you want to host your online comics for free, then you are obviously going to sign up with a provider of free web space. The problem is that these providers give you a URL (web address) along the lines of www.whizbang.com/freebies/jimssite/ acmecomics/superduperman. Doesn't exactly trip off the fingers, does it? So, if you are serious, spend the £7 and buy yourself a proper domain name. You can often get a domain name and a hosting package very cheaply, and it will pay in the long run as more people will visit your site and see all your hard work.

Online comics

Broken Saints is one of the most impressive online comics, with all of the art being created in Macromedia Flash. So successful has the series become that you can even buy it on DVD as well.

useful names and addresses

North America

Publishing houses

Aardvark Vanaheim
PO Box 1674 Station C
Kitchener
Ontario N2G 4R2
Canada

Abstract Studios
PO Box 271487
Houston TX 77277-1487
www.strangersinparadise.com

AC Comics
PO Box 521216
Longwood FL 32752-1216
www.accomics.com

AiT/Planet Lar
2034 47th Avenue
San Francisco CA 94116
(00) 1 415 504 7516
www.astronautsintrouble.com

Alternative Comics
503 North West 37th Avenue
Gainesville FL 32609-2204
(00) 1 352 373 6336

American Media Consumer
Entertainment Inc.
600 East Coast Avenue
Lantana FL 33464
(00) 1 561 586 1111

Antarctic Press
7272 Wurzbach Parkway, Suite 204
San Antonio TX 78240
www.antarctic-press.com

Archie Comic Publications
325 Fayette Avenue
Mamaroneck NY 10543
(00) 1 914 381 5155
www.archiecomics.com

Avatar Press
9 Triumph Drive
Urbana IL 61802
(00) 1 217 384 2216

Bongo Entertainment
1440 South Sepulveda Boulevard,
3rd Floor
Los Angeles CA 90025
(00) 1 310 966 6168

Caliber Comics
225 North Sheldon Road
Plymouth MI 48170
(00) 1 734 462 0457
www.calibercomics.com

Cartoon Books
PO Box 16973
Columbus OH 43216
www.boneville.com

Crossgen Entertainment, Inc.
4023 Tampa Road, Suite 2400
Oldsmar FL 34677
(00) 1 813 891 1702
www.crossgen.com

Crusade Fine Arts Ltd
PO Box 845
Bayport NY 11705
(00) 1 631 472 2866
www.shiweb.com

Dark Horse Comics
10956 South East Main Street
Milwaukie OR 97222
(00) 1 503 652 8815
www.darkhorse.com

DC Comics
1700 Broadway
New York NY 10019
(00) 1 212 636 5400
www.dccomics.com

Drawn & Quarterly
PO Box 48056
Montreal
Quebec H2V 4SB
Canada
www.drawnandquarterly.com

Dreamwave Productions
11 Allstate Parkway, Suite 200
Markham
Ontario L3R 9I8
Canada

Fantagraphics Books
7563 Lake City Way North East
Seattle WA 98115
(00) 1 206 524 1967
www.fantagraphics.com

Harris Comics
1115 Broadway, 8th Floor
New York NY 10010
(00) 1 212 807 7100
www.vampirella.com

Heavy Metal
100 North Village Road, Suite 12
Rockville Center NY 11570
www.heavymetal.com

Humanoids Publishing
PO Box 931658
Hollywood CA 90093

Image Comics
1071 North Batavia Street, Suite A
Orange CA 92867
(00) 1 714 288 0200

Marvel Entertainment Group
10th Floor, East 40th Street
New York NY 10016
www.marvel.com

NBM Publications
185 Madison Avenue, Suite 1504
New York NY 10016

Oni Press
6336 South East Milwaukie
Avenue, PMB 30
Portland OR 97202
www.onipress.com

Radio Comix
11765 West Avenue, PMB #117
San Antonio TX 78216
(00) 1 210 348 7195

Sirius Entertainment, Inc.
PO Box 834
Stanhope NJ 07802
www.sirius.choiceonline.com

Slave Labor Graphics Publishing
577 South Market Street
San Jose CA 95113

Top Shelf Productions
PO Box 1282
Marietta GA 30061-1282
(00) 1 770 427 6395

Twomorrows Publishing
10407 Bedfordtown Drive
Raleigh NC 27614
tel (00) 1 919 449 0344
fax (00) 1 919 449 0327
www.twomorrows.com

Viz Communications
PO Box 77010
San Francisco CA 94107
www.viz.com

WaRP Graphics
2600 South Road, Suite 44/242
Poughkeepsie NY 12601

Newspaper syndicates

King Features Syndicate
235 East 45th Street
New York NY 10017

Los Angeles Time Syndicate
218 Spring Street
Los Angeles CA 90012

New America Syndicate
1703 Kaiser Ave
Irvine CA 92714

Distributors

Diamond Distributors
1966 Greenspring Drive #300
Timonium MD 21093

United Kingdom

Publishing houses

AP COMICS
Suite 3, 7 French Row
St Albans
Hens AL3 5DU

COM.X
The Dickens Inn
Kirk Street
London WC1N 2DG
020 7831 7777

DC Thomson
2 Albert Square
Dundee DD1 9QJ

Dennis Publishing Ltd
30 Cleveland Street
London W1T 4JD
020 7907 6000

Egmont Magazines Ltd
Fourth Floor, 184–192 Drummond
 Street
London NW1 3HP
020 7380 6430

Hamlyn Books
2–4 Heron Quays
London E14 4JB
020 7531 8400

John Brown Citrus Publishing
The New Boathouse
136–142 Bramley Road
London W10 6SR
020 7565 3000

Knockabout Comics
10 Acklam Road
London W1D 5QZ
020 8969 2945
www.knockabout.com

Panini Comics (UK)
Panini House
Coach and Horses Passage
The Pantlles
Tunbridge Wells
Kent TN2 5UJ
01892 500 100

Pulp Theatre Entertainment
Mermaid Court
1 Mermaid House
London Bridge
London SE1 1HR
020 7403 0378

Rebellion Developments Ltd
The Studio
Brewer Street
Oxford OX1 1ON
01865 792 201

The Redan Company
Canon Court East
Abbey Lawn
Shrewsbury SY2 5DE
01743 364 433

Savoy Books
446 Wilmslow Road
Withington
Manchester M20 313W
0161 445 5771

Titan Entertainment Group Ltd
Titan House
144 Southwark Street
London SE1 0UP
020 7620 0200

Distributors

Diamond Distributors
PO Box 250
London E3 3LT

Fanzines

Comics International
345 Ditchling Road
Brighton BN1 6JJ
www.comics-international.com

Organizations

Comic Creators Guild
171 Oldfield Road
London SE16 2NE

National Union of Journalists
Acorn House
314–320 Gray's Inn Road
London WC1X 8DP

France

Albin Michel
22 rue Huyghens
75014 Paris
(0033) 1 42 79 10 00

Casterman
36 we du Chemin Verf
75011 Paris

Dargaud
15–27 rue Moussorgski
75018 Paris
tel (0033) 1 53 26 32 32
fax (0033) 1 53 26 32 00

Delcourt
54 rue d'Hauteville
75010 Paris
tel (0033) 1 56 03 92 20
fax (0033) 1 56 03 92 30

Fluide Glacial
33 avenue du Main, BP 187
75755 Paris
(0033) 1 43 20 23 96

Glenat
31-33 rue Ernest Renan
92130 Issy-Les-Moulineaux
tel (0033) 1 41 46 11 41
fax (0033) 1 41 46 11 13

J'ai Lu
84 rue de Grenelle
75007 Paris
(0033) 1 44 39 34 70

Les Humanoides Associes
5 Passage Piver
75011 Paris
tel (0033) 1 49 29 88 88
fax (0033) 1 49 29 88 89

Semic France
44316 Nantes Cedex 03
(0033) 2 51 86 14 14

Italy

Astorina SRI
via Boccaccio 32
20123 Milano

Cult Comics
viale Emilio Po' 380
41100 Modena

King Comics
via Pinerolo 3
00 182 Roma

Magic Press
Zona industriale via Ragusa 18
00040 Pavona
Roma
(0039) 06 93 02 03 61

Sergio Bonelli Editore
via Buonarroti 3
20145 Milano

Star Comics
strada Selvette ibis/1 Bosco (PG)

Spain

Ediciones La Cupula
Plaza de las Beatas 3
E-08003 Barcelona
(0034) 32 682 805

Editorial Planeta De Agostini, SA
Aribau 185
08021 Barcelona

Norma Editoral
Fluvià 89
08019 Barcelona
(0034) 93 303 68 20

Toutain Editor, SA
Diagonal 325
E-08009 Barcelona
(0034) 93 344 06 00

bibliography

In learning to draw comics there are two distinct stages: first, you must learn how to draw; second, you must learn how to draw comics. Obviously this book is concerned with the second stage. In case you need help in learning how to draw, however, here is a short selection of books that will tell you how best to go about developing your basic drawing skills.

General books

Albert, Greg
Drawing: You Can Do It!
North Light Books, Cincinnati, 1992

Alvarez, Tom
How to Create Action, Fantasy and Adventure Comics
North Light Books, Cincinnati, 1996

Artist's Market
Writer's Digest Books, published September every year

Cole, Rex
Perspective for Artists
Dover Books, New York and London, 1971

Dodson, Bert
Keys to Drawing
North Light Books, Cincinnati, 1985

Hogarth, Burne
Drawing the Human Head
Watson-Guptill Publications, New York, 1971

Hogarth, Burne
Dynamic Anatomy
Watson-Guptill Publications, New York, 1971

Hogarth. Burne
Dynamic Figure Drawing
Watson-Guptill Publications, New York, 1971

Hogarth, Burne
Dynamic Light and Shade
Watson-Guptill Publications, New York, 1971

Pellowski, Michael Morgan & Bender, Howard
The Art of Making Comic Books
First Avenue Editions, 1995

Thompson, Ross & Hewison, Bill
How to Draw and Sell Cartoons
North Light Books, Cincinnati, 1985

Other books on drawing comics

Eisner, Will
Comics and Sequential Art
Tamarac (Florida), Poorhouse Press, 1984

Lee, Stan & Buscema, John
How to Draw Comics the Marvel Way
New York, Simon and Schuster, 1978; London, Titan Books, 1986

McCloud, Scott
Understanding Comics
Kitchen Sink

author's acknowledgements

First edition

Despite what it says on the cover, no book is ever produced entirely by one person. And this book is no exception.

So special thanks to Steve Parkhouse, who produced a lot of artwork in a short space of time for this book, not least of which was the art for our special demonstration comic strip, and who also contributed valuable technical data. Thanks to Win Wiacek of Winning Streak, who researched most of the US comic-book pages we have reproduced. I'd like also to thank Dez Skinn, my first boss in the comics business, who generously donated comic-strip material from his classic publication *House of Hammer* free of charge.

I want to thank Quarto senior editor Polly Powell, who didn't bat too much of an eyelid when I told her the manuscript was going to be over a week late.

Then there are the various comics professionals I've worked with over the years who have contributed to this book, whether they realize it or not. So a tip of the hat is due to Paul Neary, Steve Moore, Dave Gibbons, Richard Burton, Alan Moore, David Lloyd, Steve Dillon, Annie Halfacree, Ellita Fell and Alan Murray.

And finally, very special thanks to Lorraine Dickey, without whom I'd probably never have written this book.

Alan McKenzie, London, 1987

Second edition

I was surprised and delighted to be asked to update this book for the 1990s. Fortunately. I was able to call on nearly ten years editorial experience on *2000AD* (still the cutting edge of comics, worldwide!) and some learned colleagues. So, big thank yous go out to John Higgins, not only the finest colourist in the business but also one of the finest artists and painters you'll ever see; Rian Hughes, one of the best graphic artists anywhere and a pretty handy comic-strip artist into the bargain; and Steve Cook, the graphic designer responsible for the graphic design of *2000AD* since … oh, since it started looking good.

Alan McKenzie, London, 1997

Third edition

Another decade, another edition. This time around the biggest change is all the information on digital comic creation. Computers have revolutionized the publishing industry in general, and comics are no exception. The lure for the publishers is the amount of money they save by cutting out the print bureaus that traditionally would scan and assemble colour artwork before plate-making. Now, publishers receive digital files straight from the creators, pretty much ready for the plate-making process. Big, expensive step wiped from the schedule, saving publishers loads of money. It was ever thus …

Cynicism aside, once more I must thank my longtime friend and sometime creative partner Steve Parkhouse for the loan of his not inconsiderable talent in the making of this book, and to all the crew at Quarto who make this such an enjoyable decannual event.

See you in 2014.

Alan McKenzie, London, 2004

index

credits

Quarto would like to thank and acknowledge the following artists and corporations for supplying illustrations and photographs reproduced in this book (Key: l left, r right, c centre, t top, b bottom)

Page	Credit
2	Dawn is ™ and © Joseph Michael Linsner
3	Chelsea Boys © Glen Hanson and Allan Neuwirth www.chelseaboys.com
7	The Originals © Dave Gibbons www.davegibbons.net
10	Little Nemo in Slumberland, Winsor McCay
11	Tarzan © Edgar Rice Burroughs Inc.
13	Private Collection Christie's Images/ BRIDGEMAN ART LIBRARY
14	Marvel Characters, Inc./CORBIS
17	Marvel Characters, Inc./CORBIS
19	Dawn is ™ and © Joseph Michael Linsner
29	Courtesy of Apple
31	Mark Harrison © Rebellion A/S. www.2000ADonline.com
32t	Angel Fire © Steve Parkhouse/Chris Blythe
33	Angel Fire © Steve Parkhouse/Chris Blythe
34b	Pogo, Walt Kelly © Okefenokee Glee and Perloo, Inc.
35	Judge Dredd and 2000 AD © Rebellion A/S. www.2000adonline.com Distributed by Knight Features
38	Shi © William Elliot Tucci/Crusade Entertainment
39t	Judge Dredd and 2000 AD © Rebellion A/S. www.2000adonline.com
39b	Dawn is ™ and © Joseph Michael Linsner
40t	Chelsea Boys © Glen Hanson and Allan Neuwirth www.chelseaboys.com
43tl	Jon Haward www.jonhawardart.com
45	Springball® is ™ and © Shanth S. Enjeti www.enjeticomics.com
47l	Dylan Teague © Rebellion A/S. www.2000adonline.com
50	Dylan Teague © Rebellion A/S. www.2000adonline.com
51	Dylan Teague © Rebellion A/S. www.2000adonline.com
55	Catherine Yen. www.studiocyen.net
56	Shi © William Elliot Tucci/Crusade Entertainment
58	Mark Heath www.markheath.com
59	Judge Dredd and 2000 AD © Rebellion A/S. www.2000adonline.com Distributed by Knight Features
60–1	Johnny Nemo © Pete Milligan (script) and Brett Ewins (art)
63	Shi © William Elliot Tucci/Crusade Entertainment
66	Mark Harrison © Rebellion A/S. www.2000adonline.com
67	Dawn is ™ and © Joseph Michael Linsner
70–1	Dylan Teague © Rebellion A/S. www.2000adonline.com
78l	Carl Pearce
78c	These Three Be Children Design © Reynold Kissling
78r	These Three Be Children Design © Reynold Kissling
80l	Dawn is ™ and © Joseph Michael Linsner
82l	Shaun "Swampy" O'Reilly
82cl	Nubian Greene
82cr	Al Davison
82r	Simon Valderrama
83l	Simon Valderrama
83c	Duane Redhead
83r	Ruben de Vela
86l	Chelsea Boys © Glen Hanson and Allan Neuwirth www.chelseaboys.com
86r	Springball® is ™ and © Shanth S. Enjeti www.enjeticomics.com
87	Springball® is ™ and © Shanth S. Enjeti www.enjeticomics.com
90l	Mark Harrison © Rebellion A/S. www.2000adonline.com
90c	Jets are ah Blastin! © Reynold Kissling
91bl	Courtesy of Nikon Corporation
94–5	Brett Ewins and Jamie Hewlett
101tr	Judge Dredd and 2000 AD © Rebellion A/S. www.2000adonline.com
104l	Rasputin Pencils © Reynold Kissling
108l	Chelsea Boys © Glen Hanson and Allan Neuwirth www.chelseaboys.com
108r	Alex Storer and Tony Bates © Fatdog Comics www.fatdog-comics.co.uk
110	Chelsea Boys © Glen Hanson and Allan Neuwirth www.chelseaboys.com
111t	Mark Harrison © Rebellion A/S. www.2000adonline.com
114t	Judge Dredd and 2000 AD © Rebellion A/S. www.2000adonline.com
114b	Glenn Fabry © Rebellion A/S. www.2000adonline.com
124	Alex Storer and Tony Bates © Fatdog Comics www.fatdog-comics.co.uk
126	The Comics Journal www.tcj.com © Fantagraphics Books www.fantagraphics.com
127	Judge Dredd and 2000 AD © Rebellion A/S. www.2000adonline.com
134	Happy Tree Friends © Mondo Media. www.happytreefriends.com
135	Broken Saints © Budget Monks Productions Inc. www.brokensaints.com

All other illustrations and photographs are the copyright of Quarto Publishing plc.

Websites

The following websites of comic-strip artists feature great examples of pencilled art, inked art and step-by-step techniques.

Neal Adams
www.nealadams.com

Gene Colan
www.genecolan.com

Bob Layton
www.boblayton.com

Bob McLeod
www.bobmcleod.com

Alex Ross
www.alexrossart.com

Dave Stevens
www.davestevens.com

Barry Windsor-Smith
www.barrywindsor-smith.com

Bernie Wrightson
www.berniewrightson.com

Other websites of value include:

Grand Comic Book Database
www.comics.org
Cover repros of every comic ever!

Silver Age Marvel Comics Covers Index
www.samcci.comics.org
Does what it says on the can

Alan McKenzie's website
www.thestoryworks.com
Includes links to the covers and art talked about in this book plus plenty more